100 Artists of the West Coast

Douglas Bullis

4880 Lower Valley Road, Atglen, PA 19310 USA

Dedication

To Lucinda Formyduval, whose love of
art has always inspired.

Library of Congress Cataloging-in-Publication Data

Bullis, Douglas.
　　　100 artists of the West Coast / by Douglas Bullis.
　　　　　p. cm.
　　　ISBN 0-7643-1931-0
1. Art, American--California--20th century. 2. Artists--Califor-
nia--Psychology. I. Title: One hundred artists of the West Coast.
II. Title
N6530.C2 B85 2003
709'.2'279--dc21
　　　　　　　　　2003013657

Designed by Ellen J. (Sue) Taltoan
Type set in ZapfHumnst DmBT/Korinna BT

ISBN: 0-7643-1931-0
Printed in China

Published by Schiffer Publishing Ltd.
4880 Lower Valley Road
Atglen, PA 19310
Phone: (610) 593-1777; Fax: (610) 593-2002
E-mail: Info@schifferbooks.com
Please visit our web site catalog at
www.schifferbooks.com
We are always looking for people to write books on new
and related subjects. If you have an idea for a book,
please contact us at the above address.

This book may be purchased from the publisher.
Include $3.95 for shipping.
Please try your bookstore first.
You may write for a free catalog.

In Europe, Schiffer books are distributed by
Bushwood Books
6 Marksbury Avenue
Kew Gardens
Surrey TW9 4JF England
Phone: 44 (0) 20 8392 8585
Fax: 44 (0) 20 8392 9876
E-mail: Bushwd@aol.com
Free postage in the UK. Europe: air mail at cost.

Contents

Acknowledgments

After the completion of any book, looking out over the box of blank thank-you notes that must become its Acknowledgments section is fraught with must-haves and don't-forgets. But this book, with its 100 artists, their assistants, their galleries, the secretaries and managers, the museum curators who recommended them, the phalanx of others who advised or cautioned—looking out over the sea of these faces and memories and names, the task is what a bee must feel like as it beholds an alpine meadow in June.

So to the first flower first. The pre-eminent source of candidates and advice for this book was Philip Linhares of the Oakland Museum. Without his thoughtful suggestions, you would be reading very much a lesser book. His generosity of information and time on behalf of the artists themselves is the perfect model for anyone who would support the arts.

Then there are those who work directly with the artists whose aid likewise made this book what it is. Hence many thanks to Curt Klebaum, Studio Manager for Peter Alexander; Emily Thompson of Tony Berlant's studio; Frank Lobdell's wife Jinx and those who made his chapter what it is; David Solomon, Diane Roby, and Anthony Torres, who summarized a series of very long interviews with Frank done in July 2002; Ed Moses' gracious assistant Carol Bernacchi; Sue Welsh of the Noah Purifoy Foundation at Tara's Hall in Los Angeles; Jayme Odgers, for his portrait of Adrian Saxe; Peter Shire's wife Donna (especially for keeping him in the studio earning a living when he'd much rather be out riding his motorcycle); Squeak Carnwath's husband Gary for his do-it-now way of collaborating. There are not enough thanks in all the world's languages for Emi Takahara's help putting together David Ireland's chapter in a time of duress for the both of them. And too, Hung Liu's husband Jeff Kelly for his portrait; Robert Ogata's wife Zandra for all the bookish detail-work she provided; Roland Petersen's wife, cook, and go-between, Caryl Ridder; Marlene Angeja for Raymond Saunders' materials; Catherine Wagner's assistant Jennifer for her edits of Catherine's artistic statement; Darren Waterston's Linda Cannon for everything; William Wiley's agent Wanda Hansen for countless trips to his home putting his section together; William Morris studio manager Holle Simmons; and Lisa Zerkowitz's husband Boyd Sugiki for her portrait.

With the many others, the only fair method is to list them as we did with the artists themselves: by region from south to north, then by their galleries in alphabetical order.

Southern California

Craig Krull of his eponymous gallery provided the contacts and assistance for the sections on Jo Ann Callis and Robbert Flick. The ever-cheerful Mingfei Gao, Gallery Director of DoubleVision Gallery provided the contacts and images for Robert Walker. Michele DePuy Leavitt, Director, and Frank Lloyd of the Frank Lloyd Gallery in Santa Monica's Bergamot Station were the go-betweens with artists John Mason, Adrian Saxe, and Peter Shire; many thanks, too, to Sonny and Mrs. Kamm for making available Peter Shire's *Teapot Mailbox* (which really *is* the Kamm family mailbox!). Sherry Frumkin, owner, and Sherin Guirguis, Associate Director of Frumkin/Duval Gallery made contact with Alex Donis for the book. Owner Jan Baum and Gallery Manager Emmy Cho of the Jan Baum Gallery provided the contacts and images for Alison and Lezley Saar and Takako Yamaguchi. Eleana Del Rio, Director, of the Koplin Del Rio Gallery sourced Sandow Birk and David Ligare. Director Kimberly Davis, Liz Fischbach, and Iza Jadach of the LA Louver Gallery gave so very generously of their time photographing the images of the work of Tony Berlant, Charles Garabdedian, Michael C. McMillen, and Ed Moses. Cliff Benjamin, Director of the Mark Moore Gallery, was the invaluable link with Carole Caroompas, Sush Machida Gaikotsu, and Yek Wong. Sue Welsh of the Noah Purifoy Foundation has almost single-handedly put this marvelous artist of the desert on the artistic map. Patricia Correia, Owner, Amy Perez, Associate Director of the Patricia Correia Gallery were the "channel" to Patssi Valdez—whose sense of humor is even better than her art. Nearby, Patricia Faure of her namesake Gallery and her wonderful Gallery Director Pilar Tompkins, who assured me that "Salomón Huerta is a real '*papi chulo*,' as we say in Spanish," leaving me to scramble for the phrase book for the exact definition ("dishy" comes close). One look at Salomón's portrait explains it all. Julia Luke of the Shoshana Wayne Gallery was the contact for Brad Spence. And Aki Kameyama of Scott White Contemporary Art in La Jolla graciously provided the many images of William Glen Crooks' artwork.

Northern California

Owners Bonnie Grossman and Assistants Karen Frerich and Wendy Morris of Berkeley's Ames Gallery referred to the delightful Wilbert Griffith and his delightful Barbados accent; Ruth Braunstein, Director, and her assistants Shannon Trimble and Cathy Whittington of the Braunstein/Quay Gallery sourced Cork Marcheschi and Mary Snowden for this book; Brian Gross, Leslie Geddes, and Tressa Williams of Brian Gross Fine Art gave us Peter Alexander, Donald Feasél, Michelle Fierro, and Patrick Wilson; Catharine Clark and Anna Rainer of the Catharine Clark Gallery suggested Ed Osborn, Inez Storer, and Masami Teraoka; Cheryl Haines and Grace Kook of the Haines Gallery gave us Alan Rath and Darren Waterston; Paule Anglim and Ed Gilbert of Gallery Paule Anglim suggested Enrique Chagoya, Mildred Howard, David Ireland, and Barry McGee, while Gallery Administrator Margaret-Ann O'Connor went to considerable efforts to track down images of their works and the many other details that went into their presence (a dream to work with, she is!); the charming quartet of Michael R. Hackett, Tracy Freedman, Francis Mill, and Susan McDonough at the Hackett-Freedman Gallery took care of Marc Trujillo, Roland Petersen, and Frank Lobdell; Michelle Townsend, Lisa Kaplan, Leah Edwards, and Meredith Johnson of the multi-location HANG Galleries group undertook the unenviable job of sorting through their dozens of young, bright, up-and-coming artists to come up with Kevin Moore and Catherine Ryan; Heather Marx and Steve Zavattero of the Heather Marx Gallery introduced us to William Swanson; Dianne Dec of the Hosfelt Gallery suggested Timothy Berry, Anthony Discenza, and Greg Rose; Georgia Lee, JJ Brookings Fine Art recommended the work of Robert Ogata; Mary Orth at the Michael Martin Galleries gave us Rex Ray; the Awesome Foursome of Rena and Trish Bransten, Walter Maciel, and Calvert Barron of the Rena Bransten Gallery suggested the equally awesome foursome of Doug Hall, William Wiley, Ron Nagle, and Hung Liu; Stephen Wirtz, Liz Mulholland, and Ellen Mahoney of the Stephen Wirtz Gallery suggested Deborah Oropallo, Michael Kenna, Raymond Saunders, and Catherine Wagner; and Nancy Toomey and Stephen Tourell of their own Toomey Tourell Gallery recommended Nathaniel Price.

Oregon

A hop, skip, and 650-mile jump took us to Portland, where Bob Kochs and Victor Maldonado at the Augen Gallery gave us Sally Cleveland, Chris Kelly, Lori-ann Latremouille, and Naomi Shigeta; Elizabeth Leach and Sue Lynn Thomas of the Elizabeth Leach Gallery introduced us to Mark Smith and Libby Wadsworth; Charles Froelick, and Sarah Taylor and the Froelick Gallery gave us Laura Ross-Paul; Martha Lee of the Laura Russo Gallery recommended Jay Backstrand and Michael Brophy; Margo Jacobsen and Colleen Northup of the Margo Jacobsen Gallery introduced Allen Cox; Rod Pulliam and MaryAnn Deffenbaugh of their own Pulliam Deffenbaugh Gallery gave us Anna Fidler and Kris Timken; and Tracy Savage with Venae Rodriguez of SAVAGE sourced for us Jacqueline Ehlis and Dianne Kornberg.

Washington and British Columbia

Ever northward into the land of perpetual sun, Bryan Ohno of his eponymous Bryan Ohno Gallery suggested Minoru Ohira and Lisa Zerkowitz; Janice Monger, Director of Contemporary Painting and Sculpture at Davidson Galleries helped us with Susan Bennerstrom, John Grade, and Francesca Sundsten; Tom Landowski, Director of the Foster White Gallery, introduced William Morris; Francine Seders, Director of her own Francine Seders Gallery helped us find Marita Dingus; Greg Kucera suggested Mark Calderon, Claudia Fitch, Sherry Markovitz, and Peter Millett; Billy Howard of Howard House suggested Joseph Park and others; Linda Hodges and David Davenport of the Linda Hodges Gallery introduced us to Margaretha Bootsma, Gaylen Hansen, and Gillian Theobald; and finally, Lisa Harris, Director of her own Lisa Harris Gallery and her assistants Erik Chittick Scarlet Batchelor were a one-stop bonanza, yielding up John Cole, Christopher Harris, Sherry Karver, and Richard Morhous.

But for freshets as these, the sea runs dry.

Erratum: The San Francisco artist Frank Lobdell was inadvertently placed in the Southern California section. Our apologies to the artist and readers.

Introduction

These pages were set into motion by seven words: *"Artists should be seen and not heard."*

It is amazing how pervasive this belief can be despite its closed-mindedness. Luckily, that view is but a burr on the garment of the world's uncountable art galleries and writers who keep alive many times that number of artists, each of whom sews on their personal patch of idea and experiment. Equally luckily, that belief was sufficiently nettlesome to inspire a series of books about artists speaking on their own behalf.

There is so much regional identity in the world's contemporary fine art that the only way to approach the subject is by region. This volume is about one of those regions: San Diego to Vancouver. Our goal was to put into a few hundred pages as much visuality as we possibly could.

Pause before an art work that remains an enigma while also inspiring, and ask, "What was that artist thinking?" There's only one way to know: ask the artist. Since few can do that, this book brings them to you. Artists frequently complain that the celebrity-mindedness of the mainstream media makes it difficult for them to be known for who they are to themselves. They are constantly filtered through an interpretive institution of critics, reviewers, journalists, and gossips, each of whom wears their own particular set of agenda-colored glasses. Interviews give artists a bit more room for maneuver, but, like most everyone facing a microphone, artists dislike a situation where a handful of words blurted into a tape recorder are later regretted.

The solution was to give artists the chance to speak for themselves, and be patient while they think it through. We asked them, in essence, this question: "Imagine that you are sitting with the reader and you are describing yourself and your work. What do you tell them?" Their initial statements were shaped and honed over months, refined with rounds of questions and edits, until, to the best of their ability and patience, what they say in their few words here is an essence of who they are.

An essence instead of *the* essence because, like so many who create, their thoughts and lives are so rich it seems no biography can capture them. The poet A. K. Ramanujan (1929–1993) observed, "You can see every orange on a tree but not all the trees in an orange." Divining an artist's inner tree is not an easy job. Yet in these snippets of self that mix thought, emotion, and spirit as one, we find a quality of character definition usually achieved only by great novelists and poets. You can sit with one on a porch saying hardly a word, and walk away feeling it was the best conversation you ever had. Rare is an idea uttered in this book that can be called commonplace. And how nice it is to hear voices trailing in and out of the cloud of unknowing, leaving us with some sense of it.

Perhaps this is why most artists do not want is being pedestaled. Artists deal in their own way with the same issues that preoccupy everyone: How do I navigate the gray area between the public and the private moment? Why does my life have so many insecurities? How do I get past the myth the press decides I should be? How do I distinguish between the social and personal issues that make our collective memory? Am I alone, or am I part of a wholeness within whose immensity my life and my deeds mean everything yet have no meaning at all? How do I express what I barely grasp at the far fringes of my feelings?

We can't walk into the life of their pictures without walking into their subconscious continent exploring and rendering answers to these questions. The era, the ideologies, the part myth and part fact of life, the buzz of changing and doing; the imaginings, the abstract and real that emerge from the jungle where they live onto the grasslands where they think. Their pictures may depict realisms or metaphors, but their message is *that* we are seeing, not *what* we are seeing. The happiest of people don't come from having the best of everything, but from making the best of what comes their way. Those who joy, those who hurt, those who have searched, and those who have tried, these can appreciate the importance of each moment in their lives.

Construct has a way of erecting edifices while shallowing minds. Walk away from the edifice and we find ourselves in a mapless terrain with but one guide, the artist's tiny moment of seeing. The artist's Job One is to envision ideals, and Job Two is to find the right means to proclaim them. Their work makes clear how they have channeled feeling into the central energy of oneness with life, demonstrating to us that theirs is a way of being, not seeing. As one of the artists in this book put it, "It's not the job of art to mirror. A mirror reflects us in reverse. An artist's responsibility is to reveal consciousness."

The artist hopes you will see. Their imparting of a brand-new idea is an equilibrium being punctuated: "I could have seen that, too. Why didn't I?" Their art is gen-

erous. It accommodates itself to everybody and asks nothing. If we think about where an artwork comes from and where it goes, or speculate what it is about, we become no less the art than the artwork. Looking at it, we are not just getting by, but putting a little in the bank, too. Do this long enough and we discover we are every picture we have ever known. A mystery turned into a friend, the picture fades, but we remain.

There's a hidden agenda to this book, so let's unhide it: Looking at art is not enough. Regard without support is the equivalent of adoring flowers without watering them. If you value art, buy good art. If you don't follow art all that keenly, go to reputable galleries and ask what their artists are doing. Many people fear they might appear poorly informed. To the contrary. Artists and their gallery representatives cherish someone with an open mind willing to learn and to enjoy. Meeting an artist is one of life's most fruitful opportunities to know nothing.

Agenda No. 2: Don't hesitate to buy the work of artists working and living today. They are creating tomorrow's excitement. With contemporary art, all the time is a good time to get in on the ground floor. Art is a better long-term investment than many more traditional monetary instruments, and certainly more comely on the walls. Today's visionaries will be the ones in the news ten, twenty, thirty years from now. And if the dinner talk wanes weak, the work on the wall is an ever-reliable freshener.

Investment in art satisfies a nobler sentiment as well. Of all the contrivances managerial and spiritual by which a culture organizes itself, it is via art—which includes theater, dance and literature—that a culture is remembered. How little we know of the myriad feet that passed the carved stones of Moissac or Chartres, or the fingers that penned calligraphy more graceful even than their words, or the hands that shaped the Oribe glazed cups of Japan, but how well we know the eyes that gave shape to all these. It is the artists in this book and their unnumbered colleagues past and future who will delineate who we are to curious eyes decades, centuries, millennia hence. A bit of fragrance clings to the hand that gives the rose.

A bit about selectivity. In the Pacific Slope region alone we could have assembled ten more books just like this one and still not have exhausted the pool of worthy talent. We avoided the Top 40 approach in which you are about to see what you've seen before. To art devotees, there are some very obvious names that are not in here.

Some opted not to be, some didn't respond to the invitation, and some are so much in the news that it is really time to allot a bit of room to those a bit less lofty on the ladder. To put our criteria in three words, we wanted variety, veracity, and venturesomeness.

There may be readers who demand, "Why are there glass and ceramics artists in here—and even one who works with the medium of salt? Those aren't art, they are craft. Why are they in an art book?

Because the distinction between craft and art is growing less tenable by the day, and, as is the case in so many rigidities of esthetic judgment, is so arbitrary and open to interpretation that it should never have been made at all. The ennobling lesson that has come out of the World Fusion Music movement over the last two decades is that while instruments are many, music is one.

One of the artists in this book summed up a perennial problem artists face, "In 2000 the J. Paul Getty Museum invited eleven Los Angeles artists to come and look at the collection and create work in response to the collection. My response was that the Getty is very European and very Western. I wanted to show how much is left out and how much history and how much contemporary culture is excluded in that collection."

The artist was Alison Saar (p. 48) and her work is great art by any definition of the term. Another artist, Adrian Saxe, submitted a very different work: a floor-sized installation *1-900-Zeitgeist* (p. 53), which consisted of porcelain, stoneware, mixed media, furnishings, and floor space. About this he said, "I consider pottery in its social, political, economic, and intellectual context. I do not make the distinction between 'crafts' versus 'fine arts' that so circumscribes professional opportunities and markets these days. I want my ceramic work to respond to my time and place in a larger cultural context—art that reflects and interprets the world around me through critical analysis and the particular techniques I choose."

Ms. Saar and Mr. Saxe touch on the vast gulf of perception between those who create art and those who anoint it. Personality as labyrinthine as it is, and creativity as mysterious as it is, it impossible to understand the work of an artist without hearing it directly from the artist. The most important thing we can do is hear them out, and value their work by what they say of it.

Seen and not heard? It's yours to decide.

Peter Alexander
Brian Gross Fine Art, San Francisco

I like things that glow.

Region 1
Southern California

Van Nuys, 1987. Oil and acrylic on canvas, 60" x 66". *Courtesy of Brian Gross Fine Art. All photographs courtesy of Brian Gross Fine Art Gallery.*

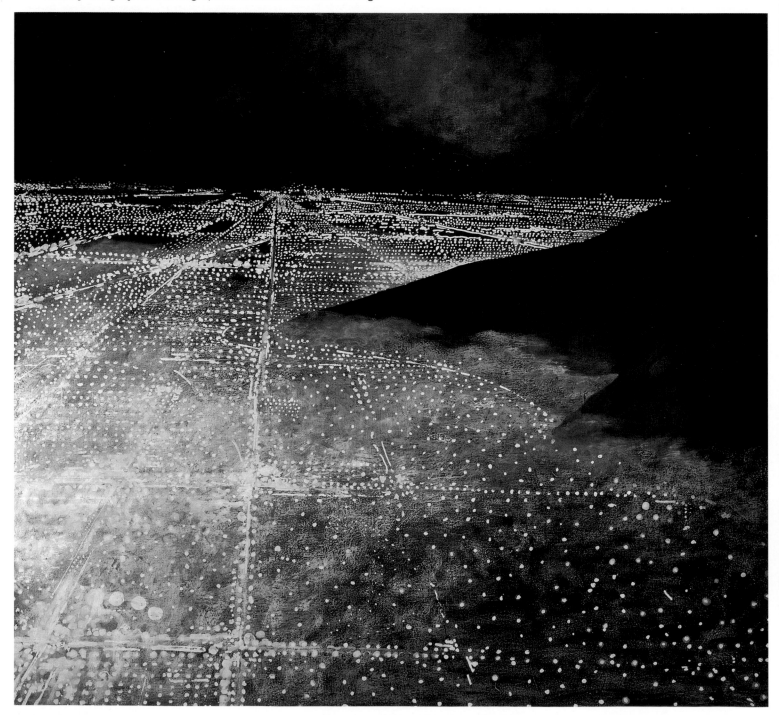

Gulper, 1982. Mixed media on velvet, 108" x 142". *Collection of Los Angeles County Museum of Art, Modern and Contemporary Art Council Fund.*

Lucifer, 1985. Oil and wax on canvas, 48" x 53". *Collection of Melanie and Tom Staggs, Beverly Hills.*

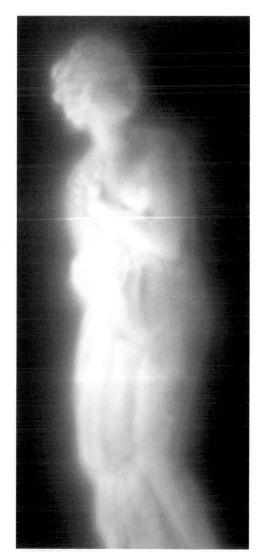

Clubs, 1993. Acrylic on canvas, 84" x 48". *Collection of Peter & Turkey Stremmel, Reno, NV.*

Tony Berlant

L.A. Louver, Venice

Photograph courtesy of the artist.

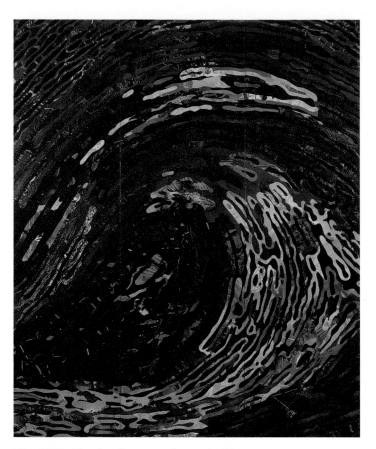

Rio, 2001. Metal collage on plywood with
steel brads, 114" x 96" overall (3 panels).

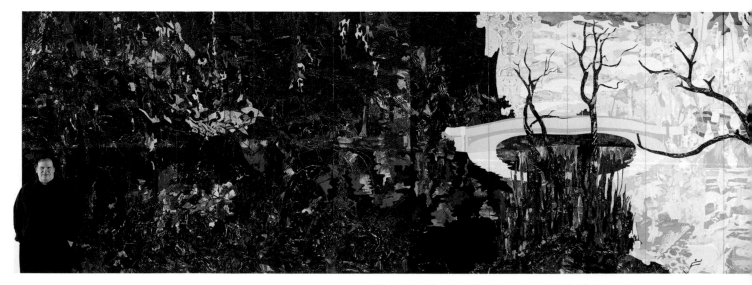

What You See Is Who You Are, 2003. Metal collage on wood
with steel brads, 9' 3/4" x W: 56' 2 3/4". *Private collection, Los
Angeles. All photographs courtesy of Robert Wedemeyer.*

Topanga, 2001. Metal collage on plywood with steel brads, 96"
x 132" overall (3 panels).

Sandow Birk
Koplin Del Rio Gallery, Los Angeles

Courtesy of James Cassimus.

A new piece usually emerges from something in art history and my thinking about contemporary events. Many of my paintings are inspired by current affairs, social issues, the daily events of our lives. Even something as mundane as going to the ATM can be an interesting topic for a work. Once I have the theme or concept for a piece, I search for a past image that relates to contemporary reality in some meaningful way. The stronger the link there is between past art and the present concept, the stronger I feel my own work becomes.

I never thought about being an artist until I hit college. I'd planned to study architecture but at the last minute went to an art school for a look. That was it. I could either study math and physics for six years or I could study history and drawing.

Dante in the Wilderness, 2002. Oil and acrylic on canvas, 48" x 32". *Private collection. All pictures courtesy of Koplin Del Rio Gallery.*

Much of my work quotes from the historical conventions of painting as a way to comment on contemporary issues and the role of painting in the world today. I want people to be able to see how my work draws on traditions and history. Even if they might not know the specific sources of a work of mine, I want it to be evident that I use compositions or styles from the past for specific ends. Even when my own work might spoof those traditional elements, there is always a reason for doing so.

My work has many different purposes, but I think it most basically is about thinking. I want viewers to think about the subject matter of a work, about the events it depicts and our relationship to those events, about what it means that there is a painting about something happening now, about what sort of paintings came before it and about what role painting might have in our contemporary world of television and movies. Whatever the actual topic of an artwork, I want to draw from the past history of painting and, hopefully, to add to that history and acknowledge it. Whether the topic might be about politics, current events, graffiti, social issues, surfing, skateboarding, youth cultures, or whatever, I want my paintings to be relevant to people, get them to think.

In general, I think art has as many reasons and forms and purposes as writing does. It plays the same role as writing and can be used for the same reasons. But no one ever asks, "What is writing?" the way they ask, "What is art?" A work of art can be a brief note, a long poem, an elegy, a grocery list. It can be an essay, a book, a short story. I don't think there's a definition of what art should or shouldn't be, does or doesn't do. It seems an irrelevant question. For me, painting is about thinking, not about making. The technical aspects of a work may be interesting, but they are no more important to my thinking than the spoon a cook uses is important to the enjoyment of the meal.

The Battle of Los Angeles (The Great War of the Californias), 1998. Oil and acrylic on canvas, 64" x 120". *Private collection.*
For me painting is a form of communication. With no viewers there's no discussion. My potential audience is everyone, not just the rather small audience of the "art world." The more who see my work, the better.

Right:
Northward the Course of Immigration Makes its Way, 1999. Oil and acrylic on canvas, 65" x 96". *Private collection.*
I guess I could call myself a skeptical romantic. I would like there to be a larger role for painting and for artists in the world, but I'm pretty realistic about what that role really is.

The Bombardment of the Getty Center (The Great War of the Californias), 2000. Etching/aquatint and ink on paper, ed. 40, 25" x 48". *Private collection.*
If I'm a romantic, then I'm a pessimistic one. To me it's a bleak vision, the audience for painting today. Living in L.A. where film and television are so dominant, makes it seem even more irrelevant, but even so, I believe in it.

Jo Ann Callis
Craig Krull Gallery, Santa Monica

Photograph courtesy of Andrew Freeman.

Untitled JMW, 2002. Oil on canvas on panel, 55" x 39". Courtesy of Craig Krull Gallery. All photographs courtesy of Craig Krull Gallery.

I want viewers to see my work on at least two levels, what is depicted and what is implied. In my photographs everything is seen, but the meaning is ambiguous.

In the 1960s I was making sculptures and a few paintings. In the 1970s I learned to use a camera. From the very beginning of my photographic career, I orchestrated what I wanted to photograph; that is, I put together objects and/or people in the image before taking the picture. That made me one of the "Fabricated to be Photographed" school of photographers. My earliest works were more theatrical than my present ones. Now I find strangeness and beauty in the commonplace, in a non-dramatic way. The photographic medium can be precise and "truthful" and, at the same time, metaphorical. I enjoy the "magic" of transforming what

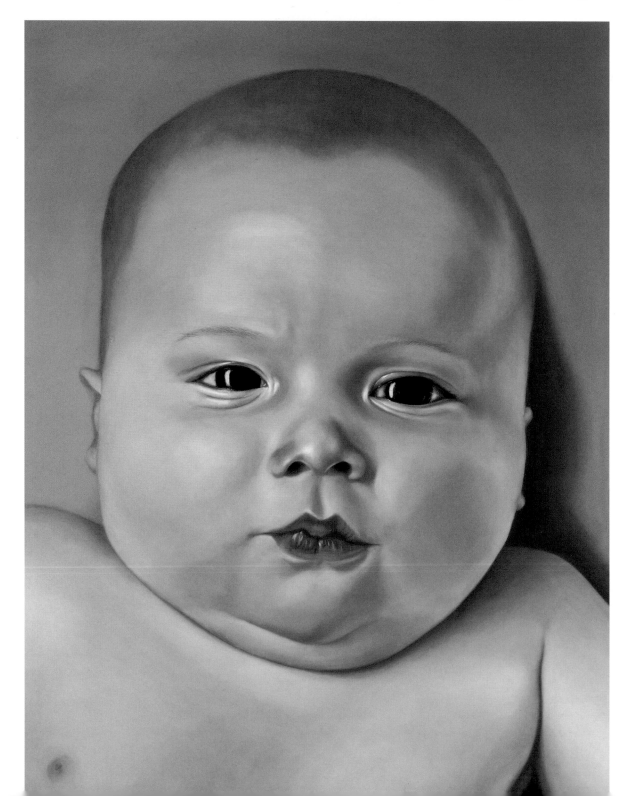

is in front of the lens into something as psychological as it is real. Even today, whether I am making digital photographs, objects, drawings, or paintings, I want the viewer to react emotionally to what appears to be a straightforward image. By going from one medium to another, I simply add ways to put what I want into my work. What I want is to heighten one's perceptions of the familiar and the ordinary. The medium may change but the overall results are similar.

My current paintings are realistic because they are based on photographs. As always, I pre-load them with psychological content. I see making art as a means of connecting with others, and as being part of an exciting, ongoing visual conversation that resonates in every aspect of my life. In art as in life, all the contrasts between beauty and edginess exist simultaneously. Sometimes simple ideas can be the most engaging.

I've always enjoyed changing the self-imposed parameters I set for making a new body of work. Much of my enthusiasm comes from looking at art from other eras of history. Making art in ways that challenge me or give me pleasure is what I have always wanted.

Right:
Glove, Balloon, Shoe Horn, 1983. Gelatin silver print, 20" x 24". *Collection of Center for Creative Photography.*
Art isn't a career, it is a lifetime.

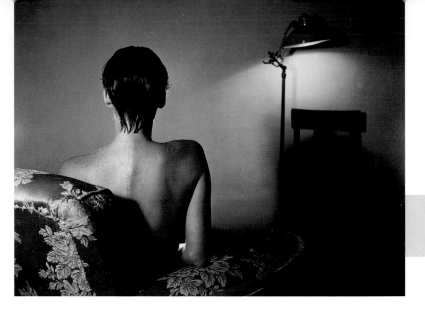

Woman with Wet Hair, 1979. Dye transfer, 20" x 24". *Collection of Gay Block, New Mexico.*
The context of how a work is presented is part of its meaning. I can't separate the work itself from the means I use to achieve the results. The emphasis is on the effect that the work has on the viewer and on me. I am always very curious and excited to see how it will turn out.

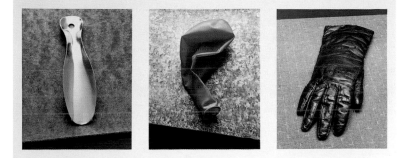

Dish Trick, 1985. Cibachrome, 30" x 40". *Private collection.*

Charles, 1999. Oil on panel, 13" x 12". *Private collection.*

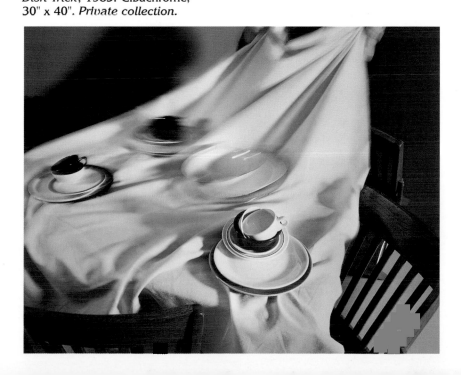

15

Carole Caroompas
Mark Moore Gallery, Santa Monica

Since 1971 I have taken a conceptual approach to painting. The intention in my recent series of paintings—as often in the past—is to deconstruct sexist and authoritarian perspectives, reexamine their narrative, and restructure them by contrasting traditional and contemporary symbols of belief. My paintings examine the past to ask questions about—and pose alternatives to—the social, gender, and sexual roles of today. These fragmented narratives employ the use of literature and cinematic sources for cultural cross-references through the use of image as metaphor and diagram.

Starting in 1989 I have explored the themes illustrated by the titles: *Fairy Tales, Before and After Frankenstein: The Woman Who Knew Too Much*, and *Hester and Zorro: In Quest of A New World*. These, too, are fragmented narratives. They use psychological imagery to explore the struggle, conflict, and vulnerability of male and female

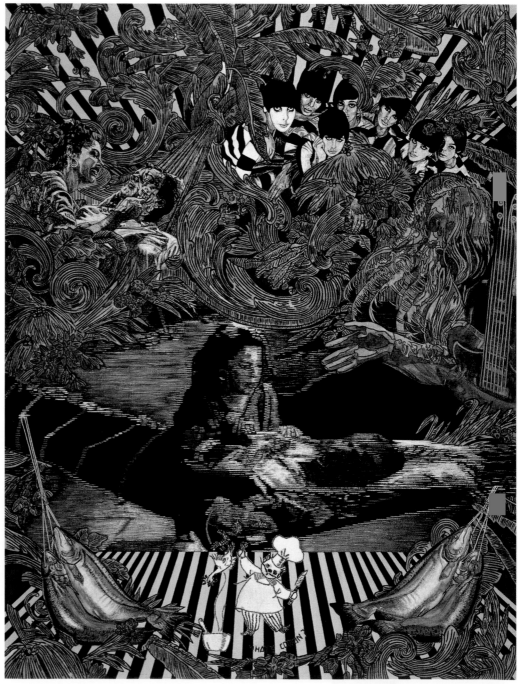

Psychedelic Jungle: A Comfortable Crucifixion in a Hammock, 2002. Acrylic and found embroidery on panel, 35" x 27". *All photos courtesy of Scott Lindgren.*

In all of my work there is a simultaneity of events that occur all at once. The delayed black and white of Huston's *Night of the Iguana* video image, black and white images of 1960s fashion, psychedelic musicians, and black and white still from Huston's *Night of the Iguana*, and the *Vanitas* referenced fish. This series references 1960s psychedelic rock posters and speaks of loss and renewal.

roles in a male-dominant culture. To accomplish this on a technical level I use a hybridization of painting techniques on canvas and panels laminated with found embroideries, and a deconstruction of pattern and decoration.

The series *Heathcliff and The Femme Fatale Go On Tour* continue my exploration of issues and techniques, this time using references to Emily Bronte's *Wuthering Heights*, film noir, and rock n' roll. The series explores how culture and myth affect desire; it is likewise composed of paint and found embroideries.

I recently started a new series, *Psychedelic Jungle*. It references Tennessee Williams' play and John Huston's film *Night of the Iguana*, 1960s counterculture, and rock n' roll. The paintings explore misfits and pilgrims at the end of their road as they look for a way home. They are outsiders confronting a loss of spiritual belief, their alienation from society, and their fear of mortality.

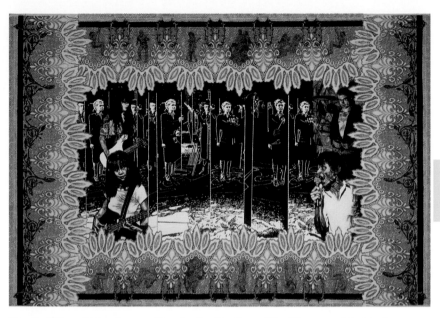

Heathcliff and The Femme Fatale Go On Tour; The Honeysuckle Embraces the Thorn, 1999. Mixed media on canvas, 63" x 90.25".
This painting is framed by laminated lace curtains with painted images on the border of cultural stereotypical imagery of male/female representations. The central image is a black and white painting of repeated representations of a movie still from *Lady of Shanghai*. It is the house of mirrors where it is all being shattered by bullets. The film noir scene is surrounded by and interrupted by L. A. punk musicians. The dark and the beautiful emerge—the honeysuckle embraces the thorn.

Heathcliff and The Femme Fatale Go On Tour; Before and After Frankenstein: The Woman Who Knew Too Much—Bedside Vigil, 1992. Acrylic on canvas, 96" x 108".

Ladies, Gentlemen, Master, Servant, 2000. Mixed media on canvas, 84" x 72".
This painting was done on found embroideries of a bedspread and two pillow cases that were laminated on canvas. The representational images and decorative patterns play against each other in terms of high/low culture: film noir stills, *Wuthering Heights* movie stills, Betty Page, the anonymous stripper, punk musicians, the poodle. Who is the lady, the gentleman, the master, the servant?

William Glen Crooks
Scott White Contemporary Art, San Diego

Photograph courtesy of Marty Crooks.

House by Railroad, 1999. Oil on canvas, 48" x 48". *Collection of Scott & Carolyn White, San Diego, CA.*

Now Showing, 1997. Oil on canvas, 48" 72", *Private collection, Rancho Santa Fe, CA. All photographs courtesy of Jeff Lancaster Photographics, Inc., San Diego.*

Regardless of the apparent subject—a tree, a building, a figure, or a truck—the real subject of my painting is the transparency of shadow and the opacity of light. I try to work in a straightforward manner using light and shadow to carry the sensations I mean to convey. I hope that there are several meanings for the viewer to find in my paintings, but so far all attempts to define what I mean, even my own, seem foolish or at least incomplete.

Into Legend, 2002. Oil on canvas, 60" x 72". *Courtesy of Scott White Contemporary Art.*

Portico, 2000. Oil on canvas, 45" x 84.5", *Private collection, La Jolla, CA.*

In Jackson's Yard, 2001. Oil on canvas, 48" x 72".

19

Alex Donis
Frumkin/Duval Gallery, Santa Monica

Photograph courtesy of Cecilia Wendt.

In 1996 I went to a meditation center. It was a life-altering experience. In the deepest core of my being I felt that I must either stop making art because of the ego involved or create works that altered the way people viewed life and use this to bring about social change. I opted for the latter.

Today my work has a lot to do with cultural fantasy. It examines and redefines the boundaries set by religion, politics, race, and sexuality. I hunger for things in popular culture that are ridiculous, unbelievable, and perversely beautiful. Everything from B-movies starring Joan Crawford to Mexican tag-team wrestling. My work is quite

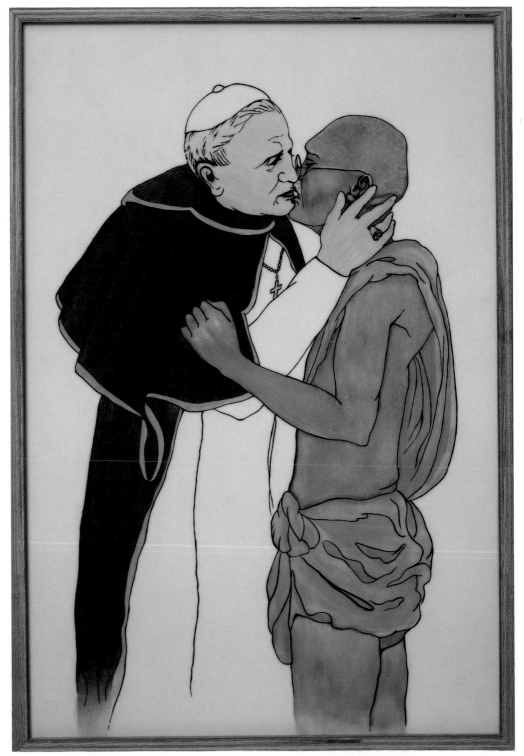

My Cathedral (Pope John Paul II and Gandhi), **1997. Oil and enamel on plexiglass light box, 36" x 24" x 7".** *All artworks courtesy Frumkin/Duval Gallery.*

My Cathedral was repeatedly vandalized at its first showing. People who couldn't accept the message of Christian divine love and Gandhian loving compassion instead chose to focus on what they perceived to be a purely homoerotic message. Losing an artwork is like losing a child. The experience made me strong and committed to the arts.

similar to myself. I am interested in challenging society's relationship to icons. My work is often influenced by my own tri-cultural (Pop, Latin, and Queer) experience. I love it when people laugh as they look at my work. I love humor because of the way it can lighten difficult subject matter. Doing work that is at once overtly political and candidly silly, I am gratified when people really "get it."

I brainstorm by making lists of all kinds of things. Much of my work pops out during this process. Sometimes ideas are prompted by an invitation to do a show and the work I dream up is site-specific to the location. Then I have to think how to balance aesthetics and content. How do people "see" or "not see" my point beyond the imagery in pictures? All artists deal with this dilemma. My solution is to rely on instinct and intuition.

Art isn't a love for me. It is an intellectual, visual, and physical obsession. Nor is art my best friend. It is more like a relative that I've lived with for a long time and have learned to put up with. Art is woven into our life experience often without our noticing. It helps me develop social and aesthetic awareness. This has made me more aware of my relationship with the public, the audience. In turn I've become more selective in choosing imagery and in editing my work.

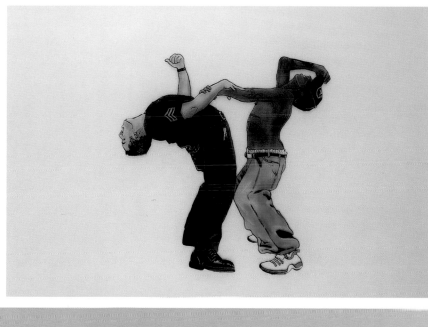

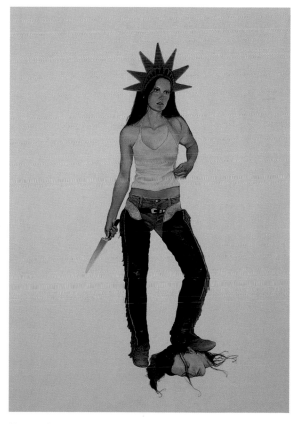

Officer Moreno and Joker, 2001. Oil and enamel on plexiglass, 28" x 41".

Katy after Donatello, 2003. Pastel on paper, 50" x 34".
I love the relationships I've developed with people through the arts. Women have made my experience as an artist vastly layered and rich. They are by far my drug of choice.

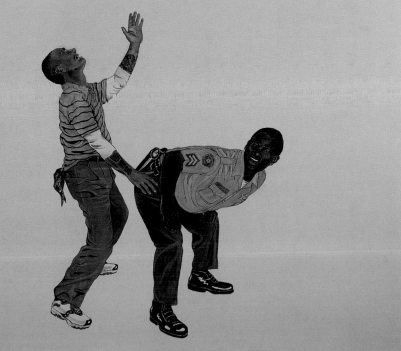

Popeye and Sergeant McGill, 2001. Oil and enamel on canvas, 60" x 84".
It has been incredibly traumatic dealing with censorship and physical threats because of the work I've produced. I know what it feels like to swim against the current. Some would rather I not make waves. They don't realize I am the waves.

Michelle Fierro
Brian Gross Fine Art, San Francisco

Push for A.F., 1999. Oil, acrylic, and pencil; 66" x 60". *Courtesy of The James Harris Gallery, Seattle.*
Photography went from the first medium that enabled me to capture scenes, to one that gave me the ability to analyze interactions and relate them to a medium more conducive to my temperament, painting. The immediacy of painting was love at first sight.

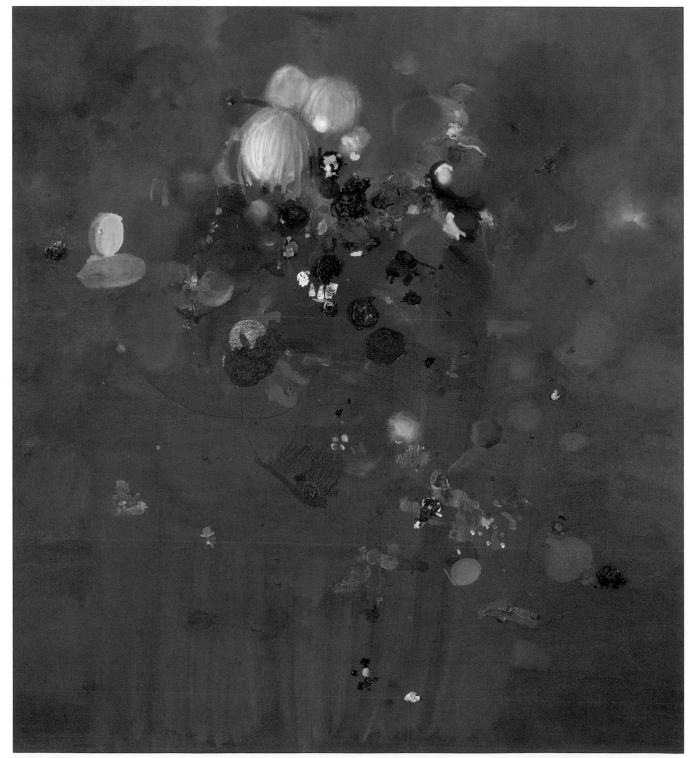

For nearly two decades now I've been recording my surroundings with pictures of people, places, and things. Each snapshot is a chronological autobiography, a reference point of personal interests at a particular time. I am increasingly aware of their importance in my image-making process, and today think of my pictures as a sketchbook. Rooted in the notion "waste not want not," my mark-making is a comment on the economy of means. Early in my artistic development I noticed that the objects that fascinated me were things people were getting rid of or were in disarray. Questions like, "Is this really waste?" or "Should I take this?" inevitably led either to taking it or snapping a photograph of it to put a stamp on my engagement with it. Collecting became an obsession while I was in graduate school. People threw out all sorts of things that I scrambled to use—paint scraped from palettes, fabric cut from sewing projects, wadded-up paper in colorful piles. Found pieces became like findings from my memory.

By 1994 I had started to arrange the elements I had chosen onto the surfaces of paintings, not randomly, but in ways that I would dictate as I worked on them. They were composed in relation to the reaction they had towards each other. Sometimes small fragments were scattered very quickly to allow their randomness to effect my preconceived notions on what looked just right. This expedited application developed different movements on the surface, and I related their effects to the different ways we interact with other people or places. My photographs were starting points to a study of people and things, and how they affect one another with different results. Continually adding sculpted paint onto the visual momentum of the applied elements, one on another, brought to mind the issue of origin: exactly where does something start and end? Scavenged paint mixed at another time or donated by a friend brought me to almost luxuriate in the enigma of sources. After all these applications, these layers, these chronologies, I draw lines to suggest that there is an architecture or edge, however rudimentary, that holds all the things together.

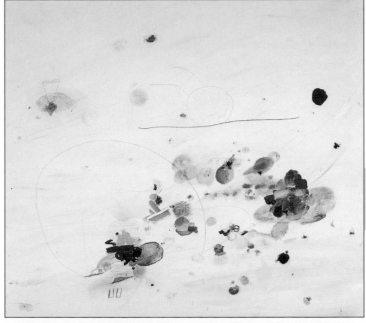

Above, right:
Succession #3, 2002. Oil and mixed media on canvas, 48" x 54".

Center:
Inducement of Sorts, 2000. Oil, acrylic, and pencil; 48" x 54".
For me, painting is an unending study of areas or objects affecting each other without resulting in conclusions. Scavenging whatever I recognize to be of value for my mark-making, and studying the documentation of frozen pictures, encourages a correlation of memories that I first revere, then depict as scavenged reality.

Right:
Neither Here Nor There Too, 2002. Oil and mixed media on canvas, 36" x 42.5".
With painting I can revel in the moments that resonate between my obsessive recording and a finished work. I can merge my need to record with my desire for immediacy.

Robbert Flick
Craig Krull Gallery, Santa Monica

Photograph courtesy of D. Yamamoto.

Over the last decade I have evolved a working method that addresses the visual complexities and simultaneities of the Southern California metropolitan area. I videotape the city in long continuous sweeps from a moving vehicle, either by following predetermined trajectories or by systematically rendering parallel streets. The result is a collection of visual textures and phenomena that capture the appearances of neighborhoods during particular spans of time. When woven together in consecutive frames and bands, this form of sampling plays on frequencies of occurrence to reveal conditions and to suggest possible contexts for interpretation.

In my work I bring together what the memory links up out of what is physically apart. I try to find ways to invite viewers to scrutinize particulars; to look at details in different places at almost the same time and establish relationships between them.

I use the systematic display and logic of the camera to render what is out there. But the camera and lens can frame only a segment of what is in front of it. Only part of a building, part of an alley, part of a corner will appear in a single frame. If I move (even only a little) before the next exposure, part of that previous image will coexist with part of the next. This linking of adjacencies between this part and that part of the two frames will suggest a continuity and a movement. But because of the repetition, something new is created. Something that only occurred once now occurs twice. The possibility for manipulating perception and the creation of a fiction has begun.

I see my work as part of an ongoing process of documenting and constructing visual pieces that poetically explore the extraordinary diversity of Southern California and its inhabitants, while at the same time providing an inventory of the ongoing changes in our environment.

at Cambria_A, 2002. Ilfochrome, 50" x 80". *Collection of Santa Barbara Museum of Art. All photographs courtesy of the artist.*

I use digital video-capture technologies to composite large grid-like structures that trace encounters over time.

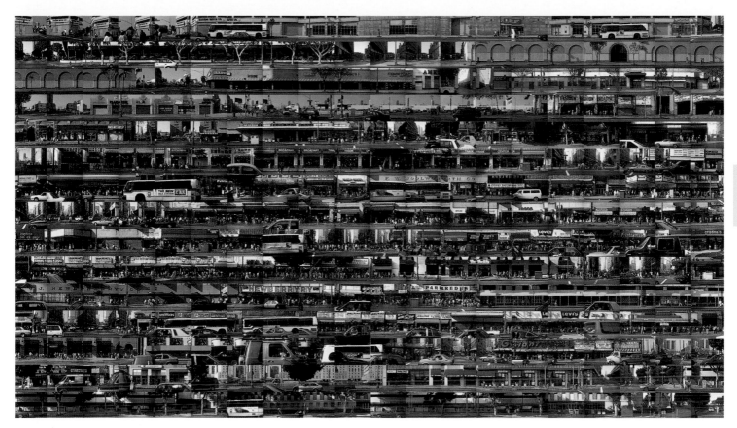

along Broadway looking West, between Pico and Temple, 1997. Ilfochrome, 20" x 24". *Collection of Creative Artists Agency, Beverly Hills.*

My work straddles both the archive and the arts. At the core of what I do is an abiding interest in the dialogs that evolve around photography and its usage.

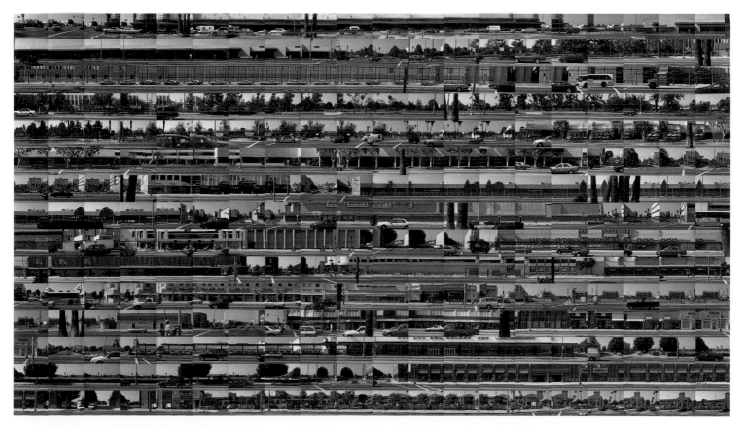

along Wilshire looking North, between Fairfax and Highland, 1994. Ilfochrome, 32" x 48". *Collection of Creative Artists Agency, Beverly Hills.*

Charles Garabedian
L.A. Louver, Venice, California

Photograph courtesy of Roxanne Jannette.

It is quite an experience, an artist growing old. Movement is inward, depending on and searching for an inner vision. I have no patience for details, wit, or communication; just change-change-change, in an effort to find simple and direct solutions.

Forest, 2001. Acrylic on canvas, 96" x 78". *Photograph courtesy of Robert Wedemeyer.*

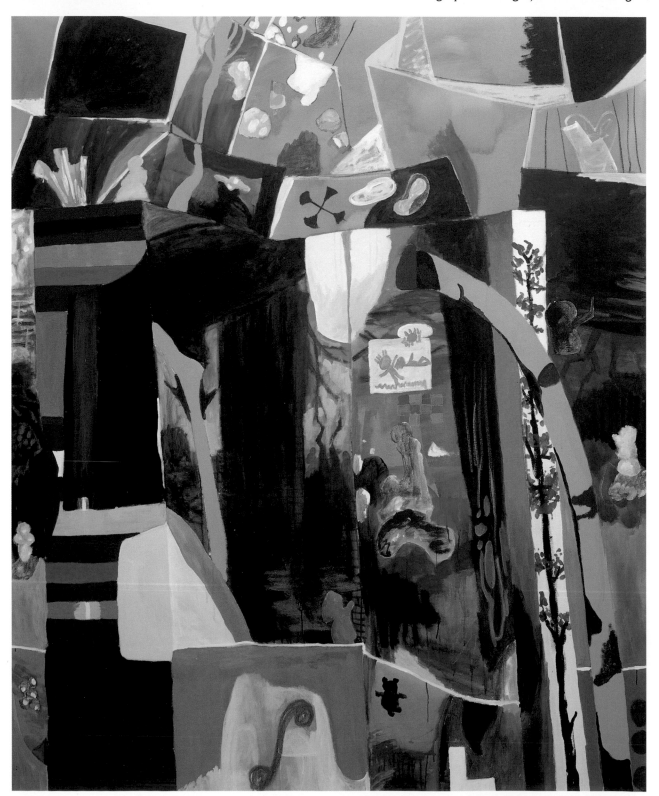

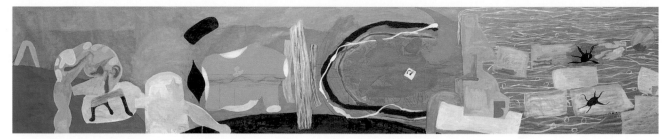

The Dam, 2001. Acrylic on paper, 48" x 234". *Photograph courtesy of Robert Wedemeyer.*

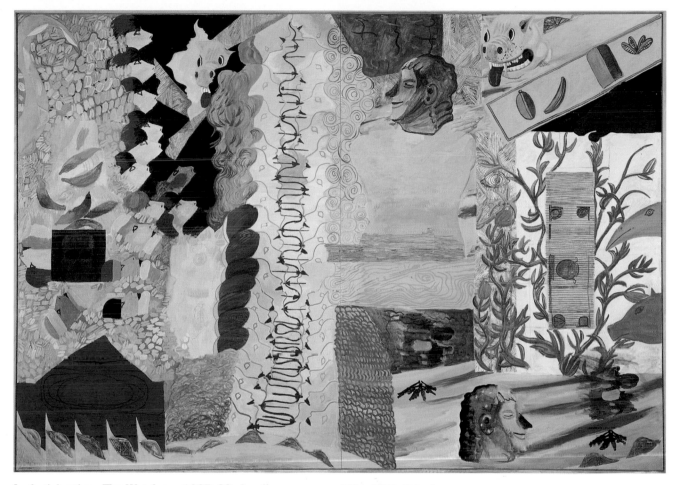

In Anticipation, The Watchers, 1985–88. Acrylic on canvas, 84" x 120". *Private collection. Photograph courtesy of Robert Wedemeyer.*

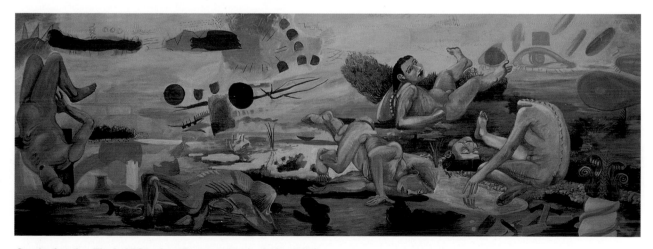

Study for the Iliad, 1991. Acrylic on canvas, 84" x 242". *Photograph courtesy of William Nettles.*

Maxwell Hendler
Patricia Faure Gallery, Santa Monica

My art is for enjoyment.

Aqua Pool, 1994. Resin on wood, 39" x 40".

Compañero, 1998. Resin on wood, 55" x 30". *Private collection. All images courtesy Patricia Faure Gallery.*

Palomar, 2001. Resin on wood, 32" x 49".

San Raphael, 2000. Resin on wood, 20.8" x 26.8".

Medium, 1993. Resin on wood, 36" x 48".

29

Salomón Huerta
Patricia Faure Gallery, Santa Monica

Photograph courtesy of Andrea Artz.

While I was the youngest boy amid three older sisters I received a lot of attention. Then my younger brothers were born and the attention on me dwindled. So I took up art to get back the attention I wanted.

I have a love/hate relationship with my art. It is my love when things are going well, and my worst enemy when things aren't working right. There is no middle ground. But loving or hating, my art means different things to me at different times. It is my inner and outer dreams, and also my fears. Success is overrated, but it does keep up my enthusiasm.

When I am flying free in my mind's eye, I fly towards the light. Hopefully it will lead me to a Georgia O'Keeffe flower. Then I am inspired by a moment, a place, a person. I begin with one painting, which leads to a body of work. Art has nothing to do with the materials used to make it. It

Untitled Head (#9), 2001. Oil on canvas on panel, 12" x 11.75". *Private Collection.*
Great art is not about thinking, it is about creating.

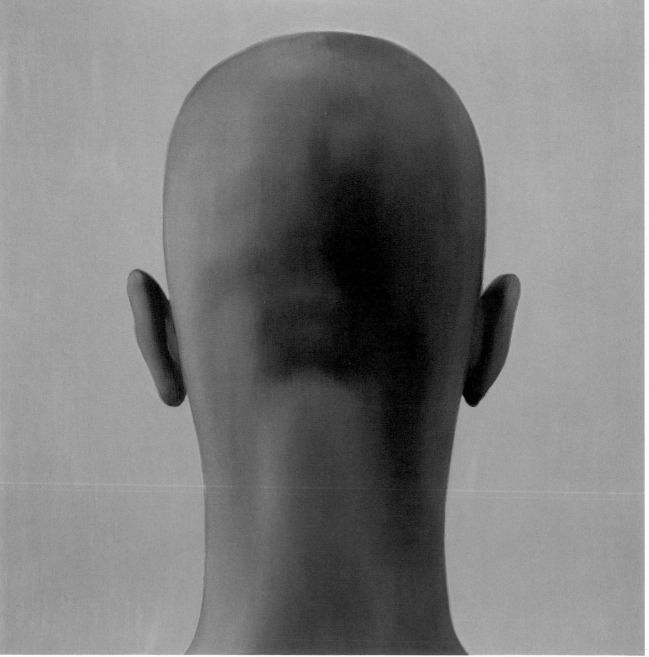

Untitled House, **2000. Oil on canvas on panel, 14" x 54".** *Collection of Gil Friesen. All photographs courtesy Patricia Faure Gallery.*
When people look at my artwork I want them to listen to what is being provoked.

goes beyond that. I have learned to stop when I feel I have captured the moment that I was seeking and there is no need to pick up the brush.

Some say art should help people enjoy life. Others say it should help them go beyond it. I say it should awaken their senses. My art is me and everything around me, but I often have the feeling that viewers see themselves mirrored in my paintings. They want to see themselves there, so they do.

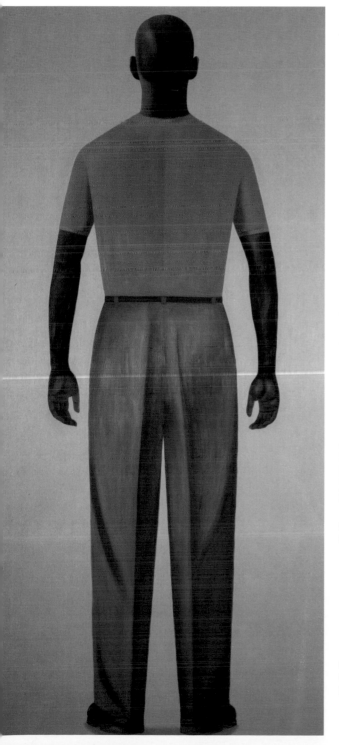

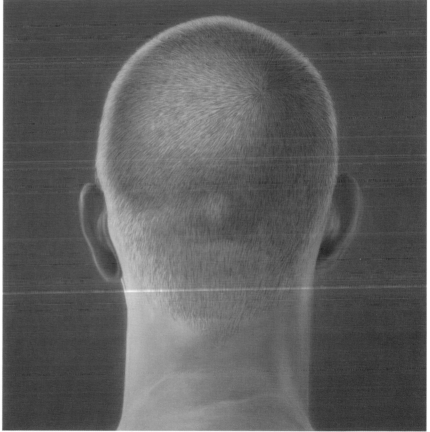

Untitled Head (#5), 2001. Oil on canvas on panel, 12" x 11.75". *Private Collection.*

Untitled Figure (#5), 2001. Oil on canvas on panel, 73" x 32". *Private Collection.*
If I had to define myself I would call myself an abstract minimalist.

31

David Ligare
Koplin Del Rio Gallery, Los Angeles

Photograph courtesy of Ted Mahieu.

I have drawn and painted since I was a child. At the beginning of my career I wanted only to paint outdoors, directly from nature. Those paintings segued into more formal studies of drapery in sunlight which, in turn, became paintings of draperies being thrown into the air above the sea. These "thrown drapery paintings" implied many things, from classical marble sculpture to John Baldassari's photos of three red balls being thrown into the air.

In 1978 I decided to make paintings that embraced Graeco-Roman Classicism. I did not feel that this work was a rejection of modern art, but an addition to it. By choosing narrative, allegory, history, and the formal qualities of historical painting I felt that I was doing something radically outside of contemporary methods. I wanted to make something, to paraphrase Marcel Duchamp, "with hidden noise."

Penelope, **1980. Oil on canvas, 40" x 48".** *Collection of the artist.*
I want people to first see the beauty of the light in my images, and then the possibility of specific or implied meaning. It is so easy to look for meaning and forget the light.

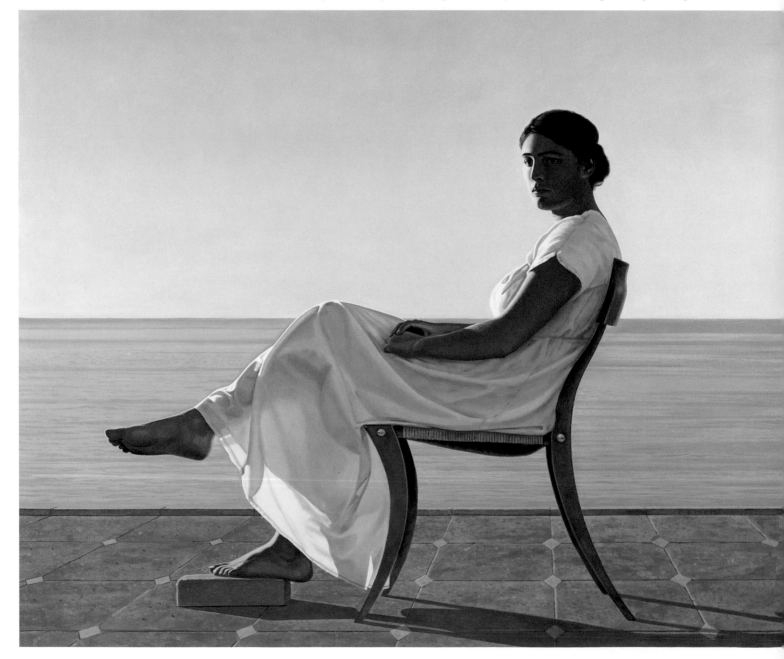

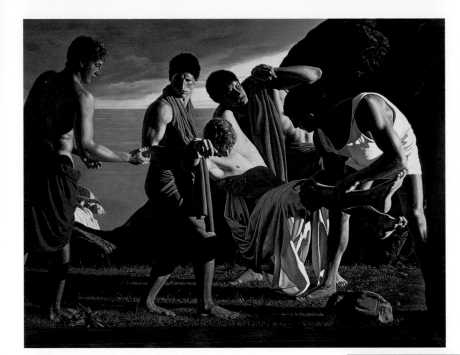

Achilles and the Body of Patroclus, 1986. Oil on canvas, 60" x 87". *Collection of Louis and Phyllis Mann, Los Angeles.*
Gustave Courbet said "Je suis realist." I say just as simply, "I am a Classicist." I try hard to not let my work reflect my inner life, but that is impossible. Innerness is where my ideas and observations and inspirations come from.

For me, making art is a passion, but it is also a profession. If I were only interested in financial success, I would have become an Abstract Expressionist or a Pop artist. The commodity value of art derives from meeting what critics, curators, and collectors expect of it as fitting into the language of contemporary art. For me, it is more interesting, and certainly more challenging, to think about the larger needs of society. There is value in trying to renew a desire for knowledge and the perspective of history.

The only thing absolute in art is that nothing is absolute. Over the course of history, art has served every kind of function from illumination and education to subversion and pleasure. I personally think that art is one of the forward metaphors for a society. Art can-

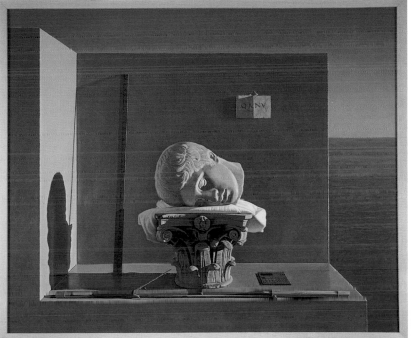

Still Life with Polykletian Head (The Kanon), 1995. Oil on canvas, 40" x 48". *Collection of Mr. and Mrs. Phillip Bernstein, Santa Barbara.*
My mind goes towards the light and towards the meaning of light. The meaning of light is knowledge.

not be a different "self" than the artist. Even if the artist subverts his or her own desires and beliefs, that is still a statement of self. I try to adhere to the detachment of history, yet my choice of subject matter sometimes reflects my sexual and intellectual nature in the here and now. This duality is fundamental in Classicism. It is a marriage of the past and the present and that is a duality that attracts me very much.

Perspectiva, 2000. Oil on canvas, 80" x 96". *Collection of Darrel and Marsha Anderson, Newport Beach, CA.*
This painting is an essay on rule, measure, and the integration of diversity.

33

Frank Lobdell
Hackett-Freedman Gallery, San Francisco

Photograph by David Solomon.

In general my work is formed in the crucible of the high expectations I have for it when I begin, and where it arrives at the end—often realized without knowing how I got there. In between is a struggle to address the issues and challenges that arise in making the work.

For me, the work process is a way to discover something new, to learn something new, or to understand something I did not understand before—about myself. In my work, I have experimented with spatial relationships, signs, images, and color, exploring a variety of ideas and techniques in the effort to bring something new to life. Over the years, I have appropriated and transformed a range of life experiences and personal encounters into a kind of visual al-

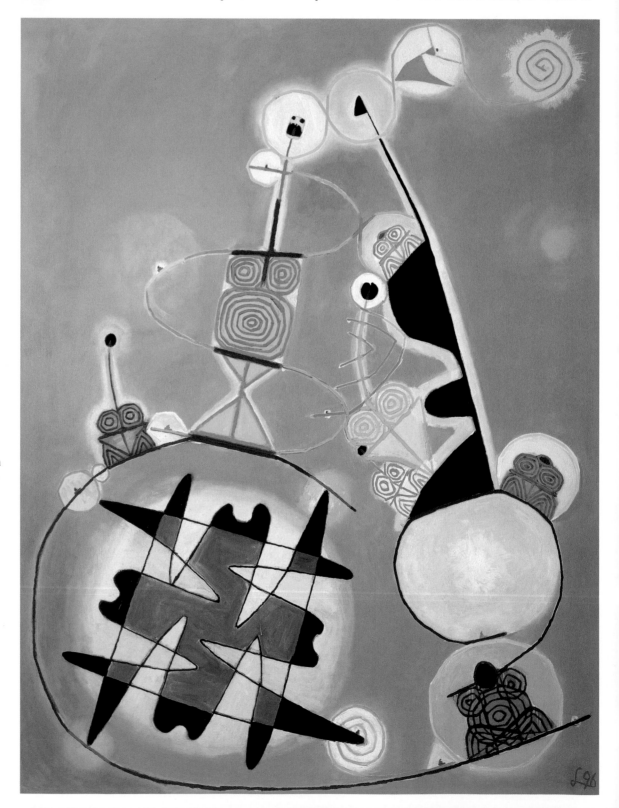

3.3.96–12.17.96
Bleeker, 1996. Oil on
canvas, 96" x 72.25".
Private collection.

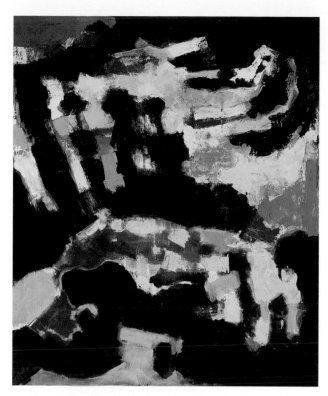

31 December 1948, 1948. Oil on canvas, 44" x 36".
*Fine Arts Museums of San Francisco, Museum
Purchase, Dr. Leeland and Gladys K. Barber Fund. All
photographs by M. Lee Fatherree.*

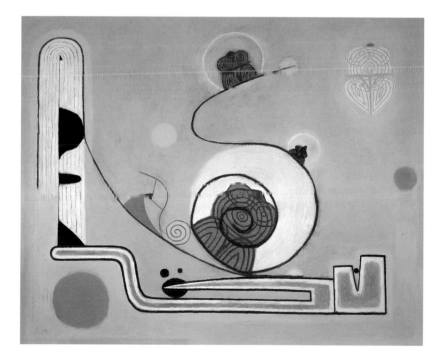

5.23.94 Bleeker, 1994. Oil on canvas, 78" x 96". *Courtesy of
Hackett-Freedman Gallery.*

chemy of figures, symbols, and formal structures, with
elements emerging and reappearing in various incarna-
tions of form, content, and medium.

The exploration of various media and image-making
techniques has served as a means for me to acquire
knowledge, as I try to resolve visual problems through a
"working out" process that trains both my head and my

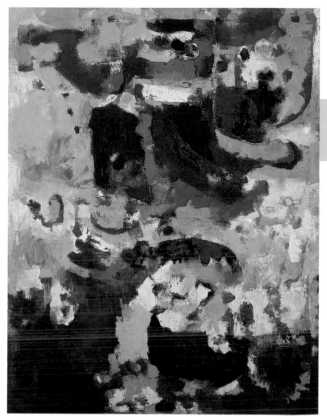

May 1949, 1949. Oil on canvas, 54" x 42".
Private collection.

hand—in sketchbooks, drawings, prints, sculp-
tures, and on canvas, probing relationships
among figures and forms, discovering what is
useful or not, and testing what is valuable in the
development of specific works. Figures, forms,
and symbols float or anchor the compositions
as key elements in visual guidance systems that
are set up in order to articulate dynamic move-
ment through compositional flows, and thus
serve as guideposts to facilitate modes of read-
ing and responding to the ideas and formal ar-
rangements in the work.

The early works often articulated a kind of
angst, a deep personal expression centered in
fear, anger, and outrage over social and politi-
cal realities, and thus constituted a kind of emo-
tional unloading on the canvas as I worked my
way through many of these feelings with paint.
Now, the work is also informed by an aspiration towards
union of head, heart, and hand, and is capable of ex-
pressing the joy of being alive and the endless intrigue of
color, form, and materials.

*Compiled from written statements by Frank Lobdell
and interviews conducted with the artist at Pier 70, San
Francisco, July 2002, by Anthony Torres.*

John Mason
Frank Lloyd Gallery, Santa Monica

So where do I get my ideas; what's the creative process? There seems to be an art director inside my head who points me in a direction and says, "Go!" That directive means pursuing those elusive images that seek physical form. In the beginning my focus was on the generation of form through direct use of the material. Namely, my hands in the clay. That work produced a series of iconic images—the cross, the figure, the monolith, and a form I call the spear. Early influences for me were archaic art forms developed by early cultures, and the Nevada landscape where I was raised. Needless to say, the history of art continues to inspire me.

Spear Form, Ember, 2002. Ceramic, 64" x 26.75". All images courtesy Frank Lloyd Gallery, with photographs by Anthony Cuñha.

I often work in clay, one of the oldest of all art mediums. What about new technology? I concede new technology is great—my forklift and my computer and its peripherals are technology I'd be hard-pressed to do without. I don't dig my own clay, but I do mix tons of it in my antique dough mixer.

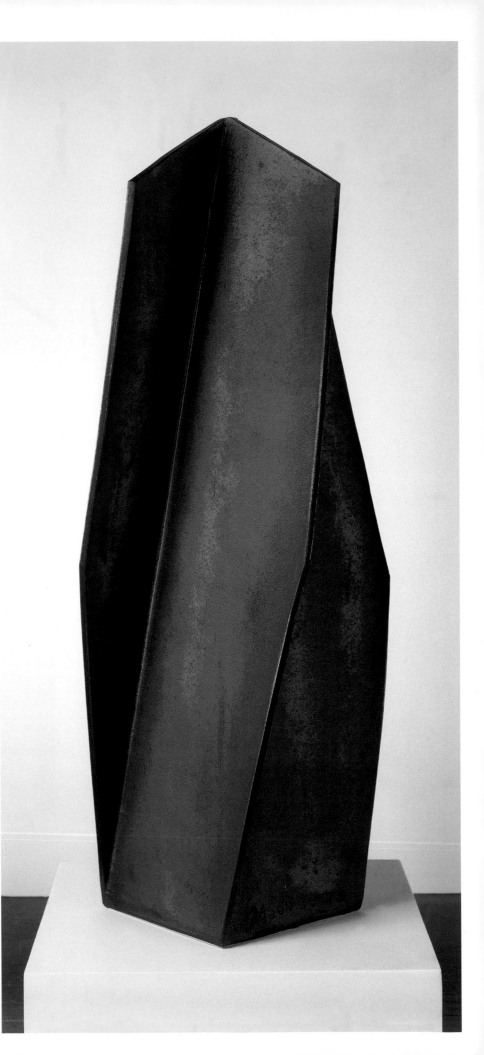

Now, my new work is conceptually generated and is independent of any specific medium. Since the 1970s I have incorporated principles found in group theory as a structural element in my creative process. At first my approach was a hands-on manipulation of firebrick modules, but as my ideas developed further, I began to use maquettes. What is sometimes visible and sometimes hidden in the work are two symmetry operations, rotation and translation. These group-theory symmetries first appeared in my early firebrick sculpture and more visibly in the *Hudson River Series* of 1978. That series was realized as ten site-specific installations in six museums across the country.

Beginning in the 1980s and continuing today I returned to expressing my ideas in clay. My new sculptures are constructed with intersecting planes; this work continues the research of the 1970s. What, more of this math stuff? It sounded pretty esoteric for a sculptor. True, but as a sculptor I'm interested in structure, and these principles have made it possible for me to create new forms and to understand some of nature's structural secrets.

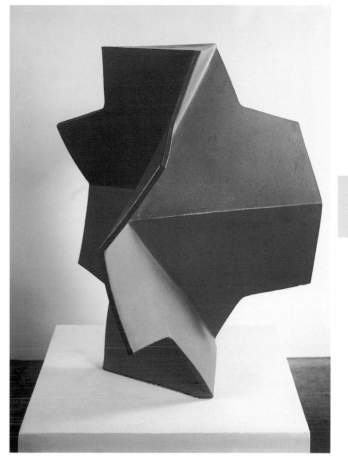

Figure, Blue, 2002. Ceramic, 59" x 23.75".
In every historical period there is creative work that needs to be done, finding it is the challenge. I continue that search.

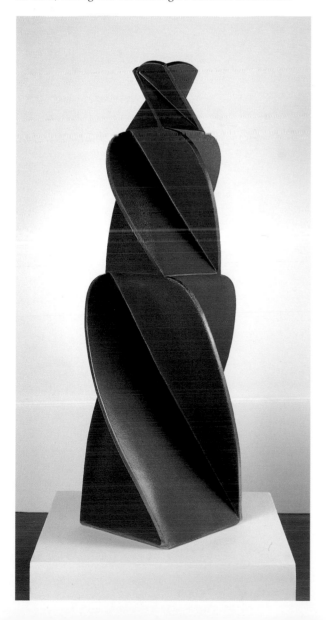

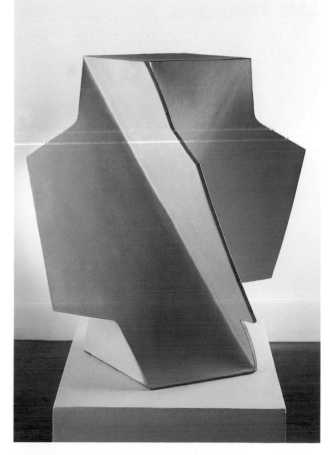

Folded Cross, Yellow-Gold, 2002. Ceramic, 39" x 31.5" x 24".

Folded Cross, White, 2002. Ceramic, 44.5" x 41" x 36".

37

Michael C. McMillen
L.A. Louver, Venice, California

Photograph courtesy of Aero Pacific Research.

Since the early 1970s I have been working with installation art as a way to directly engage the viewer in the experience. My work has often used architectural references and scale alterations to transport the viewer into realms of metaphor and open narrative, where they become active participants.

I currently have such an installation on view at the Los Angeles County Museum of Art; it is *The Central Meridian* but is also known as *The Garage*. This simulacrum of a mid-20th-century American garage functions to transport the visitor "out" of the museum setting and into another time and location. It is this "translocation" potential that intrigues me.

In addition to installations, I also make constructions and paintings to investigate the intertwined themes of time, change, and illusion. I have always been attracted to the cast-offs of our material society. I combine things in a search to find meaning and structure and to incorporate such materials in the ongoing search for a visual/spiritual poetry. From the analog age to the present digital age, human desires and dreams don't seem to change much. Perhaps the best thing an artist can do is to keep raising questions.

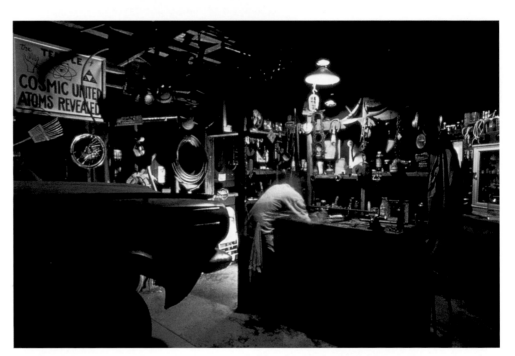

The Central Meridian [aka *The Garage*], 1981–1995. **Installation with audio, 12' x 20' x 48'.** *Collection of the artist on long-term loan to the Los Angeles County Museum of Art. Photograph © the artist.*

I recall exploratory treks through the sand and tar alleys of Santa Monica in the early 1950s, filling my wagon with deceased Philco radios, *Popular Mechanics* magazines, and discarded equipment from the Second World War. These were my treasures mined from the urban landscape.

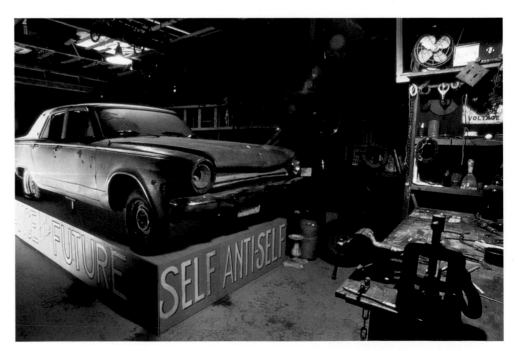

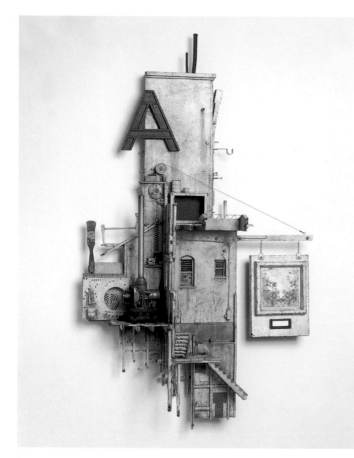

Luna Park, 1993. Painted construction, 52" x 31" x 10.5".
*Photograph by William Nettles, © the artist, courtesy LA
Louver, Venice, California.*
My roots in art came initially from the popular culture of America in the
twentieth century and the eccentric and curious worlds of my parents
and neighbors. Early television, radio dramas, and the hovering threat of
nuclear attack provided a fertile ground for imagination.

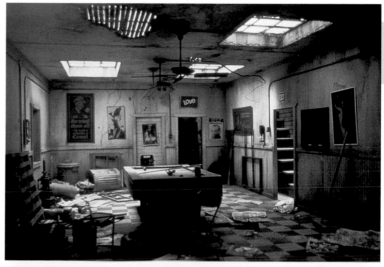

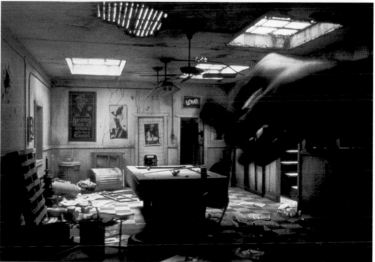

Mike's Pool Hall, 1977. Kinetic Miniature installation, 9" x 20.5"
x 20.5". *Photograph © the artist.*

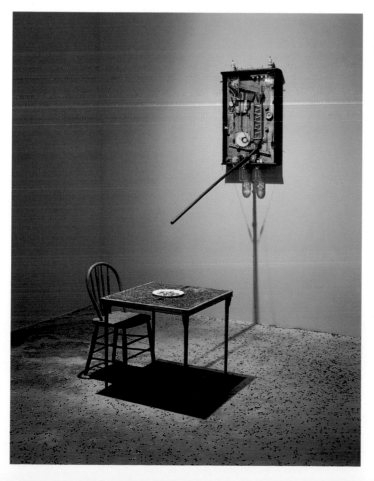

Deliverance, 1992. Kinetic installation with 200,000 black
beans, 12' x 12' x 12'. *Photograph by Brian Forrest, © the
artist, courtesy LA Louver, Venice, California.*
On my walk home after school, I would frequently stop by Ken
Strickfaden's workshop. He built the electrical effects machines for the
1932 movie *Frankenstein* and many sci-fi films that followed. I would find
him there tinkering with his giant Tesla coils and crackling lightning
machines. I consider him an early mentor. This vision of the blend of art
and science has never left me.

Memphis
**La Petite Gallery,
Los Angeles**

Photograph courtesy of Jay Spence.

My work makes public many of my private lines of inquiry as a person of African descent living in America. My work often poses questions for which I have no answer, or simply do not wish to contemplate. That is when I consider my muse to be a nuisance. When, however, I see global questions emerge that address issues of race, identity, heritage, and type, my muse is a helpful companion and I her humble servant, and so it all begins…

I particularly enjoy deconstructing negative icons that have been ascribed to African Americans over the centuries. My work involves refashioning these bitter effigies in such a way as to render them powerless and serve as a launch pad for new cultural questions, introspection, tolerance, forgiveness, and self-love.

Tia, 2002. Photomontage, 18" x 22" (limited ed. of 12). *Image courtesy of the artist.*

Tia was an exercise in restraint. Her delicate simplicity could have very easily been ruined by my tendency to work an image to death. *Tia* was a great teacher in my growth as an artist. She taught me the wisdom of knowing when to stop.

While my reference point is African American, I believe that the "message" (for want of a better word) of my work, is global in every way.

My art is but a lens and I don't think it is anything special to have such a lens. Indeed, we all have a magnifying glass through which we perceive things. The issue then becomes whether or not we have the courage to look through this lens and have the strength remaining to turn right around and say out loud, for better or for worse, all the things we see. It is in this courage that I find my truth, and in this truth that I find my creation.

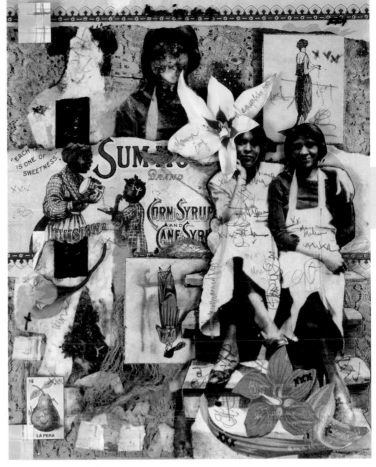

Mama Joy, 2000. Mixed Media Assemblage, 11" x 14". *Collection of Darryl Theirse. Photograph by Jon Deshler.*

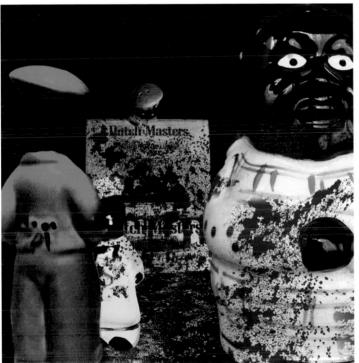

Salted Wounds in Old Dutch Masters, 2002. Photomontage, 21" x 21" (limited ed. of 9). *Image courtesy of the artist.*
What to do with "Black Americana" is hotly debated among artists, academics, and historians alike. As an artist, I choose to take these cruel, demeaning objects and place them in contexts where they can finally confront, battle, and emerge victorious over their oppressors.

Mama Ynez Spirit Trap, 2000. Mixed media assemblage, 12.5" x 9" x 2". *Collection of the artist. Photograph courtesy of Jon Deshler.*
My grandmother Inez (or Ynez) came from British Honduras (now Belize) to forge a new life in the States. While she rarely spoke of her life in Belize, from time to time, she would give me little sets of instructions (spells if you will) to address my *problem de jour*. One time I was being bullied at school. Mama Ynez instructed me to write the boy's name down on a small piece from a brown paper bag in red ink. Then take that paper, put it in a medicine bottle, fill it with the juice from a fresh squeezed lemon and put it in the freezer. The sixth-grade bully never bothered me again.

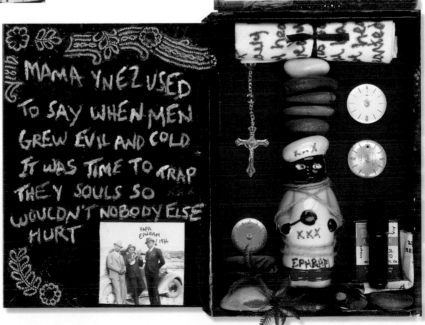

Ed Moses
L.A. Louver, Venice, California

Is the exclamation "Wow" the provision of obsessional madness or is it aleatory? (*Aleatory* = depending on the throw of a die or on chance... involving random choice.)

"And how will you try to find out something, Socrates, when you have no notion at all what it is? Will you lay out before us a thing you don't know, and then try to find it? Or, if at best you meet it by chance..."
Great Dialogues of Plato. Transl. W. H. D. Rouse (Signet Classic; Reissue edition, 1999), p. 41.

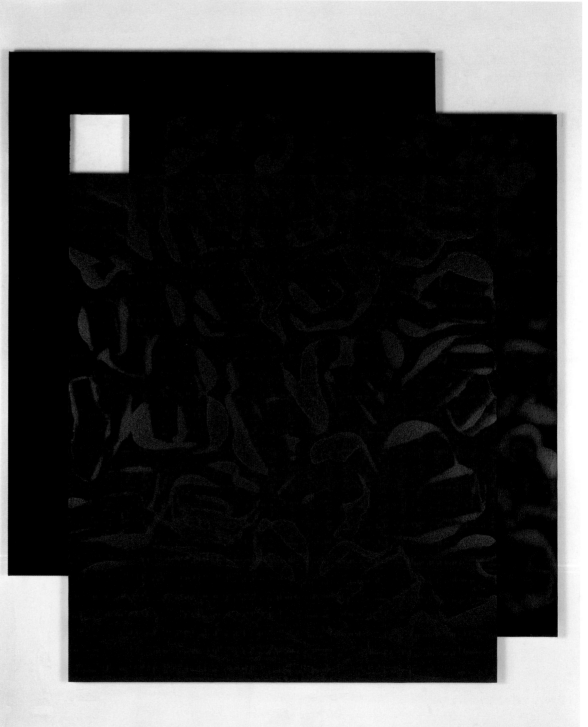

The Queen, 2003. Acrylic on canvas, 89.25" x 77.25". *All photographs by Brian Forrest,* © *the artist.*

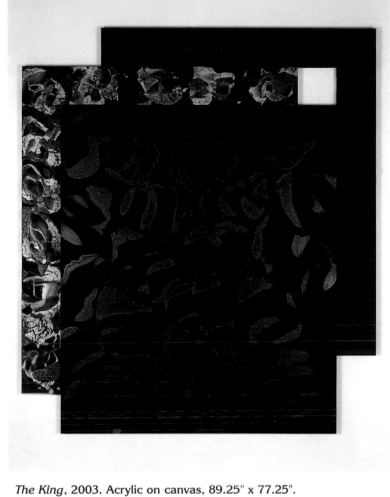

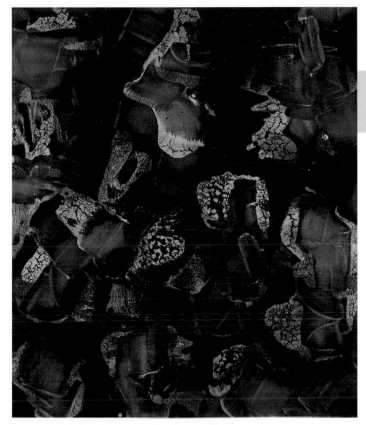

The King, 2003. Acrylic on canvas, 89.25" x 77.25".

Lava-Sum, 2002. Acrylic on canvas, 78" x 66".

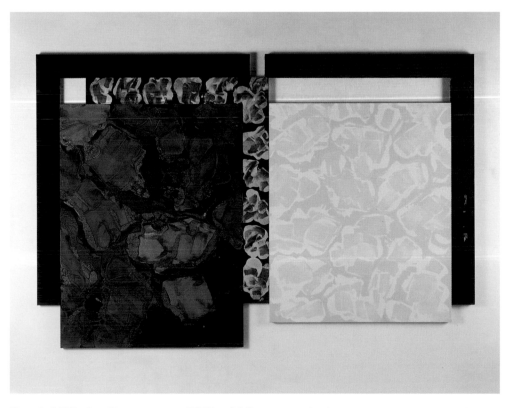

Ocnal, 2003. Acrylic on canvas, 96.3" x 144".

Minoru Ohira
Bryan Ohno Gallery, Seattle

Photograph courtesy of the artist.

There are hidden elements of nature all around the urban metropolis—little artifacts of nature, especially wood, that have been transformed into a functional state. Taking processed, sanded, and shaped wood from houses being torn down, I try to release the natural qualities inside the wood by shaving and splitting it into strips and chips that reveal its natural core. Depending on the sculpture, I then glue, bind, or tie these wood pieces onto wooden structure that establishes the compositional form I wish to create. Rather than use the wood merely as a medium for sculpture, it is integrated into the purpose of the sculpture. The composition inherits an inviting surface, smell, and visual experience that reflects nature.

One might observe two purposes in my sculpture. The first is to pay homage to nature. The works' smell, touch, and texture testify to the wholesomeness of nature as an end in itself. On the other hand, I have a compositional purpose of seeking new expressions of shape, form, density, and ways my sculptures can interact with their environment. There are not two separate purposes for my sculptures; they coexist in each piece. I love fusing these ideas by recycling wood for my materials. The wood in my sculptures follows a path from forest growth to wooden structure and then to art. Thus, I like to imagine my sculptures as an insert into the cycle of nature.

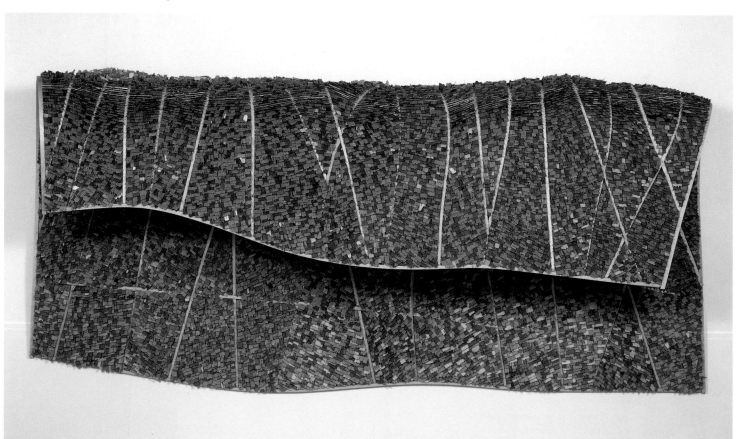

Santa Ana Wind #4, 2001. Recycled found wood, maple; 57" x 120" x 24". *All photographs courtesy of Susan Einstein.*

44

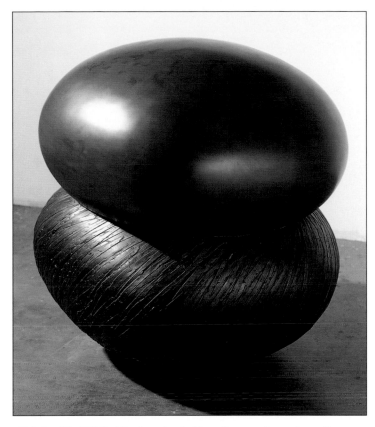

Origin #1, 2001. Black walnut, fiberglass resin, polyurethane; 58" x 48" dia. (each).

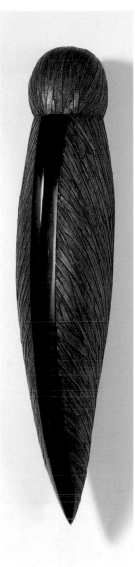

Bird #2, 1999. Maple, fiberglass resin, lacquer, oil paint; 68" x 15" x 20".

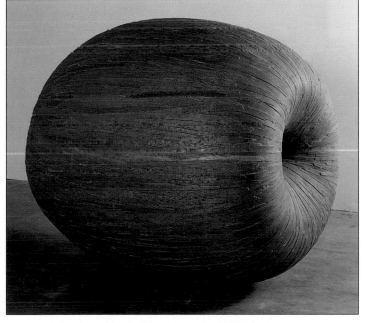

Beginning #4, 1997. Cherrywood, modeling paste, oil; 48" x 54" x 48".

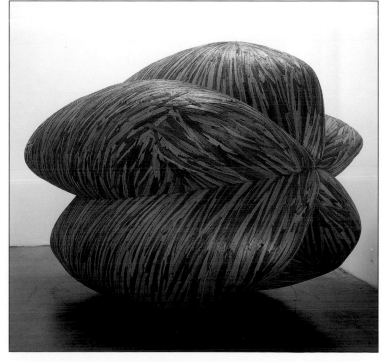

Silent Conversation, 1994. Recycled found wood on wood form, 96" x 90" x 125".

Noah Purifoy
Outdoor Desert Art Museum, Joshua Tree

Photograph courtesy of Tony Cuñha.

I always wanted to find my own way in art. In art school, I ran across Marcel Duchamp, "as is" art, the Dada movement, and how they reversed the whole concept of art. I had two degrees in social work and one in art when I was invited to start an art center at the Watts Towers in the early 1960s. I didn't become an artist until I witnessed the traumatic events of the Watts Rebellion. It forced me to confront myself and my idea of art. Art, it seemed to me, should not be an escape from the world but a confrontation with a "me" that is always in need of improving. In Watts, we saw ourselves as community artists and we believed that an art experience was transferable to any other activity. We took art from inaccessible high places into the streets to let it touch people. I recruited six other artists. We collected three tons of debris from the Watts fires and created sixty-six assemblages and sculptures that traveled nationally in an exhibition entitled *Sixty-six Signs of Neon*.

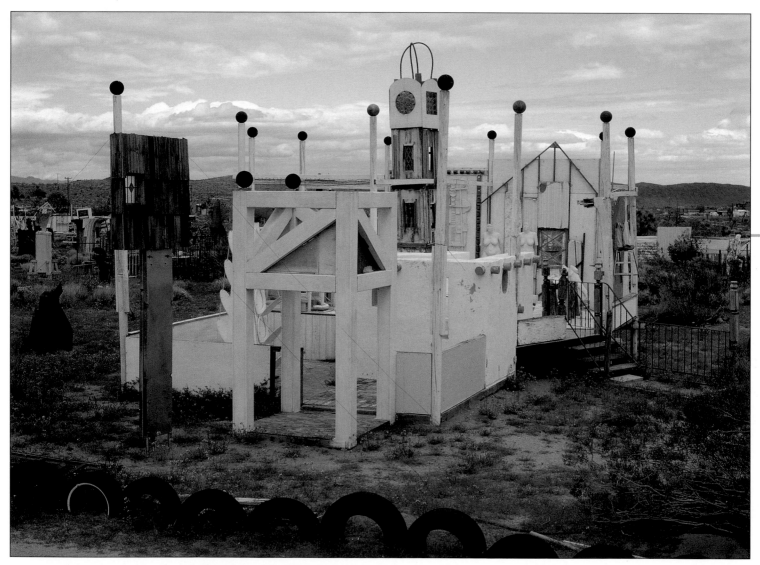

The White House (Exterior), 1990–1993. Assemblage sculpture, 20' x 20' x 40'. *Collection of Noah Purifoy Outdoor Desert Art Museum. Photograph courtesy of Tony Cuñha.*

This piece is a good example of an individual sculpture housing rotating exhibitions of other sculptures—the "sculpture within a sculpture" concept. Originally, the piece was entitled *The Castle*, but a viewer named it *The White House*. The name stuck, but there is no political statement being made.

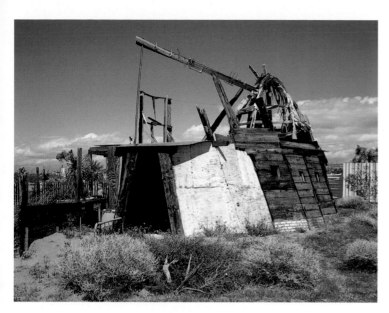

Shelter (Exterior), 1993. Assemblage sculpture, 30' x 45'.
Built from wood salvaged from a neighbor's house that burned down, this is a walk-through piece that speaks to the homeless worldwide. The act of doing art makes me want to know where it comes from. I believe that everyone is empowered with an equal amount of creative potential. Creativity can be an act of living, a way of life, and a formula for doing the right thing.

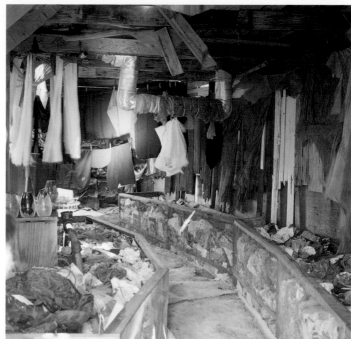

Shelter (Interior), 1993. Assemblage sculpture, 30' x 45'.
A social worker in the 1980s, I was deeply affected by poor and mentally ill persons being ejected from mental hospitals onto city streets. The interior of *Shelter* with its trash and old clothing reflects poverty and homelessness. The creative process explains what art is or at least what's involved in the doing of art. When an artist makes art, he/she has extracted the step by step process from creativity and applied it to art making.

Many years later, an artist friend invited me to the high desert where I live today and I find other ways to confront the mystery of relationships. I always wanted to do environmental sculpture. It took me ten years to gather the funds and materials to do an earth piece. I've also devoted some serious thought to the idea of sculpture. The desert permits me to build with the breadth, the width and the depth of a piece. I collect ideas like I collect objects and I execute them when I get around to it. I let the objects discover their own relationships. I let go of the idea of control so whatever comes up comes out. I use perishable materials because I can see change in the work by allowing nature, the sun and wind and rain, to participate in the creative process.

I believe that assemblage art is closer to existence than any other art form because the found objects are something people don't want and throw away. Then I come along and pick them up and make something with their cast-offs. One single piece or several single pieces stimulate me to want to put some more things with it, to provide company for it, and soon I'm caught up in it. It's through me that the assemblage happens. It's my calling. I've made more than a hundred sculptures and assemblages in what has become an outdoor museum where people don't have to dress up to see good art. I only hope that my effort inspires someone to go home and do what they really want to do. I simply want to be known as an artist who makes art for the sake of change and who strives to understand art and its role in the world.

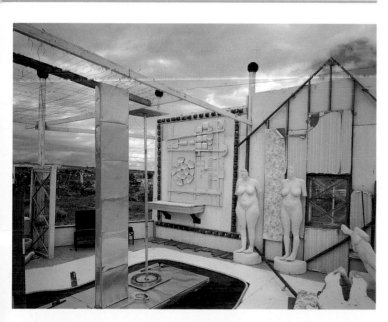

The White House (Interior), 1990–1993. Assemblage sculpture, 20' x 20 x 40'.
The viewer of my work must not go looking for hidden meanings, symbols, or signals. I'm not interested in mystifying, dramatizing, or mesmerizing the viewer. I do want to establish rapport with my audience, but I am not likely to offer much information or explanation regarding my work.

Alison Saar
Jan Baum Gallery, Los Angeles

Photograph courtesy of Thomas Leeser.

I grew up surrounded by art. My mom was an artist and my dad an art restorer. My earliest books were about art. I got to go to the usual museums, but also saw so-called "Outsider Art" like Simon Rodia's *Watts Towers* in Los Angeles and Grandma Prisbrey's *Bottle Village* in Simi Valley, a group of buildings whose walls are discarded bottles joined with cement. Folk art helped me see the beauty in cast-offs.

I sometimes helped my dad in his restoration work. I got a close look at just about everything—Chinese frescoes, Egyptian mummies, pre-Columbian and African art, you name it. Then at Scripps College I studied African and Caribbean art, but ended up taking more art history courses than studio classes. Now it's my turn to pass it on. I teach kids what art means to different cultures. I show how art isn't a product, it's a process. I open their eyes to self-taught artists and art from Africa and China. I hold up a Van Gogh and they know it's a Van Gogh, but they know all kinds of other stuff, too.

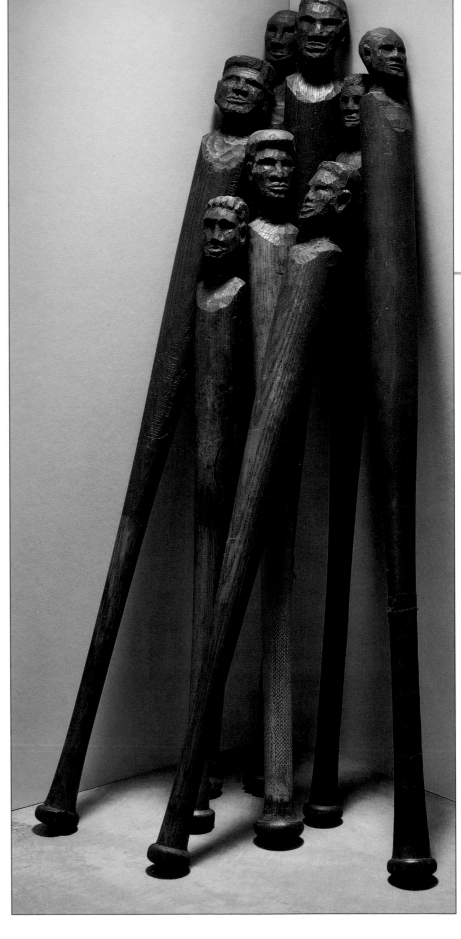

Bat Boys, 2001. Pitch and baseball bats, 34" x 12" x 12". *All photographs courtesy of Douglas Parker Studio and Jan Baum Gallery.*

I really love the chainsaw. I'm extremely impatient and I love the ability to whip through large masses of material at once. I use it like a butter knife. I love the physicality of it, the sweat of whacking away, taking an aggressive approach to the artwork, then later doing the refinements. As the piece progresses, each step gets finer.

When I grew up we lived in a neighborhood that had a bad fire in the 1950s. Every time it rained all kinds of unexpected objects would wash onto the streets. I looked at these objects as artifacts from history. When I think of the materials I work, I think of them as artifacts. They have spirit and wisdom. If I work with a skillet it's a real skillet. It cooked bacon and chicken and fed kids, and then was discarded when something new came along. Pieces like that are really talking about the forgottenness of something, in this case the faint ghosts of things domestic. There's always some sort of spirit power out there.

Since the birth of my son, my work has often dealt with the strength of the female body. It comes out of my experiences with my children, but also from recognizing that I have done things I didn't think were possible. Childbirth and rearing a family. Intelligence and creativity. Problem solving and patience. All these are part of being a women.

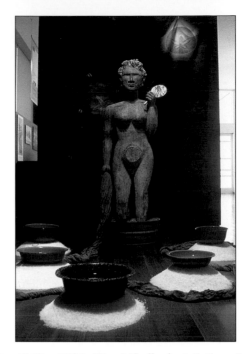

Afro-d(e)ity, 2000. Mixed Media, installation view from the exhibition *Depatures*, 2002; dimensions variable.

The people in my pieces don't look like me, but they've always been self-portraits in their own way. My work is autobiographical, even though a particular piece may be about something I haven't personally experienced. Even when they're male figures, they are autobiographical. They are about emotional empathy with different people's experiences.

Bat Boys (detail), 2001.

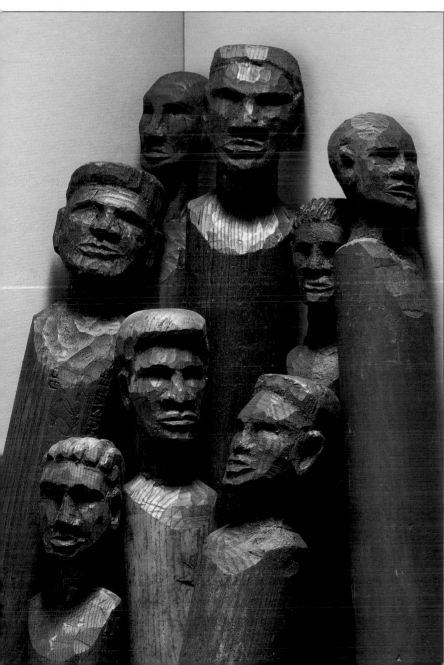

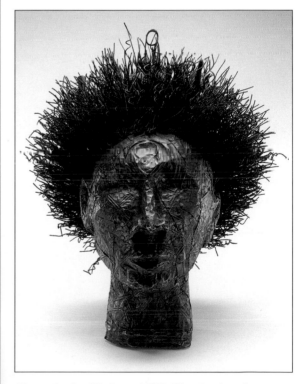

Chaos in the Kitchen, 1998. Wood, wire, tin, tar, miscellaneous objects; 23" x 20". *Collection of Dr. Richard and Jan Baum.*

What's great about art is that viewers draw different conclusions from the same piece. It means different things to different people depending on their history. They can literally see themselves while in some sense being part of the piece's history, even though it is foreign to them.

49

Lezley Saar
Jan Baum Gallery, Los Angeles

Photograph courtesy of Agust Agustsson.

Most of my paintings are self-portraits, whether they're conjoined twins, gangsta rappers, or blackface vaudevillians. Rappers are today's *griot*s, the storytellers of Africa who kept their history alive with their words. People say gangsta rap is violent and anti-women, but I hear its poetic language as a mirror not just of our culture, but the conscience we don't want to face. Rap is a vibrant cultural phenomenon. I love its energy, anger, even its ridiculousness.

How much I want people to know me from my art depends on the specific piece or series. For example, with my *Rap Series* I wanted people to know that I was Black, but God forbid that they know my age. With my *Mulatto Nation Series*, I didn't want to be known personally at all but rather as my alter ego, a professor/curator who organized the artifacts and dioramas for their exhibit.

Writers and critics often think I'm sincere when I'm being sarcastic, or that I'm vilifying something when in fact I'm revering it. I wish they would realize that I approach subjects or themes with seriousness and humor at the same time, politically correct and incorrect all at once, the beauty in horror and horror in beauty. The contradictions in my work are intentional. What I really want is people to be transported as they look at it.

I usually do pieces in a series. I start with a cultural, political, or emotional concept that's been on my mind. Then I assemble various found materials that express the theme or concept. Finally I come up with the image, scale, and composition for the piece. I use unusual materials to push pretty far out there. Album covers, money, gold lamé, traditional African fabrics—those are art media for me. It depends on who or what I'm going to portray. Gold, jewelry, fake diamonds, chains, wigs, and joints are rappers' symbols of power. Fantasy vacations and gold lamé are rappers' glamour side. T&A poses from 1950s record albums are juxtaposed alongside today's independent women.

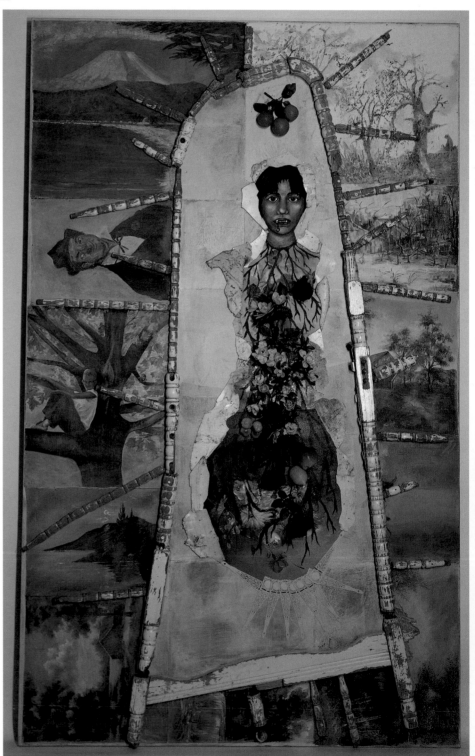

Geneva Saar Agustsson—labeled Autistic, **1998. Acrylic and mixed media, 80" x 48" x 4".** *Photograph courtesy of Agust Agustsson.*
I look at people on the physical and emotional outskirts. They're accused of being freaks, but I don't see peculiarities. I see traits I admire, and I use fairy-tale fantasy to show their dignity.

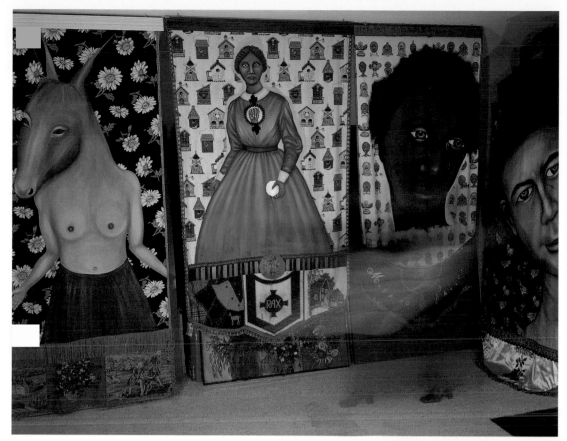

Founding Mothers and Fathers of the Mulatto Nation, 2002. Acrylic on fabric and mixed media. Installation, dimensions vary. *Photograph courtesy of Agust Agustsson.*

I don't know what "great" art is. My pieces aren't art objects, they're artifacts in the cultural history of the Mulatto Nation. I use "mulatto" and "half-breed" a lot when I talk about my pieces. They're about the absurdity of racial categories and words. My "Mulattoville Museum" jokes at the way art exhibitions perpetuate cultural myths by inventing new words for them. As a proud citizen of the Mulatto Nation any idea with the word "mixed" in it works for me.

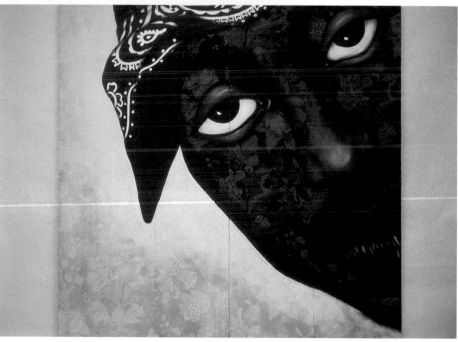

2 Pac, 2000. Acrylic on fabric, 72" x 72". *Photograph courtesy of Jan Baum Gallery.*

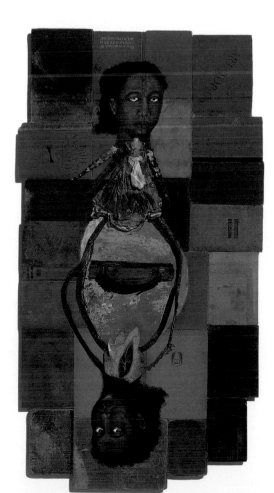

The Silent Twins, 1996. Mixed media, 48" x 25.5". *Photograph courtesy of Douglas Parker.*

I am prone to "messing" with a piece too much, to the point where it's a disaster. But then, dealing with the disaster can redirect the piece to a more interesting place, or push me into a new painting if that one's too far gone.

Adrian Saxe
Frank Lloyd Gallery, Santa Monica

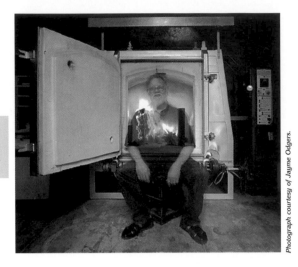

Photograph courtesy of Jayme Odgers.

I am the village potter for the Global Village. I love working with ceramics in its totality—not merely as clay—with all its technical possibilities and historical exemplars. To me clay is a material; ceramics is a locus of art. I consider pottery in its social, political, economic, and intellectual context. I don't make the distinction between "crafts" versus "fine arts" that so limits professional opportunities and markets today. Along with poetry, ceramics is among the most marginalized disciplines in the arts. I want my work to respond to my time and place in a larger cultural context by reflecting and interpreting the world around me via critical analysis and craftsmanship.

My current work explores the possibilities and challenges a craft-based studio faces in our rapidly changing, theory-driven global arena. I am part of the first generation of university-trained studio artists in the United States who were exposed to a wider range of art histories, including non-Western traditions that were termed "primitive" and "ethnic."

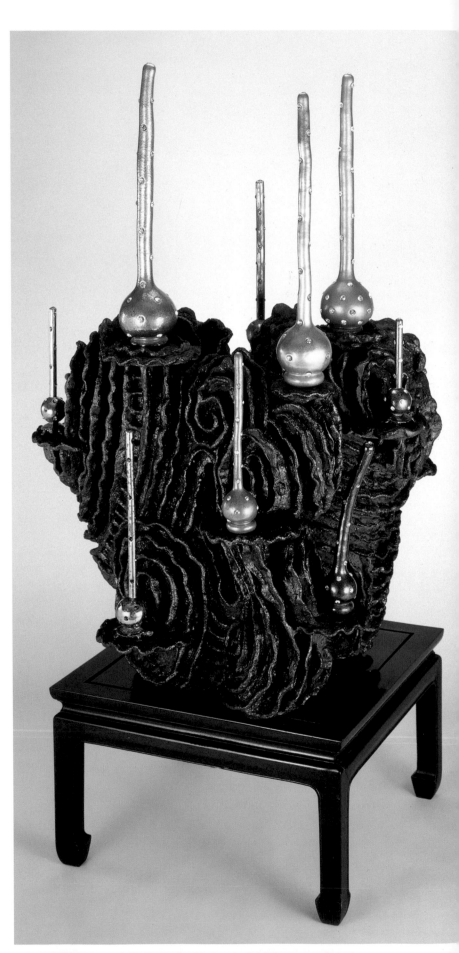

Nirvanarrhea, 2002. Ceramic and stoneware, 63"
x 32". *Courtesy of Frank Lloyd Gallery, with
photographs by Anthony Cuñha.*

Media-specific arts like ceramics are considered "minor" in the Eurocentric and American academia of today. In 1983-1984, when I was awarded a French Ministry of the Arts Fellowship at the Manufacture national de Sèvres in Paris, the French arts bureaucracy enforced strong distinctions between the *beaux-arts* and the applied arts. To somehow bestow prestige that justified an award usually reserved for painters, architects, and sculptors, they called my work "sculpture whose subject was pottery."

Nonetheless, the time away from my emotional and professional support system allowed me to re-evaluate my "vessel" work. I ratcheted up their complex reference content. Most of my pottery up to that time was intended to be appealing and accessible to a broad audience. Critical response was generally antagonistic or dismissive. But commentators had to look long and hard at my work to explain exactly *why* it was minor or irrelevant.

Since then I have attempted to redefine the relevancy of ceramics and the decorative arts in contemporary art. Much of my recent work has returned to my early interest in small objects best experienced as an intimate encounter in private spaces. My *Magic Lamps* pieces must be touched and smelled as well as seen. They are animated by the moving air that surrounds them, accompanied by changes in the ambient light they emit and receive. They operate in low or uneven light, in visually and physically complex environments. The viewing requirements for smaller works like my *Magic Lamps* differ from my larger didactic and theatrical "court porcelains," which are best viewed in large, well-lit public spaces.

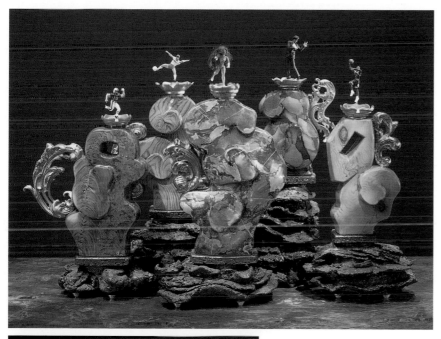

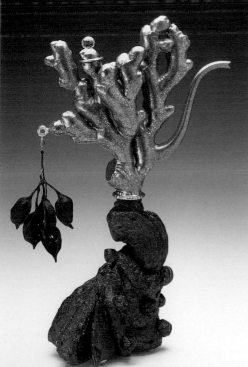

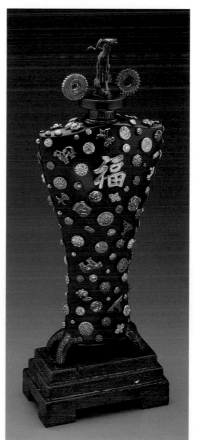

1-900-Zeitgeist, 2000. Porcelain, stoneware, and mixed media, Centerpiece 36" x 30" x 46" overall, Torchère vessels 24" x 20" x 15" each. Installation at the J. Paul Getty Museum, Los Angeles, 2000. *Courtesy of Frank Lloyd Gallery and Anthony Cuñha.*

Today my work is concerned with scaling up the ideas and formal qualities incorporated in my small works into large installations and sculptures where the viewer becomes a variable element moving through the artwork. *1-900-Zeitgeist*, a large room-sized installation created for "Departures: 11 Artists at the Getty" in 2000, was a major realization of these interests. Making this work was driven in part by my fascination with how contemporary popular culture constructs and commodifies celebrity, how we create and signify "value," how we keep score, and how people cash in on the value created.

Left:
Untitled Ewer (St. Beverly Hills), 1995. Porcelain and stoneware, 18.75" x 10.85" x 5.4". *Courtesy of Frank Lloyd Gallery and Anthony Cuñha.*

Right:
Untitled Jar with Antelope Finial (Prosperity), 1987. Porcelain, 31.5" x 11" x 6". *Photograph courtesy of John White.*

Peter Shire
Frank Lloyd Gallery, Santa Monica

Courtesy of Pamela Fong.

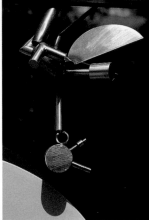

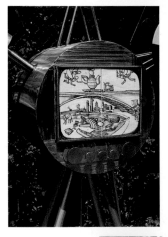

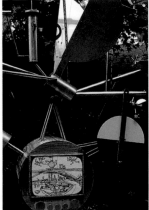

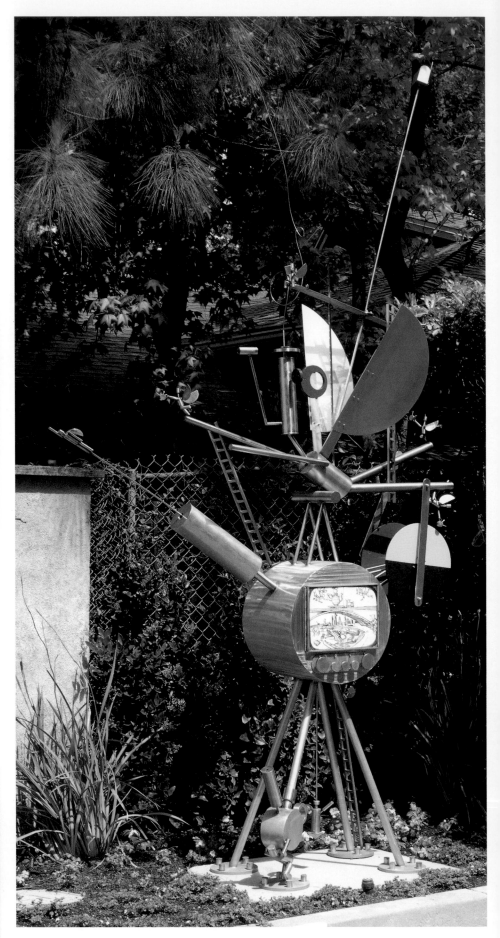

Kamm-o-Lot, 2003. Stainless steel, aluminum, enamel; 12" vertical. *Gloria and Sonny Kamm collection. All photographs by Anthony Cuñha.*

I'm a shy, modest, restrained fellow as far as artists go. All I really want from people as they look at my work is money, awe, adulation, acceptance, a place in history—little things like that. Did I mention money?

It all started one day in the 1970s. There was a Gay Pride Day radio show on the local progressive radio station KPFK. The announcer said, "Imagine yourself as a child again. You are standing in front of a hill. On the other side, out of sight, you are ascending the hill with someone coming toward your self. As you see yourself come into view at the top, are you with a man or a woman?"

For me, the person that I was was an artist. My work is my life, and my life is my work. It's like the belly button, the conduit between us and our original source. Sometimes it's an inney, and sometimes an outey. The art I make is solid and complete images that flash for an instant in the corner of my eye, sunlight glinting off store windows at 50 mph. Mysterious and beautiful. My art is neither my love nor my friend. It's more like a mistress—more exciting, slightly outside the range of conventional behavior, a logistical pirouette, an exquisite pleasure. And very high maintenance.

Ceramics has a lot of imperatives. The incorrigible aspect I introduce is always seeking ways to increase them. If I'm lucky I can conceptualize a work fully formed. Most of the time, though, a piece starts out with a good corner and I build the rest with many drawings and a lot of trial and error.

There is a Mexican saying: "If it's all the same clay, how come some turns out to be a tea cup and some a chamber pot?" To an artist, a piece of art happens more or less the same way, yet differently each time. The moment that counts is when I open the oven and it all happened the way I wanted—and then some. The momentum of the kiln is the natural definition of the end of a piece. Whatever comes out of the kiln, that's that. The piece is finished. Vitrified. Sealed. Gone through a critical change that turned it into a rather nice-looking rock.

Is art more pervasive, more persuasive, more addictive, more effective than drugs? Is it more sociologically compelling and attractive than buying a new car? That's up to you. But for me, helping people enjoy life strikes me as a very ambitious thing to be doing with myself.

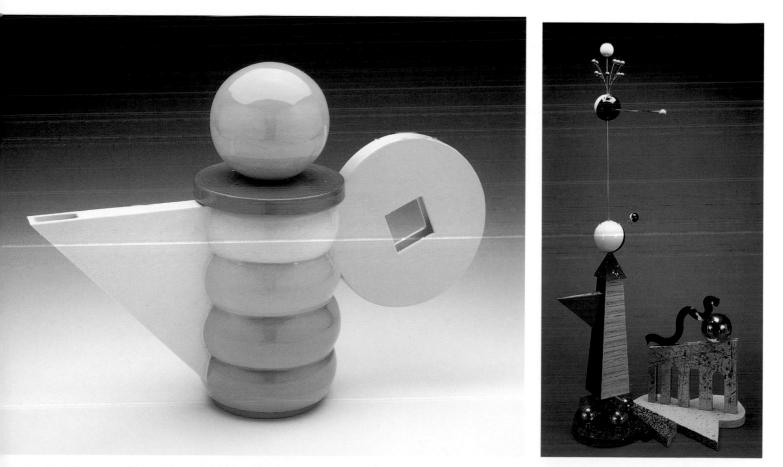

Stacked Donuts, 1982. Whiteware, 13"h. *All images courtesy Frank Lloyd Gallery, with photographs by Anthony Cuñha.*
When a piece comes out of the kiln hot and finished, there's purity, satisfaction, and unassailable definition.

Mayan Tableau, 1996. Whiteware, 41.5" x 23".
What kind of artist am I? A concrete absurdist. A transcendental quack. A post-industrial object-absurdist.

Brad Spence
Shoshana Wayne Gallery, Santa Monica

Still Life with Shrimp Cocktail (green), 2001. Acrylic on canvas, 44" x 51". *All photographs courtesy of Shoshana Wayne Gallery.*
When I find a suitable image, one that seems deadened and remote, I manipulate it in a computer and print a study. It is then projected onto a canvas and painted in high-intensity, colored layers using an airbrush.

Making art has been a way for me to overcome certain disabilities. I was somewhat autistic as a child. Even now I hesitate to label myself as such, but my younger days were spent largely in the tuned-out state commonly associated with autism. At one point, professionals gave me "Verbal Enhancing" flash cards to help remedy my problem expressing myself verbally. I obsessively looked at and hoarded these cards, with their simple pictures of, say, a fence or a hammer. They provided relief from the nauseating blur of most of my visual impressions. In my current painting, there is still some of that childhood fascination with an abstract reality of frozen images.

Thanks to the technique of mainstreaming, I went through the public schools and eventually to art school. There my deficiencies were turned into assets. My memories and imagination are still pretty dim and lifeless—I cannot conjure that sense of childlike wonder that so many artists speak of and use in their work. Instead, I search for existing images that have a quality of being embalmed, used, or culturally depleted. Much of my time is spent looking through books and magazines or searching the Internet. I usually have to avoid movies and television because of light sensitivity, a condition thankfully brought to the public's attention by Dennis De Young, leader of the melodic-rock band Styx. This condition prevents me from spending much time in daylight, but it does make color pulse and vibrate in the manner that I reproduce in my paintings.

Conceived (orange), 2001. Acrylic on canvas, 60" x 78". *Private collection.*
In my series *As I was Conceived*, I try to envision the moment I was produced. The result does not so much bring the vision to life as artificially reanimate it.

Tapestry, 2000. Acrylic on paper, 60" x 55".

Alienation, 2001. Acrylic on unprimed canvas, 83" x 66".

Sush Machida Gaikotsu
Mark Moore Gallery, Santa Monica

Photograph courtesy of Atsushi Machida.

I don't make furniture, I make paintings. I want people to be stimulated and excited by the narrative of my work, as well as the surface of it. I want them to enjoy a piece, smile, feel happy because they saw it. If they are collectors, I want them to love it tender, love it sweet, never let it go.

My parents and grandparents were good artists. I loved art even as a toddler barely one or two years old. The culture of doting on childhood is huge in Japan, so I could do anything I wanted in the utter freedom to choose what I wanted. I have been very serious about not only painting but also sport fishing, skateboarding, snowboarding, writing, and drawing Manga. As a matter of fact, I used to be a professional snowboarder and a professional tournament fisherman. Now, as a professional artist, I apply the color patterns of fishing lures and styles of snowboard and skateboard graphics into my paintings. This is how I develop my style.

Right:
Mega Onsen Bubble Jetter, 2001. Acrylic on wood panel, 96" x 11". *All images courtesy of Mark Moore Gallery, photographed by Scott Lindgren.*
I have a motto that goes: "It is easier to be published in an art book today than it will be to be to get into an art book in the 22nd century." An intention like that develops an instinct for the durable idea.

Far Right:
Ultra Phenomenon #1, 2001. Acrylic on wood panel, 72" x 11".
I want art that is loved not merely by people today, but also people far in the future. I feel it my duty to create something that will endure for hundreds of years.

I know what I want to create before I start. Since I am also a writer, I write about imagination and concentration all the time. In my writing I find what I want to paint. I create a short story to see if I can pull a good image out of one of its scenes. I sketch, design, compose various scenarios until I really love what I see. Then I set aside the piece for several days or weeks and come back to see if I still love it. If I do, I am ready to paint.

I was born and grew up in Japan, where "flat" is normal in art. Accurately portraying perspective has never been the aesthetic preoccupation it is in the West. Japanese traditional art provided for visual pleasure. Nothing more than that, nothing less. I love the great sense of humor found in 13th century *cho-jyu-giga*, early 19th century Edo prints, and in the contemporary Manga and Anime styles that Takashi Murakami and Yoshitomo Nara have popularized in the States. I try to produce a super high-quality beautiful surface that is done by an amazing technical skill. Surface quality is very important for me.

Hot Tiger 713, 2002. Acrylic on wood panel, 13" x 48".
I am from Japan, which has a long history of high-quality art that is still enjoyed by people today.

Drop Shot the Tokyo Jumbo Grubbin', 2001. Acrylic on wood panel, 15.5" x 65".

Mee the PRZ76 Ultra Heavy, 2001. Acrylic on wood panel, 16" x 96".

59

Marc Trujillo
Hackett-Freedman Gallery, San Francisco

Photograph courtesy of Linda Bowen-Trujillo.

The artist and his work *6100 Sepulveda Boulevard*.

My paintings tend to depict a purgatory of everyday in-between spaces, North American kinds of nowhere, where people do not go to be there, as opposed to a destination point, like the Grand Canyon. To portray a place in a painting articulates skepticism about placelessness. I prefer subjects from the middle ground of common experience. Too high or too low of a subject plays too easily into sentimentality. The titles of the paintings are the addresses of the places they show. They convey something absolutely specific and completely open-ended about the subjects at the same time.

The paintings are more synthetic than they may appear at first. The organization and composition are informed by the study of paintings and painters of the past and refined through stages of work starting with drawing. For example, the working method is similar to Corot's, starting with a drawing to work out a composition and a tonal (light to dark) scheme. I do this, not because Corot did it, but because I feel that it works for the paintings.

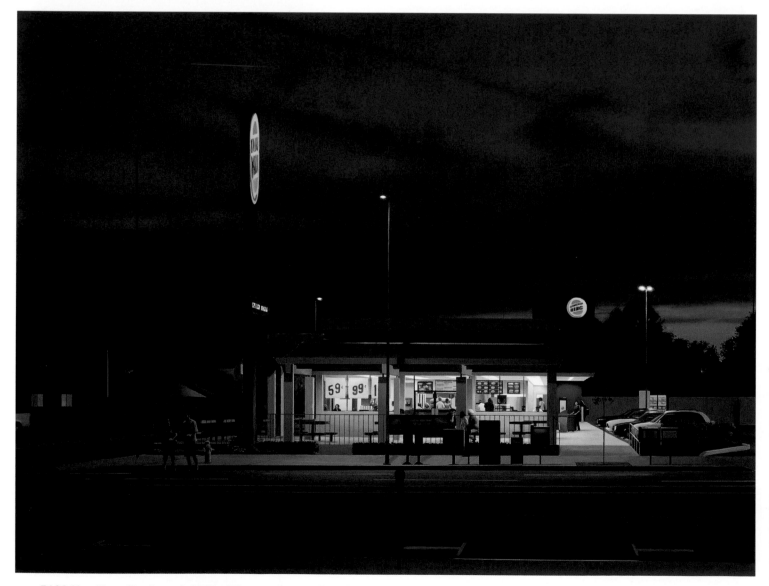

5109 Van Nuys Boulevard, 2002. Oil on canvas, 44" x 58". Collection of Lynn and Frank Kirk. All photographs courtesy of John Wilson White.
My aim when painting is concision, articulating much with brevity.

The painting itself is the acid test for everything that goes into making it. The distinction is an important one to me, for if I used a fixed formula, then the formula would be the thing and not the painting.

The preparatory drawing I do before I start a painting is a grisaille in black and white acrylic on paper. The drawing is the beginning of the conception that the painting will manifest more completely as opposed to being a drawing of a conception. This stage helps me clarify my interest in what I have decided to paint and initially determines the composition and the proportions of the painting. Hence the size and shape of the painting are a function of its composition. I then scale up the drawing onto the painting surface. This allows me to distill the composition further. Decisions are not final until the painting is done; things always change until then, but distilling through drawing is a means of getting clear— clear in terms of retaining what I responded to about a place that made me want to paint it, clear about the place of new elements that arise as I am working on the painting, clear about light.

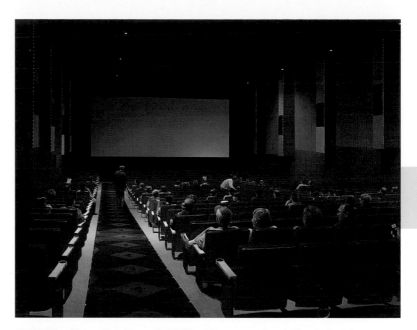

4502 Van Nuys Boulevard, 2002. Oil on canvas, 50" x 64". *Private collection.*
Light is the single most important character in the paintings, as it is the one that all of the elements in the painting must agree on to convey.

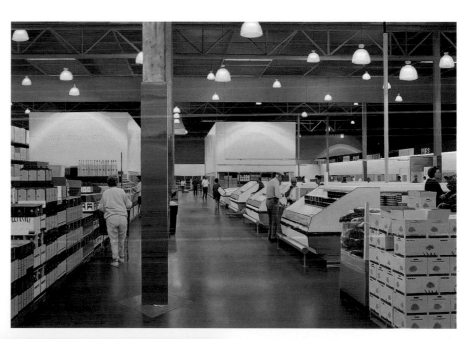

6100 Sepulveda Boulevard, 2001. Oil on canvas, 44" x 62". *Private collection.*
I spend a great deal of time on the color. I organize the colors for all parts of the painting from dark-to-light, warm and cool, for each part, so I can keep the whole painting going at once.

4822 Van Nuys Boulevard, 2002. Oil on canvas, 44" x 66". *Collection of Melinda and Kevin P. B. Johnson.*

Patssi Valdez
Patricia Correia Gallery, Santa Monica

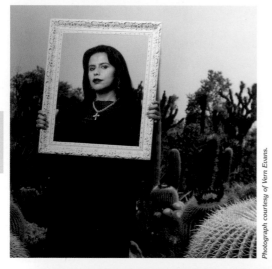

Photograph courtesy of Vern Evans.

Little Girl in Yellow Dress, 1995. Acrylic on canvas, 36" x 36". *Collection of Cheech Marin. All photographs courtesy of Gene Ogami.*
My work comes very much from the intuitive part of my being. When I feel that I have captured the feeling or idea in a painting, and there is not much more I can do to improve it, I know the piece is done. It is time to begin a new painting.

I have always been a dreamer. Art came natural to me. Even as a child I invented and created things. Through art, I could express my feelings and opinions about the world around me. It empowered me, gave me a voice.

I begin a painting with an idea, feeling, or memory. It is usually a combination of these that inspires me to create. A lot of my inspiration comes from my surroundings and what is going on around me and the world I live in. Travel to new places and experiencing different cultures plays a significant role, the opportunity to travel to new places in my art in the same way that I travel in the world. Then begins the research and exploration, putting together ideas and feelings, connecting the pieces of meaning that will put into paint the story or feeling I want to convey.

My color choices are based on seasonal as well as emotional and physical responses. I also like to use complementary colors' opposites on the color wheel to make the colors vibrate.

I think my sense of perspective comes from my photographic experience carried over into my painting. As a photographer I loved taking pictures, experimenting with various perspectives and lines of sight. I would lie on the floor and shoot up or get on a ladder and shoot down.

I have been lucky to be able to survive and flourish as an artist. When things get tough, I sometimes wonder about this career choice of mine. Then, just as fast as the question arises, I know there is nothing else I would rather do. I am grateful to my collectors and audience who make it possible for me to continue. And my mom (who's in the kitchen right now doing my paperwork) and my sister Karen, who has been a source of incredible inspiration.

Autumn, 2000. Acrylic on canvas, 66" x 53". *Collection of Cheech Marin.*
Art is not about the materials I use, it is about the feeling or message I convey.

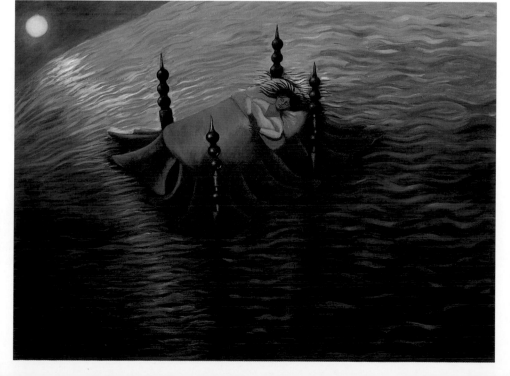

The Dream, 2000. Acrylic on canvas, 72" x 96". *Courtesy of Patricia Correia Gallery.*
I hope people who look at my paintings find something that inspires and enriches their lives.

Robert Walker
DoubleVision Gallery, Los Angeles

As an undergraduate I was educated in private religious schools where art was definitely not a part of the curriculum. I was almost twenty before I went to an art museum. At one of those visits I saw a Willem DeKooning painting that was a transforming experience for me. I started to make art shortly after that.

Art is a how creative people make sense of the world. In many ways we are living in an untenable world today, a world that is spiritually desolate. This lack of spirituality is manifest in the ravaging of our planet by political and economic powers. We seem unable to stop making war, even when we know the consequences. I feel that if we are ever to become evolved as a people, we must stop killing one another. What better time to make art? Art reminds us that civilization still rises in spite of the absurdities of human nature.

***Restricted Use**, 2001. Oil and acrylic on wood panel, 60" x 72". Collection of the artist.*
All photographs courtesy of William Nettles.
Picasso said art is a lie that tells the truth. Art is the only way I know to make sense of total chaos, a simple way of clarifying the otherwise inexplicable.

I think of myself as a process artist. When process work functions at a high level it moves toward its own autonomy. It de-emphasizes the concept of finality, suggesting that we contemplate the artistic process, and by extension, the cyclical order of nature.

I've always questioned some widely held assumptions about sculpture, especially the notion of Donald Judd's that art must achieve a rigorous formal statement, a notion that was very prevalent when I finished art school in the early 1970s. In a piece like *Cul-de-Sac* I deliberately used unconventional material to question the traditional expectations of density and mass. I wanted to subvert the very nature of the "hands-off" formal presence of so much minimalist sculpture. I deliberately make work that invites touching. It is also a play against the hyper-masculine presence of much of Minimalism.

I want people to be captivated by the visual impact of a work. I like art that asks a lot of questions. I'm interested in abstraction that retains only the faintest residue of the subject's actual form. I hope to achieve a new metaphor, a new autonomous reality. I prefer that the viewer doesn't understand the work immediately, but is engaged enough to continue an exploration with the work that will lead to a deeper understanding. Many of my pieces, like *Critical Categories* exist in the realm between sculpture and painting. Being in-between suggests multiple readings or new interpretations that give the viewer more potential to find resonance in the work.

Critical Categories, 2002. Nylon netting, dental tray plastic, oil, enamel; 36" x 84" x 12". *Private collection.*
I try to make work that voices my doubts yet is still in touch with some fundamental force.

Cul-de-Sac, 2002. Nylon netting, dental tray plastic, pigment; 37" x 37" x 37". *Private collection.*
An artist has to walk a tight wire between existing as a monk and a business man. It is not an easy balance.

Patrick Wilson
Brian Gross Fine Art, San Francisco

***Los Angeles**, 2002. Alkyd, oil, acrylic, and pigment on canvas; 76" x 76".*
Private collection. Photograph courtesy of Gene Ogami.
The twenty-five panels in *Los Angeles* are a portrait of the city (the spectrum being a metaphor for the complexity of its identity), but each of the individual parts also include transient imagery, which refer to the importance of personal and mundane experiences in our own evolution.

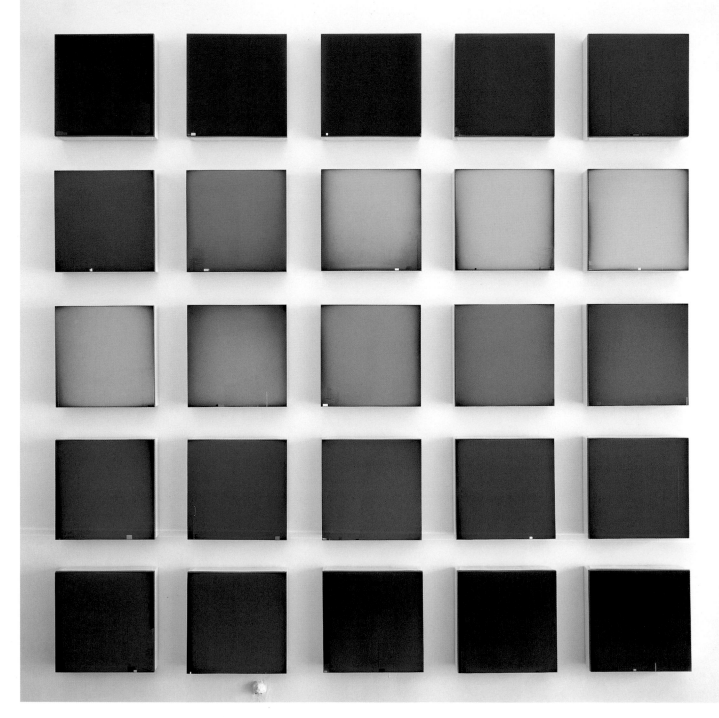

My paintings refer to space. Not just the space above and around things, but also a mental and emotional space that is articulated and defined by light. Dozens of thin, translucent layers of alkyd and oil, combined with the suspension of a carefully placed architecture of rectangles and lines between these layers, are my response to the environment surrounding me and an examination of my place within it.

The inclusion of obscured imagery and a solid conceptual foundation in what are essentially abstract color paintings, results in a level of complexity similar to the unpredictability of pleasure.

Ultimately, I am satisfied when the works exist both as beautiful objects and as something more cerebral.

Entertainment Center II, **2002. Alkyd, oil, acrylic, and pigment on canvas; 12" x 12".** *Collection of Hal Segelstad. Courtesy of Brian Gross Fine Art.* It is important to keep things in check. Somehow, making a fetish of the ultimate nonintellectual activity seemed as relevant as other, more highbrow pursuits.

Motel 8, **2001. Alkyd, oil, acrylic, and pigment on canvas; 105.5" x 27".** *Courtesy of Susanne Vielmetter Los Angeles Projects. Photograph courtesy of Gene Ogami.*

Takako Yamaguchi
Jan Baum Gallery, Los Angeles

I am attracted by images and ideas that fall outside the boundaries of today's dominant art discourse. From the very beginning this attraction to difference guided me away from the mainstream of contemporary art to a place the poet Wallace Stevens called "the dump:"

> Of the floweriest flowers dewed with the dewiest dew,
> One grows to hate these things except on the dump.

I place decoration, fashion, and beauty alongside empathy, sentimentality, and pleasure. I hold dear these forms and values because of their long exclusion from "serious" art. I am so at variance with mainstream culture that I countermand it with my own aesthetics of difference.

I've come to recognize competing visions of the world. One says the world is an organic whole breaking violently into parts. The other says the world is a wild and primitive place being "civilized" into utility. This dialectic of order and chaos debates just beneath the surface of my paintings. Are the islands in a painting the promise of form emerging from the formless ocean? Is "form" a mental conceit that can be swept away at any moment by capri-

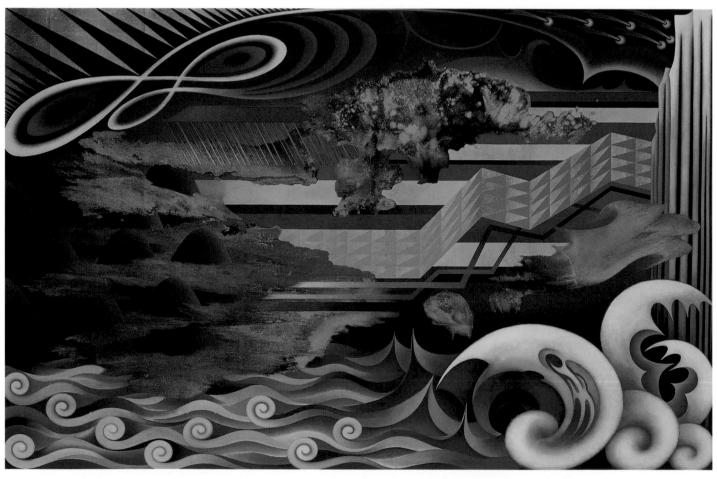

Kyoto Protocol, 2001. Oil and bronze leaf on paper, 52.5" x 82". *All photographs courtesy of Douglas M. Parker Studios.*

The metaphor in this painting is the maelstrom—the great storm at sea. Romantics saw the maelstrom as disorder on a frightening and unmanageable scale. Looking into the same storm I see a decorative pattern. Pattern here is not to be confused with abstraction. To me, the abstract never escapes reality; everything means something.

cious, all-powerful Nature? The world's mystery narrative is suggested in my collisions of splashed paint and geometric pattern.

My recent work features water images—cloud, rain, stream, current, ocean. They reminisce through now-colored glasses to the limitless horizons and fathomless depths of the monumental, disquieting seascapes of 19th century Romanticism. My paintings also are influenced by the kimonos of my native Japan, where boldly abstract patterns cheerfully juxtapose with delicate representations of nature. It is difficult to think of a greater anachronism than 19th century Romanticism, yet I seek a way to revive the forgotten poignancy of the seascape by reinventing it.

My techniques are exacting but not difficult. The base is splashed paint, atop which I flow representations in oil and acrylic around and through the "space" of the imagery, changing form between figure and ground, shifting identity between surface and depth. The effect I want is a turbulent soup. Then I add a pattern of geometric designs in metal leaf that suggest the graphic designs in a weather report.

Sophle and Muffln, 1995. Oil, acrylic, and bronze leaf on canvas, 52" x 52".
A woman and her cat in a pose decorated by the terrible beauty of her cigarette's curling smoke. Here, as in my other paintings, beauty and mortality are intimately connected, but this time the scene is domestic and familiar. I do not search, as Modernism does, for a truth that is hidden deep beneath the appearance of things. The mystery of the world is hidden in plain sight.

Fossil Fuel, 1991. Oil and bronze leaf on canvas, 72" x 96".
This painting is in the cosmological tradition of those primitive and folk artists who try to fit everything into a single picture. In my version, the scientific disciplines of astronomy, geology, and biology are poured into the landscape genre and mixed vigorously. The result is blood red lava erupting from a muscular volcano, spewing out galaxy-filled spermatozoa and cartoon-like chromosome shapes.

Untitled, 1999. Oil and metal leaf on paper, 42" x 80". *Private collection. Photograph courtesy of Douglas M. Parker Studio.*

Yek
Mark Moore Gallery, Santa Monica

Art was always my best friend, in my blood from very early on. The actual feeling of being an "artist" didn't start until the third year of graduate school when I made my first "great" piece. Great to me because it felt original and fresh. Everything about art—all my choices, the possibilities, the impossibilities—gradually became absolutely clear.

My inspiration is everything around me. Mostly visual things like a movie, a magazine image, or reflection off a windshield. But music can do it, too. Some tunes are easy to visualize. It is a lot of fun to compose an image around a song. In fact, I think of my images as great love songs from the 1980s. (I relate to the 1980s because those were my teenage and early adulthood years when the foundation of my identity was laid.) Then I mull the idea for a piece over a long period of time, sometimes months. I usu-

True, 2001. Acrylic, latex, and enamel on panel, 44" x 44" x 4". *Private collection.*
I have been told my pictures are self portraits. That's a little bit true. Externally, they are kind of like me, quiet and off in a corner. Internally, they are also like me, quiet and off in a corner.

ally skip the sketch or design-study stage and go directly to the finished product.

I have never thought very much about what is great art. I have thus far been grouped with the "Light and Space," "Colorfield," "Op," and "Pop" groups. Very flattering, but I don't really define myself. For me, my self and my art are one and the same. I don't want the world to perceive me any particular way—I prefer to be an enigma to the world. Art is a different experience for each person, but some people get too caught up with everything about art but the art itself. Success only makes future success harder to achieve. The obvious pressure of having to match one's previous work is a demon all creative professionals have to slay. Success is only about ten percent of the whole experience of art. Enthusiasm is the other ninety percent.

Plush, 2001. Acrylic, latex, and enamel on panel, 30" x 30" x 3". Collection of Mr. & Mrs. Laskey, Longwood, Florida. All photographs courtesy of Scott Lindgren.
Art is its own navigator. It takes me wherever it wants. I have always perceived my role as passive. I prefer the viewers to be active, to take what they can from the experience.

Dash, 2002. Acrylic, latex, and enamel on panel, 35" x 35" x 3". Worman & Londgren Collection, Beverly Hills.

Zoo, 2001. Acrylic, latex, and enamel on panel, 44" x 44" x 4". Collection of the Los Angeles County Museum of Art.

Smooth, 2000. Acrylic, latex, and enamel on panel, 64" x 64" x 5". Collection of John & Phyllis Kleinberg, Villa Park, CA.

Timothy Berry
Hosfelt Gallery, San Francisco

Region 2
Northern California

Sublime Currency, 2002. Oil and encaustic on canvas, 38" x 36". *All photographs courtesy of the artist and Hosfelt Gallery.*
The act of creation for me becomes one of navigating my ignorance while trying to resurrect my desires.

I hope people who engage my work get the sense of an individual. I have a belief that objects have an extraordinary force in the world—that in life you can discover some measure of who you are, of what you've lost, through language—in my case, a visual language.

Like most people, I'm always seeing myself to a great extent through the eyes of others. From childhood to the present, making art was, and is, the only activity where I need not go outside for confirmation. When I began to have some success as an artist it called into question this understanding because others were now part of the equation. I have to work harder now to make sure my work is still a true reflection of me so as to be more fully appreciated.

In the studio I work from a stream of consciousness approach. I begin with any combination of word–image–concept, and let the piece develop from an initial mark. This approach develops into a series of works because of the multifaceted possibilities inherent in each beginning. The series ends when I become more interested in the next combination and see other possibilities for expression.

I believe art is about what is not present. When asked about my art, if it is a picture of my inner life, I can only say that I am somehow trying to present visual evidence and feelings not totally dictated by culture. I hope the work anticipates a condition of ignorance founded only in representing the experience at the time of its creation. Only the viewer can determine the distance.

When asked to define myself as an artist in relation to a school or a style, I can only refer to myself as a bastard child of proximity. My interests are founded in an open-ended approach and I've found my life to be the same.

Portmanteau Pi Cabinet, 2002. Oil, encaustic, graphite, and toner on canvas and paper, 40" x 62".
Because the art of creation has so much to do with a contrary definition of time, it deals with the betrayal of consciousness.

Quell, 2000. Oil and encaustic on canvas, 49" x 47".
There is much more evidence in the way things are done than in the way things look, although the final evidence must be in the way things make one feel.

Had Idea, 2003. Oil, encaustic, and toner on paper mounted on canvas, 28" x 23".

73

Christopher Brown
John Berggruen Gallery, San Francisco

Between the way the world looks and the way I seem to picture it is a gap that's exactly my size. I'm inconsistent, idealistic, uncertain, impatient, driven, confused—it's a long list. No matter what I think my paintings are about (and that changes all the time, too) the more I paint, the more that gap seems like my subject.

Fontana, 2002. Gouache and acrylic on panel, 45" x 30". *Private collection, San Francisco. All photographs courtesy of M. Lee Fatherree.*

Willow and Birch, 2002. Gouache and acrylic on panel, 45" x 30". *Collection of the artist.*

Golf, 2002. Gouache and acrylic on panel, 45" x 30". *Collection of the artist.*

Storm Window, 2002. Gouache and acrylic on panel, 45" x 30". *Collection of the artist.*

King of Siam, 2002. Gouache and acrylic on paper, 45" x 30". *Collection of the artist.*

Squeak Carnwath
John Berggruen Gallery, San Francisco

More About Sex, 2000. Oil and alkyd on canvas, 77" x 77". *All artwork images taken by M. Lee Fatherree, © Squeak Carnwath, 2003.*

Art is the antidote that reminds us to breathe, to feel the soles of our feet, the touch of the ground on the bottom of our toes.

Sign Language, 2000. Oil and alkyd on canvas, 80" x 80".
The world's chaos is delivered into our houses by television, radio, phone, and the Internet. The speed of information creates doubt about the nature of truth. We acquire a heightened awareness of the social construction of reality. We no longer experience a secure sense of self. Mystery is difficult to believe.

A Simple List

1. It's simple really,
 to paint is to trust.
 To believe in our instincts; to become.

2. Painting is an investigation of being.

3. It is not the job of art to mirror. Images reflected in a mirror appear to us in reverse. An artist's responsibility is to reveal consciousness; to produce a human document.

4. Painting is an act of devotion. A practiced witnessing of the human spirit.

5. Paintings are about:
 paint
 observation &
 thought.

6. Art is not about facts but about what is; the am-ness of things.

7. All paintings share a connection with all other paintings.

8. Art is evidence. Evidence of breathing in and breathing out; proof of human majesty.

Happiness Is Possible, 2000. Oil and alkyd on canvas over panel, 70" x 70".
Much of what we do is a product of our narcissistic culture. We are encouraged to create a false self, one that can quickly be understood or apprehended like so many images on a television screen. Fast cuts and fades take us out of our bodies and keep us in denial. Our disassociation is relieved by art's capacity to put us inside our skin in real time.

9. Painting places us. Painting puts us in real time. The time in which we inhabit our bodies.

10. Light is the true home of painting.

11. The visible is how we orient ourselves. It remains our principal source of information about the world. Painting reminds us of what is absent. What we don't see anymore.

12. Painting is not only a mnemonic device employed to remember events in our lifetime. Paintings address a greater memory. A memory less topical, one less provincial than the geography of our currently occupied body. Painting reminds us of what we don't know but what we recognize as familiar.

13. Painting, like water, takes any form. Paint is a film of pigment on a plane. It is not real in the way that gravity-bound sculpture is real. It is, however, real. Painting comes to reality through illusion. An illusion that allows us to make a leap of faith; to believe. To believe in a blue that can be the wing of a bug or a thought. It makes our invisible visible.

Enrique Chagoya
Gallery Paule Anglim, San Francisco

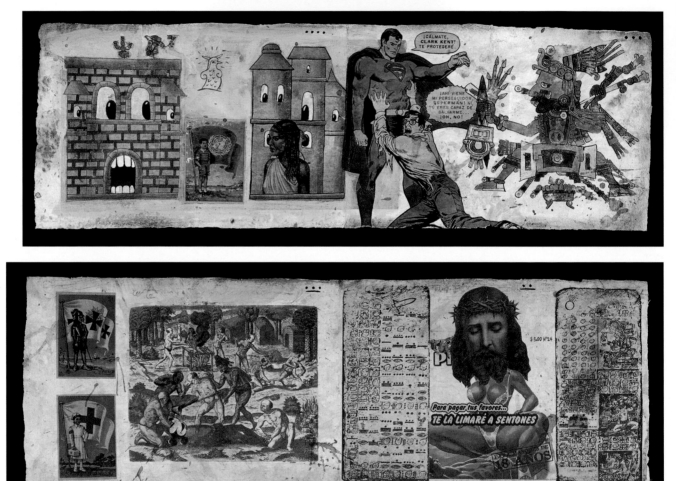

The Adventures of the Enlightened Cannibal / Las Aventural del Caníbal Iluminado, 5 panels. Acrylic and water base oil on solvent transfer on Amate paper (Mexican hand-made bark paper), 8" x 110". *Collection of Museum of Modern Art, New York. All photographs courtesy of Eugenio Castro, © 2002 by the artist.*
In the fashion of the Meso-American book, this work reads from right to left (the opposite of Western books). Page numbers are indicated in the corners of the pages with the Mayan/Aztec numeric system of dots and/or bars (dots are single units and bars are five units). Most of my paintings come from intuition and visual accidents. If I think of an image and it makes me laugh, that is the beginning of a piece. Visual thinking is different from verbal thinking, Not too different from symbolic thinking like mathematics, or as non verbal as music. Often my art is a reminder that feelings may be clear while meaning is more complex.

I would be making different art if I lived in Mexico or Europe. But I am here. I want to provoke people's thinking, preferably thinking that comes when sense of humor is the window to serious meanings. My work is commingled with my social context and many other sources— rare books, old prints, the weird stereotypes of colonialist imagery, American comics like *DC Comics* and *Underground*, the corny soft porn of Mexican comics, religious imagery such as the sexuality of Christ and Tibetan religious Tantric sculpture, images of pre-Columbian codices, religious folk art, boring art theory to make fun of, old anatomy charts from different cultures, renaissance perspective drawings, classic romantic paintings, political posters from revolutionary periods around the world, utopian idealism, modernist art before 1960, and social sciences.

Sometimes people miss what I put into my work when they see through their own biases. But that's OK, it is natural. We see with our minds. The eyes are just a window. You need someone at home to see out the window. Seeing is affected by the visual experience and beliefs of whoever sees out the window.

Sometimes success turns into an anchor for me. My freedom is compromised if I think about recognition. For me real success is to feel completely free to make the art I want and get away with it.

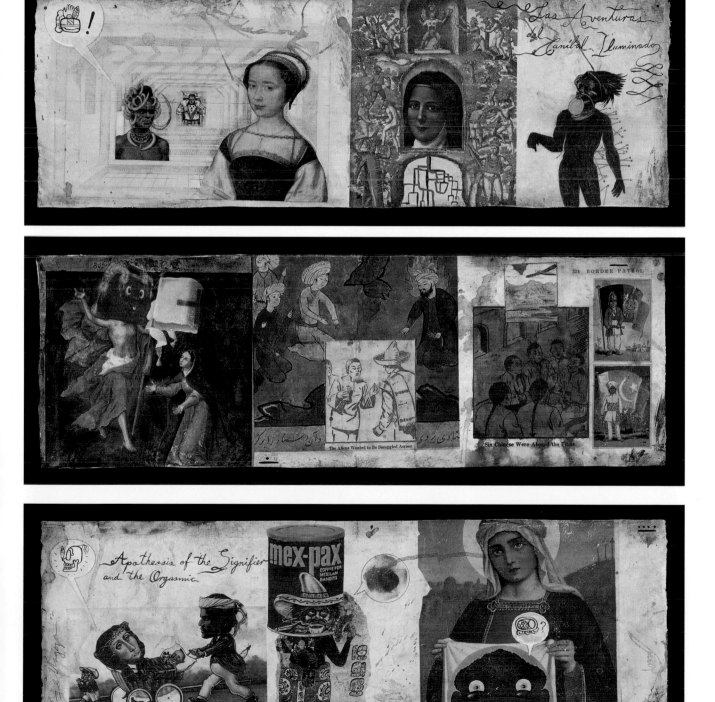

Anthony Discenza
Hosfelt Gallery, San Francisco

Between the relentless spread of consumerism and rapid advancement of technology, we find ourselves exposed to ever-greater amounts of visual stimuli. From television to movies to the internet, a steady stream of highly mediated imagery presses upon us. As a result of the escalating battle for viewer attention, more and more of our information, regardless of its content, arrives in the form of elaborately manipulated visual sequences formally and structurally indistinguishable from mass entertainment. Over time, a profound level of alienation is produced, as the possibility of authentic experience recedes before the unreality of the spectacle.

As a visual artist, I find this situation both fascinating and deeply problematic. I'm particularly concerned with the violence that underlies our overexposure to media images. By this, I'm not necessarily referring to specific violent content, but rather the dissociative effects produced by the quantity, speed, and disparity of content of the imagery we consume. My work attempts to expose this violence while acknowledging its seductive force.

While the idea of cultural critique is an integral component of what I do, I'm not trying to convey a specific message. My primary goal is to create a visceral, immersive space that provides a different vantage point on the world we've constructed around ourselves.

Even in this age of super-hybridization, there is still a tendency to evaluate art based upon the medium or technology involved. This creates false distinctions that impede our understanding of what art can provide. Though I work mainly with video, I don't define myself through my tools; I think of myself as a painter as much as a "video artist." I tend to define art in terms of how it functions rather than how it is generated.

Residual Light, 2000. Digital video, sequence of three consecutive stills from continuous projected digital video loop.

I work mainly with material appropriated from commercial film and television. Using a process of re-recording, compression, and signal decay, the source material is gradually collapsed into itself. By breaking down these images, I'm trying to uncover a new layer of meaning in them. At the same time, I want subvert the act of viewing itself, in the hopes of revitalizing our relationship to the visual.

How Love Came Amongst Us Unnoticed, 2001. Still from continuous projected digital video loop.
Always integral to art is the idea of pleasure, which both acknowledges and reconciles the possibilities of all its varied manifestations.

Ecstatic Moment #2: Johnny & Larry in Hell, 2002. Still from continuous digital video loop.

Appearance (the Area of Affect), 2002. Still from continuous digital video loop.

Donald Feasél

Brian Gross Fine Art, San Francisco

Photograph courtesy of John Zurier.

It seems to be my habit to work at the extremes when I make a painting. Some paintings move effortlessly to a natural stopping point. Others take a long period of time, often without resolution. Observing how a composition unfolds over time keeps me going, keeps me wondering what will happen next. I have become very conscious of time's role in painting. An improvisational approach is often associated with speed. When decisions and actions are fast the unconscious content of a painting is released into the foreground. Some paintings proceed very slowly. I feel like I am in the middle of a very long game of chess.

My current work involves staining color into raw canvas. The unstretched canvas is arranged over a support, and I pour liquid paint into water pouring from a watering can. It is a gift to realize a painting spontaneously out of these actions.

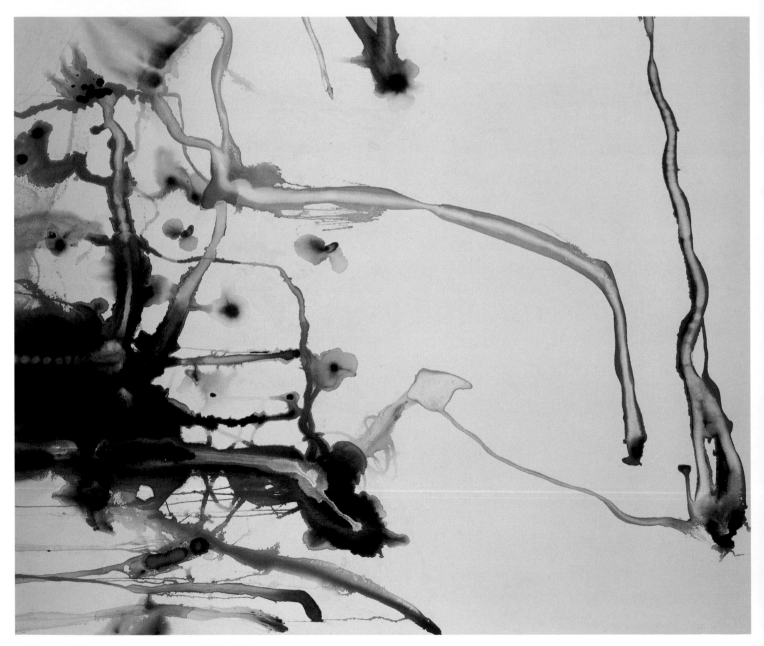

Thaw, 2001. Acrylic on canvas, 72" x 84".

82

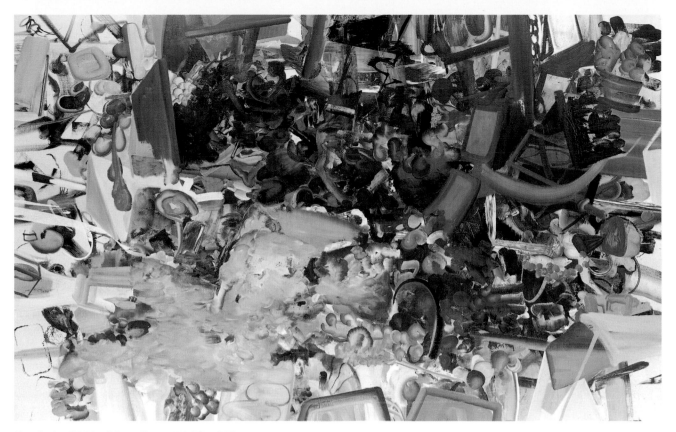

Postlude, 2001. Oil on linen, 56.5" x 89".

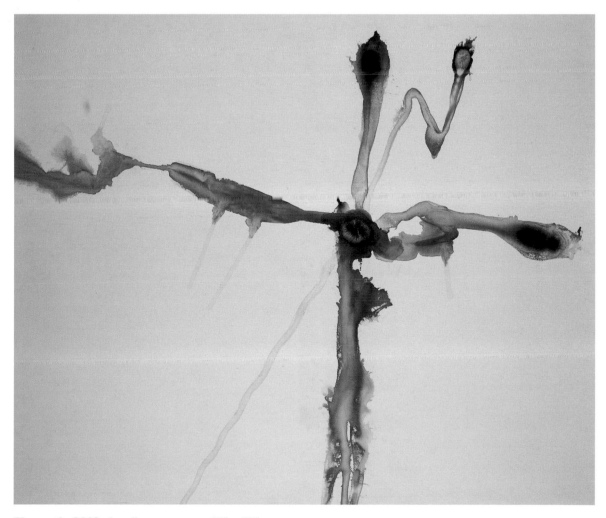

Plymouth, 2002. Acrylic on canvas, 65" x 77".

Wilbert Griffith
The Ames Gallery, Berkeley

Photograph courtesy of Saul Bromberger and Sandra Hoover.

Self-portrait Wearing Hat (detail from *Room 110*).

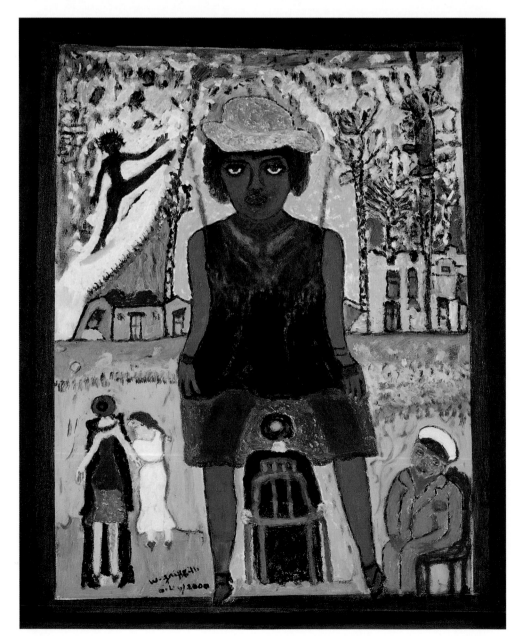

I was born in Barbados in 1920 and left school at age thirteen. I worked as a baker, got married, had seven children. I came to California and worked as a machinist's helper making parts and things till I retired in 1982. It was a long time till I started painting in 1995. I started drawing with crayon and went on from there. It was a hobby, to keep me occupied. I still paint every day. It passes the time.

By 1998 I had about sixty paintings. I brought two of them to the North Berkeley Senior Center for a show called "Celebration of Older Life." An artist there named Mari Marks Fleming and

Lady Portrait, 1997. Oil on canvasboard, 14" x 18". *All photographs courtesy of Ben Ailes Photography and The Ames Gallery.*
To me they're not really paintings, they're imaginary landscapes.

Bonnie Hughes liked them and wanted to see more. That led to my first one-man show at the Berkeley Store Gallery in 1998. That's where Bonnie Grossman of The Ames Gallery saw my work and she has represented me ever since.

I want to do things at my leisure. I work sitting in my chair in the living room or on the living room wall. I never use models or sitters. My ideas come from my imagination but I look at things in catalogs or books to get ideas or examples. I don't want to be pinned down to a particular thing. I start with a pencil sketch that I can rub out or paint over. Then I use oil paint and refined paint thinner on canvas board. I work with brush or finger, and sometimes go over work again. I might start with a *National Geographic* cover of an Indian child and end up with a portrait.

I never went in for the monetary side. I don't know how a *real* artist thinks. I don't do much thinking. I just sit down and paint. I never was taught, never had any instruction. I don't have a formula and don't do it for money, even in the bit of hard times nowadays. A lot of things in the world are unorthodox, they aren't planned, don't have any kind of blueprint to them.

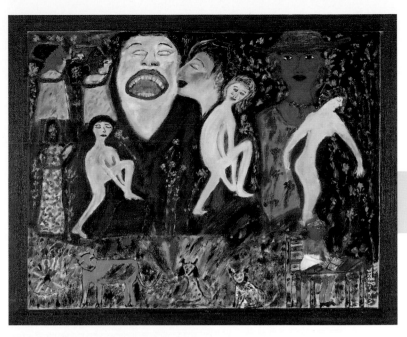

Woman with 3 Animals, 1999. Oil on canvasboard, 16" x 20".
I like to paint people at work, at play, sometimes looking directly at the viewer. I paint them standing, sitting, dancing, taking a shower. My portraits are mainly of women, and a lot of them black women. I like to paint blacks in today's society more than going back to slave days.

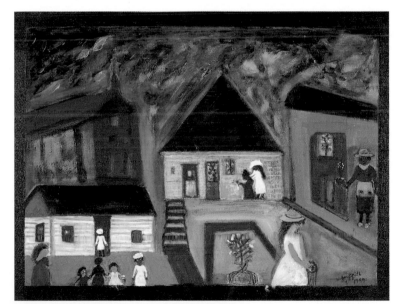

Women in Social Hall, 1999. Oil on canvasboard, 18" x 24".
I get most of my paints at the Rite Aid store. I start in the morning and work until the afternoon. I never take the thing too serious. I do it just to pass the time away, but the hours go real fast when I'm painting. I sit down at eleven in the morning and before I know it it's after four o'clock.

Room 110, 2001. Oil on canvasboard, 24" x 18".

85

Doug Hall
Rena Bransten Gallery, San Francisco

I came to photography about fourteen years ago via video and installation. From the early 1970s until the late 1980s I had been working in performance, video, and installation. Around 1988 I produced a video project called, "People In Buildings." This was a two-channel projected installation that sought private experience in public space by observing people (often using a hidden camera) in the most banal places, such as malls, offices, hospital waiting rooms, institutional corridors, art museums, etc., as they did very ordinary things—waiting, looking, working. It was during this project that I decided to use photography to stop time so I could examine spaces and situations similar to those I'd been shooting in video. From this decision an ever-expanding body of work has emerged.

The first photographs were single-point perspective views looking down institutional corridors. I thought I could get at people through their

Teatro Comunale, Modena 2, 2002. Digital C-print, 63.5" x 50", edition of 6. *Courtesy Doug Hall and Rena Bransten Gallery, San Francisco.*

absence by concentrating on the spaces they (and we) inhabit. I discovered that high resolution, high amplitude photography—the kind that large format provides—encouraged a scrutiny of the image that was impossible when the flow of time propelled the event as it does with video or film. The still image seemed to become separated from its source, as if it were disconnected or set adrift. As a result, I believed it became allegorical. The photograph, in its stark literalness, distances itself from the-world-as-fact. Combined with other images, on a gallery wall perhaps, and at a scale that relates to our own bodies, the representation insinuates itself into our consciousness in ways unlike time-based media. One

reason is that we are not propelled by the photograph's built-in temporality. We can linger, meander, enter, and exit at our own speed. Perhaps also the image is beyond real—not real at all and certainly not true—providing a level of detail and focal depth beyond the capabilities of the naked eye, as if its frozen literalness frees it from the literal. It becomes like a recollection that awaits our return, utterly unlike a real dream (or film for that matter) which has no patience with our dalliance. It is at the moment when we stand before the photograph that it abandons its false and irrelevant claims of accurately describing the world, and assumes its more important (and interesting) job of imaging ourselves.

Wild Blue Yokohama, 2000, Digital C-print, 50" x 63.5", edition of 6. *Courtesy Doug Hall and Feigen Contemporary, New York.*

Gene Autry Rock, Alabama Hills, California, 2002. Digital C-print, 50" x 62.5", edition of 6. *Courtesy Doug Hall and Rena Bransten Gallery, San Francisco.*

Mildred Howard
Gallery Paule Anglim, San Francisco

Photograph courtesy of Raymond Holbert.

Throughout my artistic life of making and exhibiting art in the public realm, the critical response has consistently addressed my work as the product of "an African-American woman." I don't mind. I *am* an African-American woman. And I have in a sense created that public designation myself by the very fact that I've committed myself to exploring what it means to be African-American. But there are other equally important and integral aspects of myself and my work. This is the part of me that sees in the particulars of any one life a concentration of feelings and experiences that are common to everyone—hopes and desires, the blurred boundaries of private and public, the hidden and the revealed, the known and unknown, the obscure and transparent.

I have focused on the local, on specific and lived experiences, and on collective memory. I make sculptures and installations that find and define the territories of understanding between objects and environment, objects and memory, memory and experience. Early in my career two main areas of interest or modes of interpretation emerged. First was exploring my notions of objects, experience, and memory in terms of self and history. I draw out as many symbolic meanings as possible to create new ones and to commingle the past and the present. The second interest is my desire to open up a broader domain of perceptual experience not tied to any specific historical or cultural referent, but rather generated by the pure sensory stimulation of light, color, and sound—the individual as perceiver and at the limits of our sensory perceptions.

Today my work reflects my idea that time and space are one. I look at the world slightly askew, from a different perspective. An object, whether found or manufactured, is a medium for me—as artistic material and as an interceding presence between this physical world and other realms of meaning and perception.

Chasing Beauty, 2002. Assemblage, cast plaster, and found objects; 23" x 14.5" x 11.25". *Photograph courtesy of Susan Byrne.*
I use found objects and fragments of objects—shoes, eggs, bottles, rocks—as emblematic references.

Skillet to the Frying Pan, 2001. Assemblage, found objects; 48" x 14" x 14". *Photograph courtesy of Lewis Watts.*

Made in the USA, Blues, 2002. Assemblage, found objects, and painted silver; 12" x 20" 8". *Photograph courtesy of Susan Byrne.*

Using found and manufactured objects in art is like making a mark on a paper. That mark has a relationship to everything else around it, and everything around it has a relationship to that mark. This applies to painting as well as to installation, assemblage, and collage. I attempt to question that mark in a deeper way.

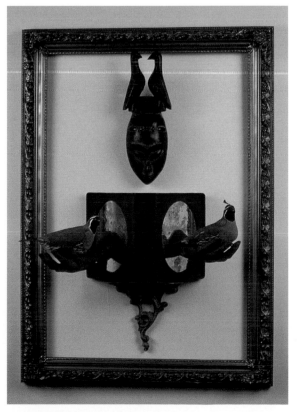

Do We Have the Right to Remain Silent, 2002. Assemblage, cast plaster, and found objects; 12" x 21" x 18". *Photograph courtesy of Lewis Watts.*

I want to stir people's emotion and make them question their beliefs.

That Which Lies Between the Mask and the Mirror, 2002. Assemblage, cast plaster, mounted bird, and found objects; 40" x 30" x 10". *Photograph courtesy of Susan Byrne.*

89

David Ireland
Gallery Paule Anglim, San Francisco

Photograph courtesy of Elisa Cicinelli.

The artist holding *Dumbball Action*, an ongoing series started in 1978.

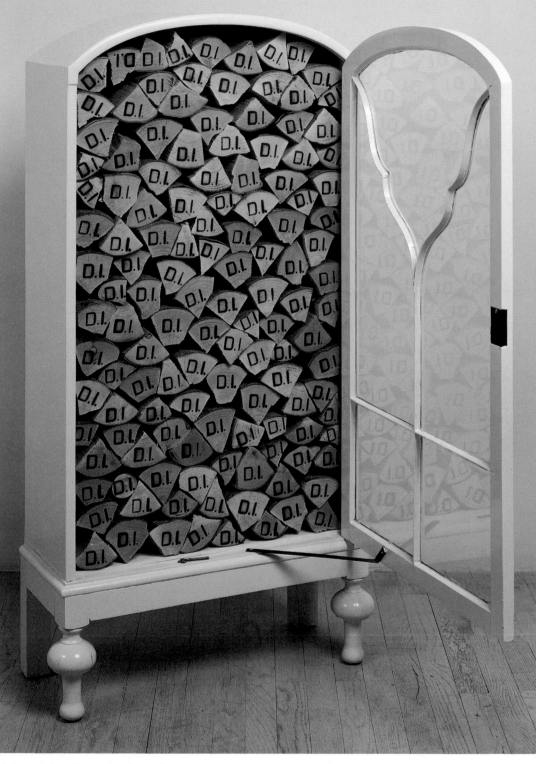

Other, Other Ego with Open Door, 1993. Alderwood, enameled wood, and glass cabinet, 50.25" x 24" x 32". *Private collection. Photograph courtesy of Gallery Paule Anglim.*
People already know everything, they just haven't thought of it yet.

It's a great titillation to have somebody walk by your work and *not* see it. It's like an astronaut in space without a tether. Maybe he won't get back, but if he does he's alive and a hero. To me, my art is all about flying free. We artists have traditionally been ones to go past boundaries. Advancement is about investigating and penetrating unknowns. Take Jackson Pollock: who would think someone dripping a glass of whiskey from one hand, an enamel from a can in the other would one day be regarded as one of the greatest artists of the twentieth century?

Some of my students say, "I can't be original any more. Everything has already been done." I say to myself that someday that student will do something that's entirely original. Every one of us has a private sensibility we bring into the world just by being born. Like our fingerprint or the sound of our voice. There is as much originality as there are people on the planet.

For me, I can't make art by making art. Making strictly visual and formal art has never been enough. Something has to inspire the work besides formal qualities, and I call that The Idea. I started off making art that I felt looked good. Its success was decided by whether it appealed in the same way to other people—or at least the people who told me they liked it. But then I began to ask, "How can I push this further to give it a reason for being?" The originality of an artwork is the *idea* of the artwork.

Art for me is an unending search for clarity. I don't know if I'll ever get there. My life is a big question for me. I think about it as a search for clarity.

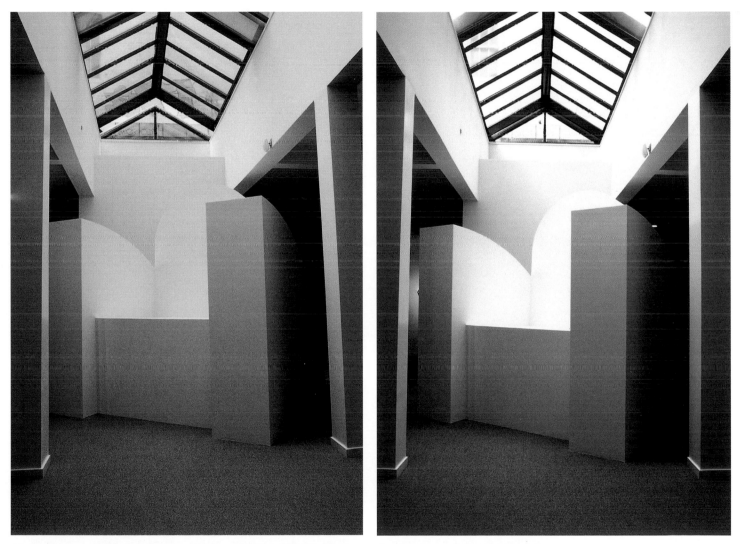

Ex Cathedra, 1998. Installation, 110" x 101.5" x 102.5". *Photographs courtesy of Joe Schopplein.*
Everything important has already been seen. We just don't always notice it.

Sherry Karver
Lisa Harris Gallery, Seattle

I knew as a child that I was an artist. The seed was sprouting as early as three or four. I got sidetracked by "career," but then one day when I was about twenty-two and working at the Chicago Heart Association, I realized the nine-to-five just wasn't me. I took a look at myself, quit the job, jumped onto the full speed locomotive of life as an artist, and never looked back.

I always work in a series. This is the only way I can evolve an idea. I start by taking hundreds of photographs, sometimes studying them for a year or more before they actually germinate into a single work. I go about my normal life, watching, waiting. I keep my eyes and ears open and do not search blindly for a congealing idea. The hard part is staying open enough and attentive enough to recognize the idea when it comes. It usually erupts out of something very simple like an ad in a magazine or a comment made by a friend.

Sometimes I look at a piece and it just "works" right then and there. I can't explain why. More often, though, it doesn't happen so easily. I continue to mess with the piece, always trying to improve it. I push the limits, which sometimes results in a total failure, but just as often launches a whole new exploration. If I simply can't resolve a piece to my satisfaction, I put it away, then haul it out several months later and mess with it some more.

Time Is on Our Side, 2002. Oil and computer-manipulated photo images with text, 60" x 48". Private collection. *Photograph courtesy of the artist and LewAllen Contemporary Gallery.*
Sometimes I add biographical text over some of the figures in an attempt to personalize or individualize the people. These brief stories are from my imagination, based solely on the figure's appearance or stance.

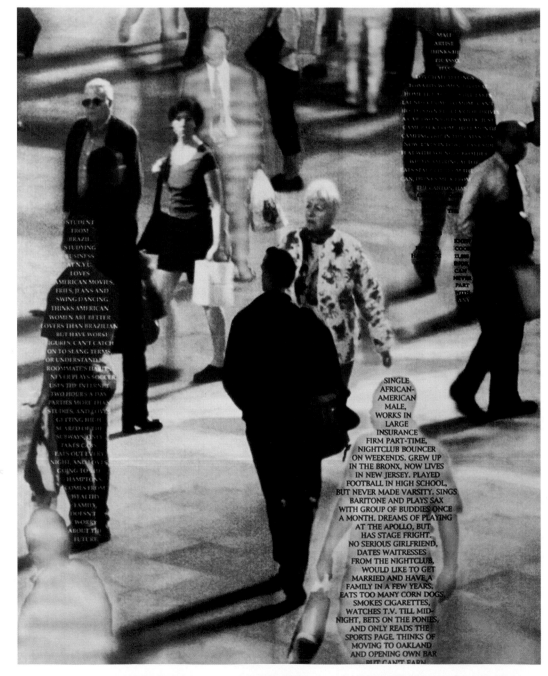

92

My imagery is figurative in nature, often in motion, conveying our individual voyages as people. The voyage is a metaphor for our journey through life—a journey in which we are collectively alone. I could never define that in words, but my pictures do it instantly. The current series of photo-based oil paintings originated from photographs I took at New York's Grand Central Station. I use the non-linear approach to time, with its random, spontaneous occurrences, rather than the traditional fixed-moment of photography. This captures our movement through time, in search of our personal identity, and underscores the loneliness and alienation of our warp-speed society.

Taking It For Granted, 2002. Oil and computer-manipulated photo images, 48" x 72". Private collection. *Courtesy of the artist.*
I took this photograph before 9/11, but the image didn't motivate me at all to create it into a painting until afterwards, when I was struck by the calmness, naïveté, and literal innocence of the people in the photo.

Tunnel Vision, 2003. Oil and computer-manipulated photo images, 30" x 60". *Courtesy of the artist and Lisa Harris Gallery.*
I combine the documentary photograph with digital manipulation, and the Old Masters' use of oil glazing for color. Although the pieces use figurative imagery, they do not fit into any traditional photography or present-day digital style.

Before the Loss of Innocence, 2002. Oil and computer-manipulated photo images, 48" x 72". Private collection. *Courtesy of the artist and LewAllen Contemporary Gallery.*
My work does not neatly fit into any particular school or category. Which is both good and bad. I blur the boundaries of traditional painting, photography, and computer art to create a new parameter, a new format.

93

Michael Kenna
Stephen Wirtz Gallery, San Francisco

Nine Birds, Izumo Taisha, Honshu, Japan, 2001. Sepia toned silver gelatin print, 8.24" x 7.5".

The landscape of our planet, its ever-changing forms and infinite configurations, has been a constant source of inspiration. I believe that my task is to show up as much as possible, for I am truly confident that amazing visual happenings always await. In general I gravitate to quiet places, which I use as antidotes to our accelerating lives. I like to photograph traces of the past that are manifest in the present, places where coexistence between nature and humans have left memories and charged atmospheres. Sometimes I imagine a world parallel to the one we see, where every thought, word, and action is recorded and integrated into the essence of a place. Perhaps it already exists and we are unable to decode it. I hope that my work reflects my inner life, sensibilities, and preferences, and that it somehow contributes to this magnificent and puzzling place we like to call our world.

Biwa Lake Tree, Study 1, Omi, Honshu, Japan, 2001. Sepia toned silver gelatin print, 9.5" x 6". *All photographs courtesy of the artist and Stephen Wirtz Gallery.*

Ratcliffe Power Station, Study 31, Nottinghamshire, England,
1987. Sepia toned silver gelatin print, 8" x 10".

Wave, Scarborough, Yorkshire, England, 1981. Sepia toned silver gelatin print, 6" x 9".

Hung Liu
Rena Bransten Gallery, San Francisco

Interregnum, 2002. Oil on canvas, 96" x 114". *Courtesy of Rena Bransten Gallery, with photographs by Ben Blackwell.* The term "interregnum" suggests an interval of time between reigns, governments, or periods of history. Here, two decadent fairies of Qing Dynasty (the last dynasty) painting pass above, and look down upon, a group of naked, toiling, anonymous laborers painted in a dissolving Socialist-Realist style—like two ships of state passing, each oblivious to the other.

I turn old photographs into new paintings. The photographs I work from are usually of Chinese subjects from the 19th and 20th centuries, including images of young Chinese prostitutes posing for the camera, soldiers, famine and war refugees, children, Qing Dynasty courtesans, and laborers. In these images I am looking for the mythic pose beneath the historical figure—the elemental human conditions of working, eating, fleeing, dying, and posing.

I also weave passages of traditional Chinese art into my paintings, hoping to stir up their surfaces with stylistic contrasts and awaken a deeper sense of the cultural memory underlying the spectacle of modern Chinese history. Often from the "bird and flower" genre, ancient figures, or landscapes, these traditional motifs are, for me, like offerings to the subjects in the photographs, many of whom have been stripped of their heritage by the wars, famines, and ideologies of modernity—and who have been captured by one of its most powerful instruments,

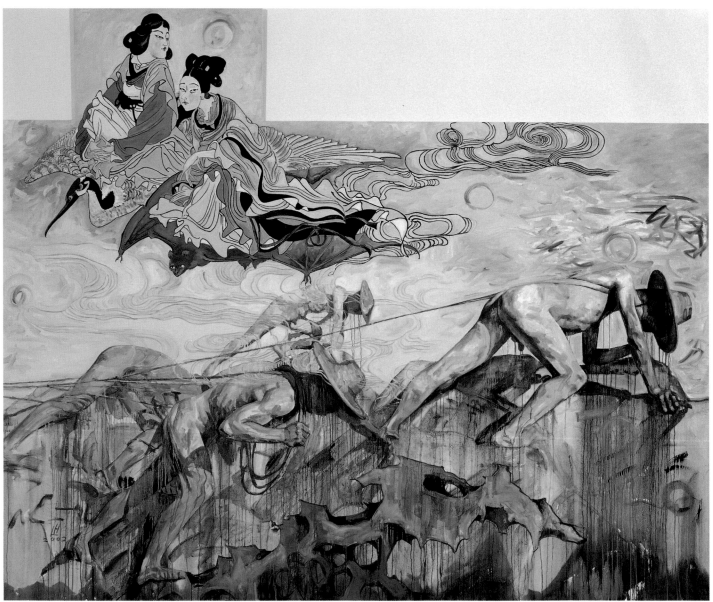

photography. In this sense, I often experience my paintings as memorial sites, shrines almost, awash in melancholy and underscored by lament, but whose subjects are rendered with the enduring dignity that paintings can provide.

As a painter, I want to preserve and destroy the image at the same time. The oil washes and drips that seep through my paintings contribute to this sense of loss while dissolving the historical authenticity of the photographs I paint from, opening them—I hope—to a slower, more reflective kind of looking. The photographs are back and white; the color in the paintings comes out of my head. Color is a way of making contact with subjects that are fading into the gray tones of history. Painting from archival photographs, especially ones that are hard to see, allows me to both discern and imagine the historical and personal narratives fixed in the photographic instant.

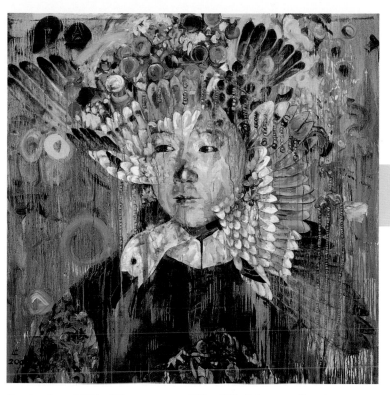

September, 2001. Oil on canvas, 66" x 66". *Private collection, Boise, Idaho.*
This image of a collision between a bird's body and a bride's face reflects my own psychic state in the days after the World Trade Center was destroyed. I felt we were suddenly wedded to a new era.

Dirge, 2002. Oil on canvas, 80" x 80". *Jeri L. Waxenberg Collection.*
A muse plays an ancient wooden instrument—a *qin*—as two woodcutters fell a large tree. She sings the song of the tree's end.

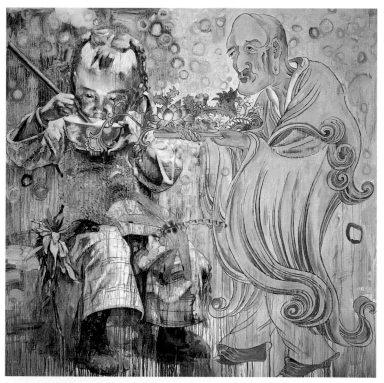

Tribute, 2002. Oil on canvas, 80" x 80". *Courtesy of Joel Straus, Washington Convention Center Authority Art Collection.*
In terms of the human figure, I work with mythical poses, like these of eating and offering. Though they come from specific photographs and paintings, they seem elemental to me in a profoundly human way—basic things we all do.

97

Cork Marcheschi
Braunstein/Quay Gallery, San Francisco

Photograph courtesy of Andrea Dance.

Mystery, magic, and humor seem to be my constant art companions. The mystery and the magic stem from experiences of being alive and having no real idea what's going on. (If the earth is round, am I standing right side up or upside down?) The humor represents the best moments in life. As Lord Buckley said, "When you are laughing your entire being is illuminated." I find this to be true!

In 1963 I was taking a survey Art History class. The professor was discussing Dada and described Kurt Schwitters "W" poem. Holding a large letter "W" above his head, he chanted the letter two hundred fifty times each time with a different intonation, then proclaimed it the greatest poem ever written! I saw the light and heard the horn. That was it for me. Something in this dada gesture made sense. I quit my classes in media and became an art major. This entry to the world of art through Dada and Futurism was wonderful. I became monastically involved in 20th century art history and the development of my own sculptural artwork. Many of the artists I admired were still alive and I carried on correspondence with them (Duchamp, Man Ray, Hans Richter, and the family of Luigi Russolo—Italian was my first language). This was a great time! I wanted to follow in the footsteps of my heroes. Armed with a romantic fervor and a head full of energy and light, I went for it!

For Max, 2001. Child's white pine chair, light bulbs, 18" x 9". *Collection of the artist. All photographs courtesy of the artist.*

98

Thirty-eight years later I am tired and thirty pounds heavier. I have learned to make what I want. There are several areas that I return to and expect to continue returning to them for as long as I work. With each cycle of exploration I find new stuff and frequently it makes me laugh. My artwork has always been involved with (real) energy/electricity. I intuitively came to the material and have developed a very personal relationship with it as a substance and as a metaphorical language. Using electricity and light allows the artwork's information to hit the pre-linguistic centers as well as the intellectual. Fire and light are primitive materials that all humans have a bred-in-the-bone understanding of. Electricity that is free from its bonds of servitude is a very pure, completely logical, substance that is at one moment both substantive and immaterial. This slippery state of being makes energy an excellent metaphorical material.

Andrea's Home! 2002. Plywood, transformers, gas flasks, glass plate; 86" dia x 12" deep. *Private collection, Berlin, Germany.*

New JuJu, 2002. Radio frequency and neon bulbs on wooden box. 20" x 6". *Private collection, Kansas City.*

Jelly's, 2002. Blown glass vessels filled with rare gases and illuminated with radio frequency, dimensions variable. *Collection Monterey Bay Aquarium.*

99

Barry McGee
Gallery Paule Anglim, San Francisco

Untitled #20, 2002. Paint (mixed media) on wood panel, 55" x 48". *All photographs courtesy of Gallery Paule Anglim.*

Untitled #17, 2002. Paint (mixed media) on wood panel, 56" x 62".

Untitled #15, 2002. Paint (mixed media) on wood panel, 31.5" x 36".

Untitled Installation View, Gallery Paule Anglim, May 2–June 1, 2002.

Kevin Moore
HANG Gallery, San Francisco

Digital Bus II, 2001. Oil on canvas, 60" x 72". *Private collection. Photo courtesy of Don Felton.*
When you're walking around a city, nothing ever stands still. I'm interested in how much detail you need in order to "see" something.

Segment II, 2002. Oil on wood panel, 26" x 26". *Private collection. Photograph courtesy of the artist.*
This is an enlarged version of a panel from a multi-piece work titled *100 City Blocks* that I painted to explore the nuances of a painting within a painting.

Drawing and painting have always been a natural part of who I am, though I can't pinpoint a particular event in my life that spurred me on to painting. I do know that I began painting because it helped me to form an identity. Being a painter means that, at least in part, I know who I am.

A work usually begins as a digital photograph, which I then rework with PhotoShop. I enhance colors, crop the image, run various filters and sometimes completely distort and alter the image altogether. I compare working with PhotoShop to the more traditional studies in charcoal, except it is faster and more forgiving.

Once I'm satisfied with the image, I begin to work directly on the canvas, using the model on my monitor as a reference. I modify the colors and composition as the work proceeds to make sure the idea works as a painting. I know when to quit when the strokes that I apply become more destructive than constructive.

Process and content are intertwined for me. I adapt my style the best I can to fit my idea about a piece. I won't paint a large crowd of people the same way that I would a small portrait because the paintings are about very different concepts: One is about mass and loss of general identity, the other about intimacy and detail.

My paintings merge the way I see outwardly (with the eyes) and inwardly (with the feelings). My paintings are strongest and work best when both the personal and the universal meanings come across in them.

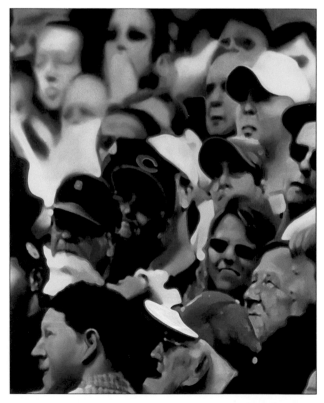

Blue Crowd, 2001. Oil on canvas, 60" x 48". *Collection of Ellena Ochoa and Ted Ridgway. Photo courtesy of Don Felton.*
I grew up in Africa, where I was never really exposed to large crowds of people. When I went to a Rolling Stones concert in Oakland a couple of years ago, I was so overwhelmed by the awareness of being an insignificant part of the masses I had to leave the concert.

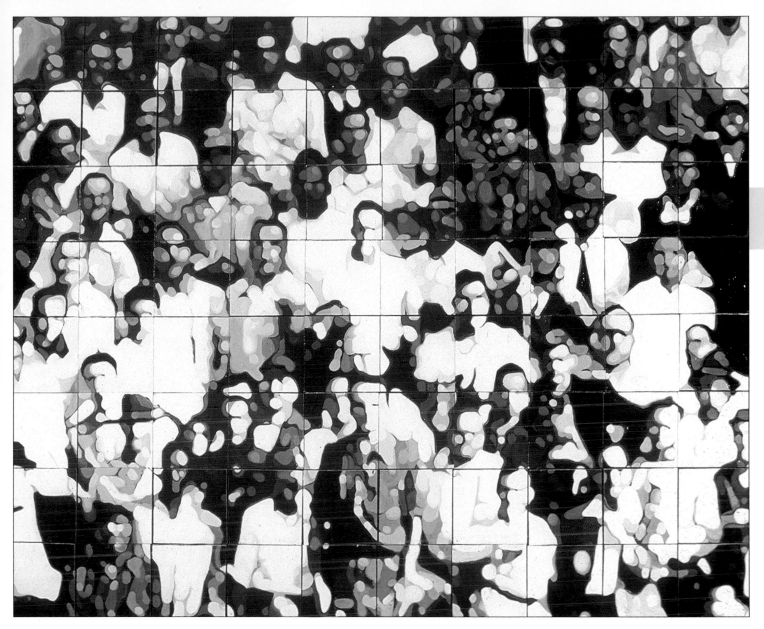

Congregation, 2002. Oil on canvas, 85.5" x 106". *Courtesy of Anthony S. Daffer, San Francisco. Photograph courtesy of the artist.*

A group of people attending a church service is called a congregation while the same group of people at an opera would be an audience or spectators at a baseball game. I am reflecting on the power of a name as well as the religious status of sports in our society.

Marie III (warped), 2001. Oil on canvas, 26" x 52". *Collection of Sandra and Steven Siino. Photograph courtesy of the artist.*

This painting is the third in a series of portraits I did of my wife's grandmother. The other two are carefully rendered photo-realistic images.

Ron Nagle
Rena Bransten Gallery, San Francisco

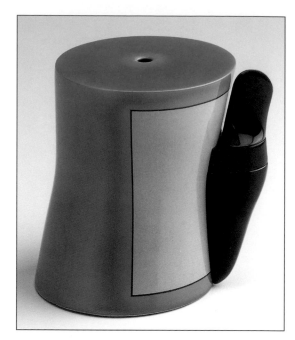

Buster's Last Stand, 2003. **Earthenware and overglaze, 4.5" x 4.75" x 3.7".**
Material, technique, time, and process have nothing to do with the real value of any work of art.

Ever since I was a child I have been making things like model airplanes and watch fobs made out of acorns. I always had a predilection for creating small objects.

My mother had a ceramics club in the basement and made ballerina figurines and Santa mugs. I learned slip casting and china painting from her. This was the hobbyist approach to ceramics. Then Peter Voulkos came along and presented an alternative, that pottery could be a format for expression of a different order.

I get ideas from nature, architecture, pop culture, other art, Japanese food presentation, and seventeenth century ceramics. I've tried to exploit various manifestations of the cup format. There is a ritual use to the cup, a ceremonial aspect, as in the Japanese tradition, that appeals to me.

Most of my work begins with rough drawings on small pieces of paper. From there, I try to capture the essence of the drawing three dimensionally, then apply color. A piece is done when it just feels right; it's completely intuitive.

I try to make vessels that have a balance between the clumsy and the refined. I'm trying to make a better pot, a different kind of vessel.

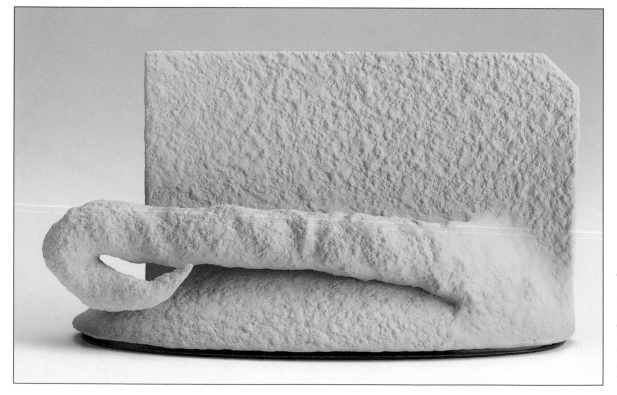

Lukington, 2002. **Earthenware and overglaze, 3.7" x 6" x 2.5".** *All photographs courtesy of Don Tuttle.* I have never had a clear thought about anything and I intend to keep it that way.

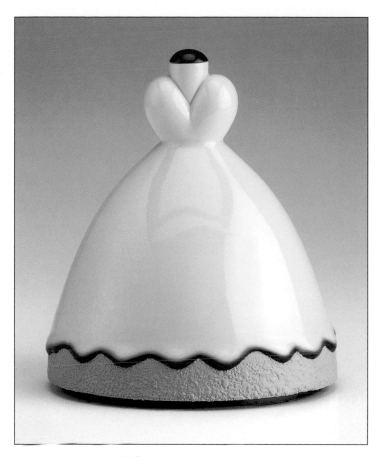

Related to Sadie, 2003. **Porcelain and overglaze, 6" x 5" x 4.5".**
I like people seeing different things in a piece. Some people see food, others sexual imagery. I like ambiguity. There is no master plan. I work intuitively.

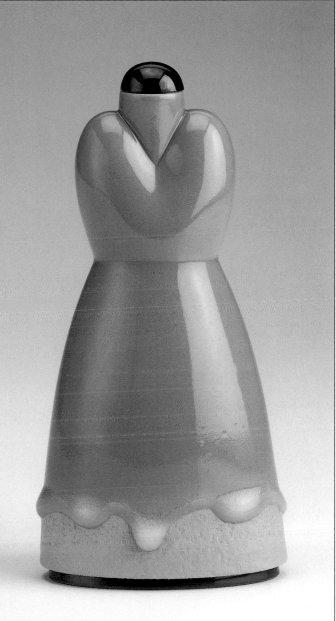

Swiss Mystic, 2002. **Porcelain and overglaze, 6.5" x 3.25" x 2.5".**

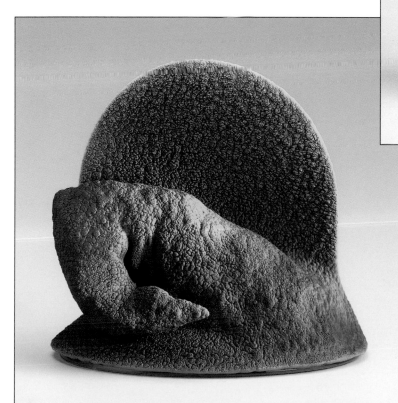

Fortgang, 2002. **Earthenware and overglaze, 4.5" x 5" x 3.75"**

Robert Ogata
Robert Ogata Studio

Photograph courtesy of Zandra Ogata.

As I have matured as a painter, my work, although not autobiographical, has become more personal. Growing up in a Japanese-American family, I was exposed to certain aesthetics, a sensibility about restraint and order. I now realize that these aesthetic values have had a profound effect on me. At the same time, I do not consider myself an "Asian" painter.

There is no clear definition for my work. Although elements or illusions of form are sometimes present, they are often not apparent to the viewer. I develop ideas through preliminary drawings and small studies and because I usually work in a series, certain elements are often carried over from one work to the next. The large format I prefer forces me to explore new directions, non-traditional tools, and new methods of paint application. Marks may be made and obliterated as the surface builds up by layering and scraping. I explore the gestural act of painting and owe a debt to Abstract Expressionism, but I do not necessarily adhere to the thinking of that era.

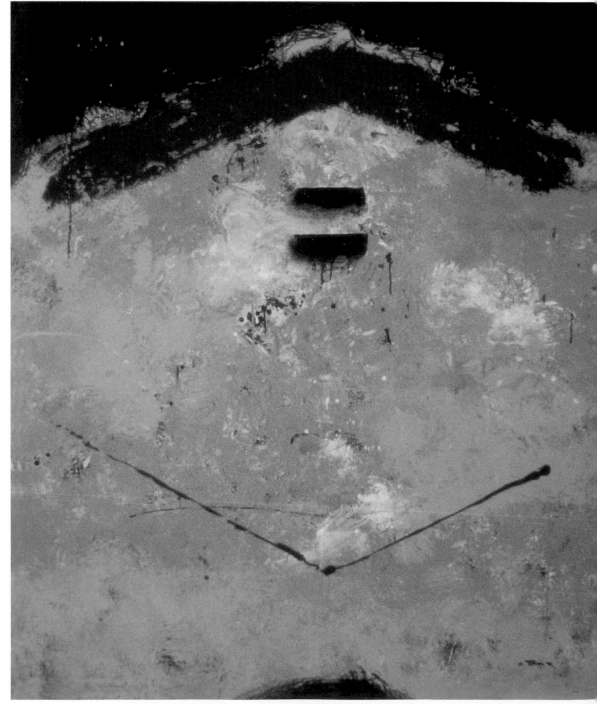

Kabuto 9, 2002. Oil on canvas, 66" x 56". *All photographs courtesy of Zandra Ogata.*

I collect visual information. Images often come to me from things I see for the first time, or from a familiar thing I suddenly see in a new way. The transformation of an idea occurs through the physical act of painting, even though the original information becomes invisible to the viewer.

The environment of my studio gives me a private world for study and contemplation. It is the only space in my life I do not have to share. This concentration sharpens the dialog that takes place between the work and myself. Success is not about the sale of paintings, but the ability to find solutions to the visual problems that arise in completing a painting. Ultimately, I want viewers to understand the mental and physical process I am engaged in when I paint, to experience the questions I ask myself and the decisions I make. In doing so, they become participants in the creative act.

Red Bank 16, 2002. Oil on canvas, 66" x 72".
Art should provoke thought. It is a personal relationship between the work and the viewer. It can offer a clearer perspective on a subject, but also can evoke feelings of ambiguity. Very important to me is that art can take viewers into sublime levels of understanding or provoke new areas of discomfort.

Cipher 14, 2002. Oil on canvas, 66" x 72".
Owning an original painting should be a stimulating experience. Living with that painting on a daily basis would ideally sensitize that person to "see" art in other aspects of life.

Deborah Oropallo
Stephen Wirtz Gallery, San Francisco

To have original, extraordinary, and perhaps even immortal ideas, one has to isolate oneself from the world for a few moments so completely that the most commonplace happenings appear to be new and unfamiliar, and in this way reveal their true essence.
—Shopenhauer

Ultramarine, 2003. Oil, wax, pigmented digital print on canvas, 54" x 56" (edition of 3). *All photographs courtesy of Ben Blackwell and Stephen Wirtz Gallery.*

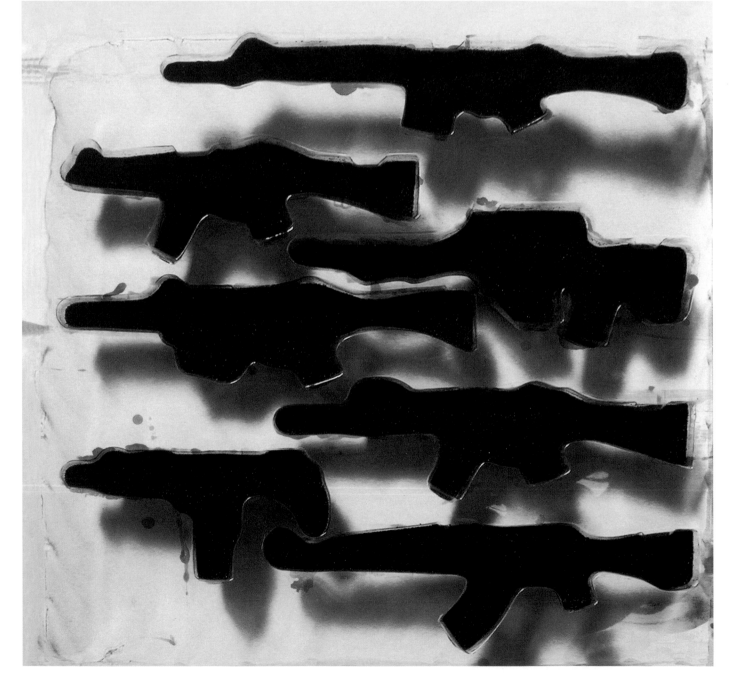

I have always thought that art is primarily about just looking. It is about curiosity, childhood, and observation. Art can change how you see the things you know. For me it is also about the meaning of objects. I am mostly finding things more than I am creating anything. The objects I have been currently using, such as children's toys, have a kind of fact that is better than fiction. As these items lay around the house, I sometimes alter them slightly before I begin photographing them. In the past three years I have partially moved away from painting with a brush to painting with digital media. For me, this unites the possibilities of traditional painting with the reproductive aspects of photography. This process blurs the boundaries of these mediums, and gives me a newer range of freedom. The challenge within the tradition of painting is to derive contemporary meaning through the fusion of hand and mind, critical thinking as well as the use of common imagery and technology, to create something of measure or inspirational value. And like the part of art that is inexhaustible, brings the viewer into closer contact those things and with ourselves, without really defining anything.

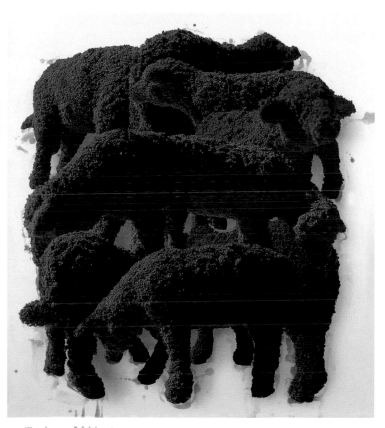

Topiary, 2003. Oil, wax, pigmented digital print on canvas, 65" x 58" (edition of 3).

Picture Frame, 2003. Oil, wax, pigmented digital print on canvas, 66" x 54" (edition of 3).

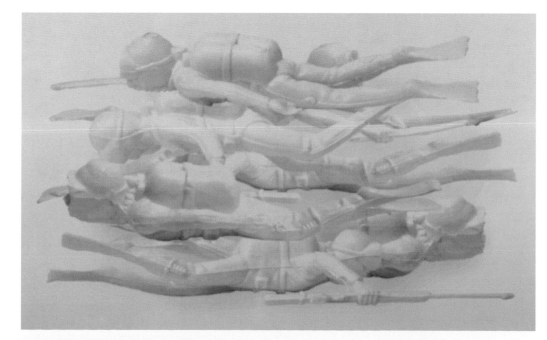

Diverge, 2003. Oil, wax, pigmented digital print on canvas, 54" x 90" (edition of 3).

109

Ed Osborn
Catharine Clark Gallery, San Francisco

In the last few years, my work in sound art has moved in several directions. Most are installation pieces, though I also have made works for performance, radio, and more recently, video and the internet.

The typical sound installation combines motion and sound into a tangible physical presence that seems or-ganic in nature. In *Flying Machines* (2001) and *Recoil* (1999), sculptural objects that resemble aberrant animals move and generate sound concurrently, their actions appearing to derive from a system of internal logic. *Recoil* incorporates motion sensors that are themselves set into motion by a system of motors, flexible supports, and counterweights. As the sensors move they generate sound signals that correspond to the velocities and vectors of the movement. The result is sounds tightly matched to motion. The signals are amplified through a set of floor-mounted speakers placed near the sensors. Hence even the movements of the speaker cones have an effect on the sounds produced.

Other pieces explore physical space in various ways. In *Vanishing Point* (2001), a set of windows at the Berke-ley Art Museum was used as a physical and conceptual framework to generate sound that moved through both the exhibition space and the area outside the museum. The work articulated the space of the building by vibrat-ing the glass in the windows, which turned the entire museum façade into a monumental sound system.

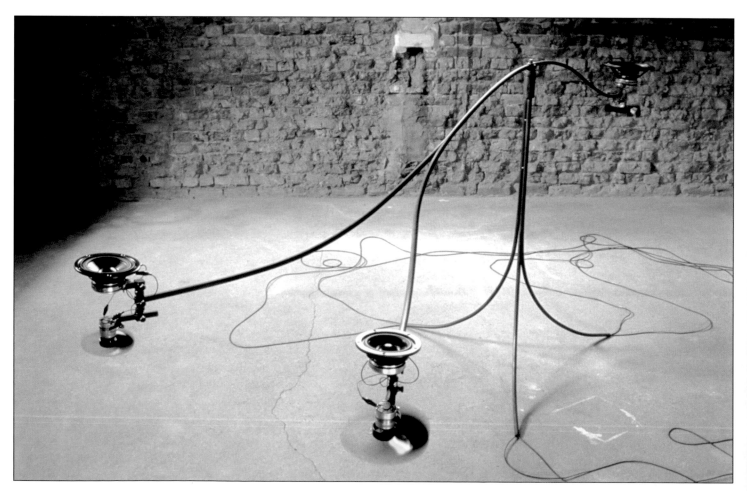

Flying Machine #3, 2001. Steel, electronics, and sound; 52" x 132" x 44". *Photograph courtesy of Roman Marz.*

The *Flying Machines* are studies in gentle motion and organic tones. The pieces are large steel mobiles with delicately balanced arms. At the ends of these arms are speakers with spinning fans suspended below them. The sounds generated by the pieces are derived from heavily processed recordings of voices. Placed in conjunction with the mobiles, the sounds lend them the character of large animals idling. Over time these machines reveal complex and subtly shifting patterns of movement and sound.

The physicality of sound in space is further explored in *Nordmaschine* (2001). A darkened room is shaped and resonated with a slowly-shifting terrain of sound and light. The resonant frequencies of the room and its materials gradually emerge and recede, producing changes in the sound. The piece is a set of evolving energy fields around the listener in which space, energy, and meditative awareness all converge.

I think of most of my pieces as systems that use sound to articulate, define, and shape the behavior of the system. The materials and their configurations in each piece are designed to be functional, minimal, efficient. The only materials in any system are those needed to construct it.

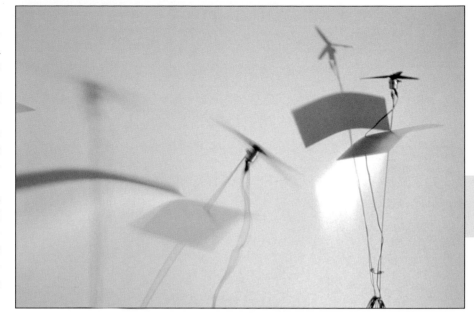

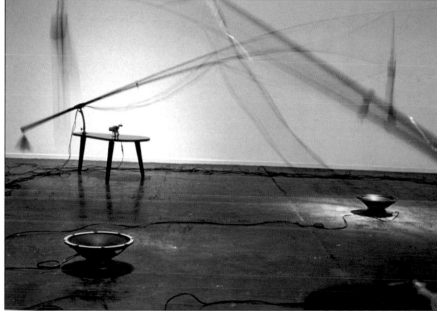

Tall Poppies, 2002. **Mixed media, custom electronics, and sound; dimensions variable.** *Photograph courtesy of the artist and Catharine Clark Gallery.*
In *Tall Poppies*, a set of unbalanced propellers attached via small motors to the tops of slender stands spin intermittently. They go into an unsteady oscillation that causes them to fluctuate uneasily. This is visually and sonically amplified through resonating metal pieces attached to the stands.

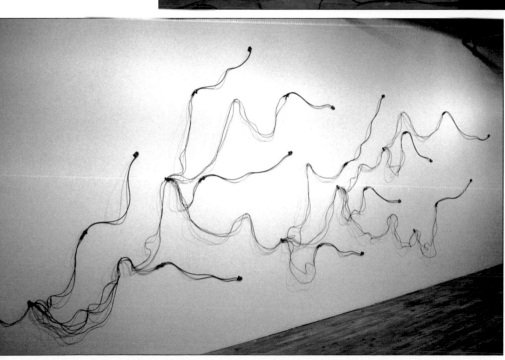

Recoil, 1999. **Mixed media and sound, dimensions variable.** *Photograph courtesy of the artist and Catharine Clark Gallery.*
Recoil is a delicate feedback system that is silent at rest but seemingly comes to life to produce chaotic visual and auditory oscillation when the piece is set into motion.

Left:
Night Sea Music, 1998. **Mixed media and sound, dimensions variable.** *Collection of the San Francisco Museum of Modern Art, San Francisco.*
Night-Sea Music simulates a living biological system that crawls blindly along a wall, singing as it moves. Made from small motors, rubber hoses, and bare music boxes, it is simultaneously playful and creepy.

Roland Petersen
Hackett-Freedman Gallery, San Francisco

I want people who look at my work to say, "There is more to this than meets the eye."

Because there is. The imagery someone sees in a painting tells much about how the person perceives. My message is about timeless feelings glimpsed through image relationships, glimpsed as though the images are a thin veil. I want the viewer to sense and respond to that. So I intentionally create tensions between figures, still-

Figure in a Landscape, 1966. Oil on canvas, 34" x 36". *Private collection. All photographs courtesy of John Wilson White.*
Some people consider my style part of the Bay Area Figurative group. I really don't think I belong to that school. I do use figures, but the concept underlying them, and the situations they are placed in, is more geometric. I feel that my work is better described as Abstract Realism, although technically, my approach follows the Hofmann school.

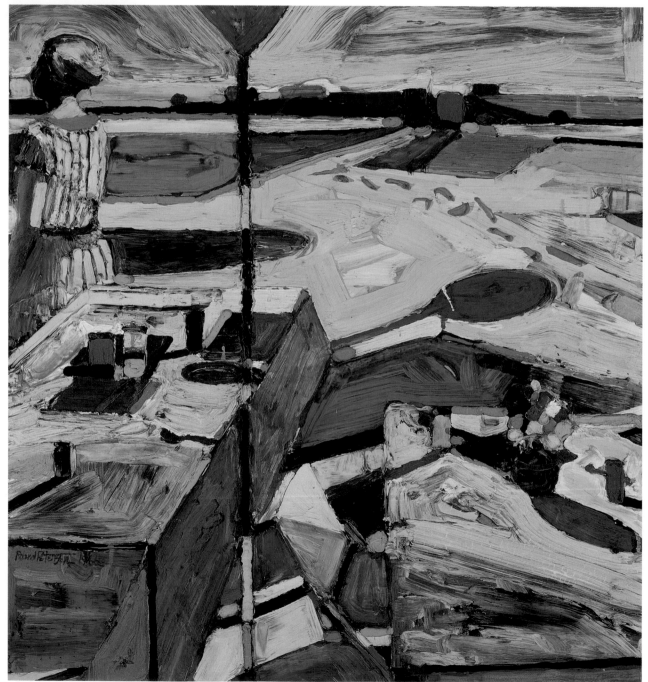

lifes, and landscapes. I balance the forces of spatial tensions and color positions. I vary color sequences to convey a thematic rhythm that constantly changes but is still tied to the work's primordial order.

The symbolic forms hidden in the shapes within a work reveal my own inner life. I paint from nature and my own daily life experiences, so in each work there are many different paintings one on top of the other on the same canvas. I decide the canvas is finished when the elements appear to merge together into a single unit.

I start a painting by making many sketches of a scene. I transfer the basic ideas of the most promising to a larger surface, and then onto a canvas. Then come the balancing of dark and light and the abstraction of shapes. After this I introduce the color rhythms.

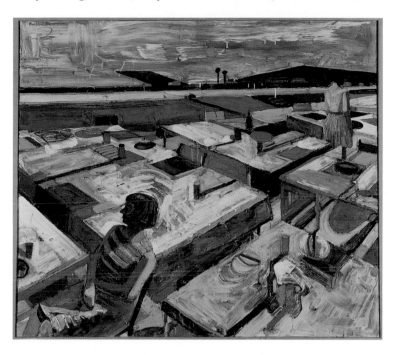

Two Figures in Space with Tables, 1966. Oil on canvas, 60" x 68". *Collection of John Boccardo and J. R. Roberts.*
Recognition encourages me to continue painting, become a better examiner of life as I experience it.

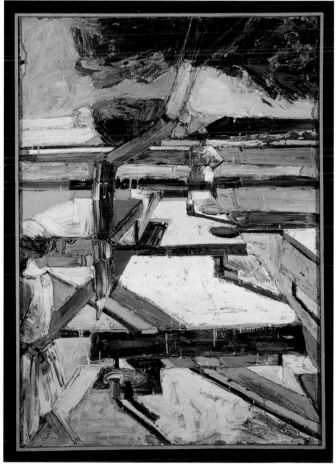

Picnic for Two, 1965. Oil on canvas, 68" x 48". *Courtesy of The Glass Collection.*

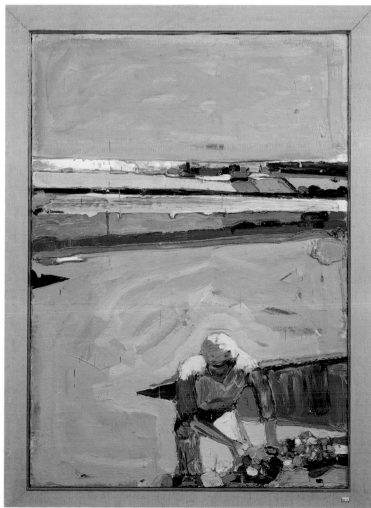

Girl Picking Flowers, 1964. Oil on canvas, 40" x 28". *Courtesy of Hackett-Freedman Gallery.*
The term "great art" is a mystery to me. How can anyone possibly understand all the difficult work it takes to achieve something summed up in a single word called "great?"

113

Nathaniel Price
Toomey–Tourell Gallery, San Francisco

A psychologist once said to a troubled child, "Which would you rather do: come to the office, sit down, and talk about yourself and your difficulties, or, come to the office and build things out of matches and popsicle sticks and set them on fire."

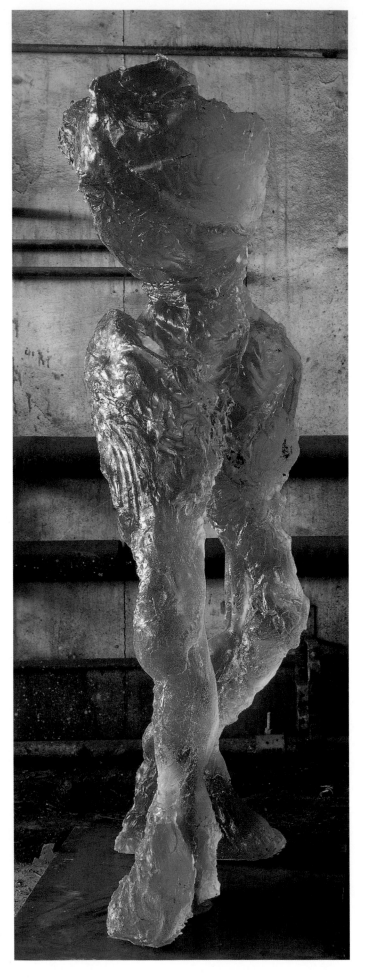

Walking Shadow II: Amber, 1998–2000. Resin, steel, and pigment; 70" x 24" x 24". *Collection of the artist. Photograph courtesy of Jay Jones.*

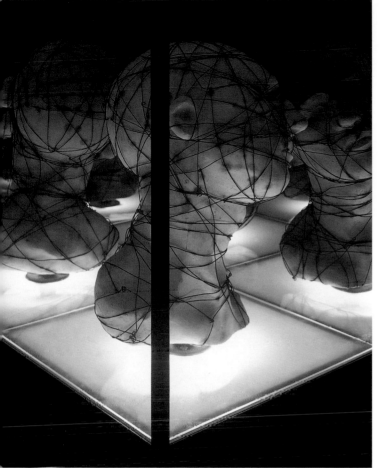

Identity Box IV: Bound, 2000. Cast stone, steel, glass, and wood; 72" x 20" x 20". *Collection of the artist. Photograph courtesy of Don Felton.*

Blue Indecision 1 between 2x2, 1999. Hydrastone, steel, and paint; 18" x 14" x 14". *Works #1-4 collection of the Skytt Family; work #5 collection of the artist. Photograph courtesy of Don Felton.*

Here the subject is that choices are often difficult for me. Knowing that the outcomes from such choices are often similar to each other makes them humorous, serious, and pathetic.

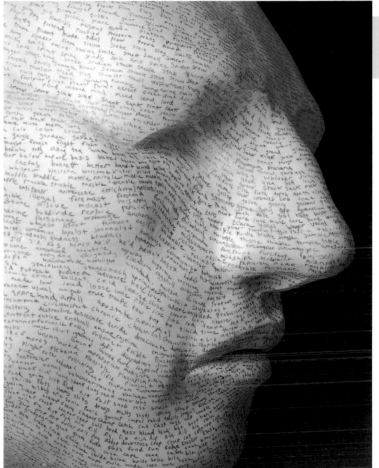

Identity Box 1: Noise (detail), 2000. Cast stone, pencil, glass, steel, and wood, 72" x 20" x 20". Collection of the artist. Photograph courtesy of Don Felton Photography.

Alan Rath
Haines Gallery, San Francisco

I remember sitting on the floor, before I ever went to school, studying the kitchen clock that hung high on the wall. I had observed the hands in different positions on different occasions and concluded that they must move. I sat still and watched carefully until I could see the big hand move while I stared. It moved by itself, ever so slowly. I was amazed—it moved by itself, but it was not alive. My introduction to automata was made by the historically earliest automaton, the clock. My pet goldfish moved too, but who cared? Animals are supposed to move.

Later, at age five, I performed my first electrical experiment: I stuck a hairpin into an electrical outlet. It wasn't clear to me exactly what happened, but the brilliant flash of light and loud *pop* certainly indicated that a large amount of energy was lurking in that outlet waiting to be released.

This was the mid sixties and soon Jimi Hendrix and others would demonstrate how electrons could be employed for art. At the same time, computers had not yet been domesticated. They were gargantuan, exotic beasts caged in air-conditioned cells with expensive, raised floors. I intuited that these machines were different. I wanted to have one of my own. Then, in 1969, the greatest public art project of our era culminated with a step on the moon. It was art that had been enabled by computers and the electrons that circulated within.

About this time I began my friendship with the electrons. It is a most abstract relationship since they defy direct observation. One can only construct ever more extensive jungle gyms for their amusement. Each sculpture is a new landscape waiting for billions of electrons to discover its various paths.

Creature, 2001. Aluminum, steel, PVC, rubber, electronics, software, motor, LCD; 26" x 12" x 13". *Collection of di Rosa Preserve, Napa, CA. Photograph courtesy of Ben Blackwell.*
I never considered building a sculpture that just sits there.

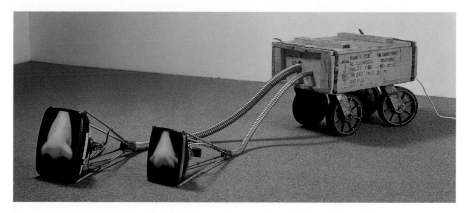

Hound, 1990. Wood, steel, aluminum, electronics, CRTs; 18" x 76" x 20". *Photograph courtesy of Lee Fatherree. Collection of Walker Art Center, Minneapolis, MN.*
Machines might not be as visually biased as humans; maybe they have extremely well developed olfactory sensitivity.

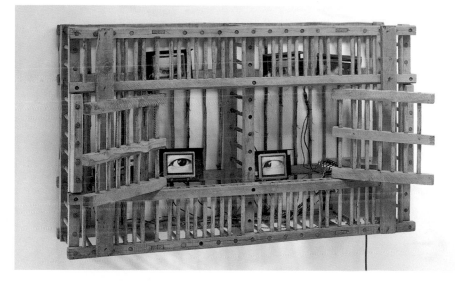

When Is Now, 2001. Wood, aluminum, electronics, LCDs; 27" x 46" x 18". *Collection of de Young Museum, San Francisco. Photograph courtesy of Ben Blackwell.*
The doors are open.

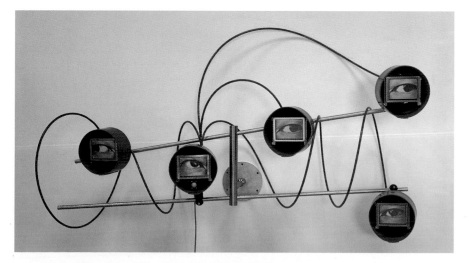

Eyeris III, 2002. Stainless steel, aluminum, PVC, polyethylene, delrin, rubber, software, LCDs; 40" x 72" x 22". *Photograph courtesy of George Tillmann.*
Five birds, the score of their music, and the oscillogram of their sounds.

Rex Ray
Michael Martin Galleries, San Francisco

I'm as well known for my commercial design as for my fine art. My collage work began as something directly opposite to my design work, play even. I wanted to free myself from the brutal editing process I must put myself through for commercial design. With my collages, I don't think very much about composition or form and balance. I simply make them. Whether I am in the mood or not, whether they were good or bad, I spend a few hours every night cutting and pasting, assembling collages. Surprisingly, it was through the failures—the troublesome compositions—that I began to see their endless possibilities.

I usually begin by sifting through piles of old magazines. I'll cut a section of a cloud that, when placed onto canvas, transcends its original glossy context. I take elements out of their original surroundings, reclaim them, redefine them with a careful snip of the scissors. A detail

On the Corner, 2000. Acrylic, oil, and paper on linen; 72" x 60". *Private collection.*

My creative process is meditative—printing and painting color fields and textures, visually scanning and snipping for hours, using scissors as a drawing tool, reconfiguring form and color and texture. All to turn disorganized pieces into effective, cohesive compositions.

from a highly conditioned mane of blond hair, patches of bare skin, textured upholstery, or the brightly hued backgrounds of any number of advertisements —all are reborn.

As I produced larger and larger pieces, I began producing my own source material, block printing and painting various papers, which I then cut up for collage. Because of the totally content-driven computer design work I do for a living, making these collages deeply appeals to me. They are not about ideas. They are about form and color. What started out as a simple exercise to loosen up and stop editing out of existence every creative impulse introduced me to a world of limitless possibilities. I glue a piece of paper down and then search for another shape, then glue that down, without planning ahead, without worrying in advance, without revising. The result is a body of work that gives me great freedom. When I realized that I was going to show these works, the editing process did creep in a little bit, so what started as a completely spontaneous process has become more self-conscious. But not much. It's still my freedom coming out.

Dolomite Loop, 2001. Acrylic, oil, and paper on linen; 60" x 36". *Private collection.*
Collage enables me to draw inspiration from many sources and, thanks to my obsessive nature, use it all. One might see references to the body, to nature, to early twentieth century modernist painters, to Fluxus and Dada, or to popular culture of the 1960s and 1970s. Viewers can read whatever they want into the work.

Tanaxacum, 2002. Acrylic, oil, and paper on linen; 60" x 68". *Private collection. All photographs courtesy of Stefan Kirkeby.*
People often mistake my collages for computer generated digital prints. In fact, they are precise and hand-made, yet bear the appearance of having been made by a computer program whose function is to produce visual pleasure.

119

Greg Rose
Hosfelt Gallery, San Francisco

Photograph courtesy of Siobhan McClure.

I look to nature for sublime experience, but instead of finding that experience in the mountains and streams of a pristine wilderness, I find it in the suburban neighborhoods of Southern California. Formalized nature—nature intended to produce an image of "nature," such as ikebana, bonsai, public and residential landscaping—appeals to me more than "real" nature. I'm attracted to the refinement that goes into making something "real" more ideal than it is in reality. "Natural Beauty"—not nature itself, but the aesthetic idea of nature—is something that humankind has invented for itself. I am in awe of that invention.

Cascade, 2000. Oil and alkyd on canvas over panel, 48.75" x 48.75". *Private collection, San Francisco. All photographs courtesy of Hosfelt Gallery.*
Landscaped nature is an attempt to recreate the Garden of Eden.

The multi-cultural diversity of Southern California is reflected in its accumulation of imported vegetation. A walk down any street in Los Angeles is like a visit to an international botanical garden. Flora from the world over can be seen flourishing in even an average front yard. It's all about being able to design and create your own personal paradise.

Long before I apply any paint to a canvas, I design the composition on a computer using Adobe PhotoShop, sourcing from images photocopied from old books on Japanese flower arranging, and photographs I have taken of people's front yards in and around my neighborhood. Once I have finalized the design, I print a hard copy and paint with the image as a guide. All of the marks in my paintings are made with stencils cut from masking tape. The paint is applied with a variety of tools that result in a wide range of surface values, from flat and smooth to thick and gestural, yet always with a manicured edge. As with formal landscaping, the relationship between chaos and order is refined into a picturesque image that suggests the idea of nature rather than nature itself.

Ikebana #42, 2001. Oil and alkyd on canvas over panel, 24.75" x 24.75".
My goal is to make work that is beautiful and ideal, not ironic.

Interlude, 2002. Oil and alkyd on canvas over panel, 48.75" x 48.75".

Morning Promenade, 2000. Oil and alkyd on canvas over panel, 48.75" x 48.75".
I think of my work as a confluence of the Hudson River, the Yangtze River, and the L.A. River.

121

Catherine Ryan
HANG, San Francisco

I want people to react from their gut. I want my paintings to provide a visceral experience in which the viewer experiences a sense of familiarity and un-easiness. I also want people to enjoy my work on a purely visual level. Aside from the initial excitement, recognition poses a challenge. On one hand it can spur motivation. On the other it can instill a fear of judgment and public failure, which can inhibit an artist's tendency to take risks. Ultimately it forces artists to examine why we make art: For ourselves or for the accolades?

Knowing when to stop is the easiest part of painting. I believe that this particular awareness is ninety-five percent of the artistic process. When I look at one of my paintings I just "know" when it is done. There is just a certain tension that I see in a finished work. Color, composition, and mood reach the perfect balance, and I take a last look and say, "Done."

The idea for my current body of work grew out of several things. I wanted to utilize imagery that had a universal appeal and could strike a chord with every person. I worked in a one-hour photo lab while I was in college and all day long I was staring at color negatives of people's family photos. The most striking things about those images were how similar everyone's were and how strange a color negative looks: the image becomes completely flat, the colors are wild, shadows pop out in front, and people's faces become gray and unrecognizable. They were the perfect subject to use to create paintings that were not only interesting from a color and compositional stand-point, but could draw such a range of emotions from the viewer. Family photos are such weighted images in the first place. They're frozen moments that remind people of events of their past, good and bad. My paintings jumped off from this point and were also inspired by several of my favorite painters who played with photographic imagery and the flattening of space: Mary Cassat, Gerhard Richter, and David Hockney.

One Girl, One Boy, One Drawing, 2002. Acrylic and charcoal on canvas, 48" x 24". *Collection of Stephen Fahringer. All photographs courtesy on Don Felton.*

The incomplete, sketched figure seated with the girl and boy is like a lost brother or sister. This painting reflects a fading memory of someone the way a real photograph never can.

Two Boys in Bed, 2001. Acrylic and charcoal on canvas, 36" x 48". *Private collection.*
The flattening of the wall and the blurred faces of the boys add tension to this piece. These elements keep the piece from being sentimental.

Below:
Two Boys, 2000. Acrylic and charcoal on canvas, 24" x 18". *Collection of Eileen Flaherty.*
My favorite things about this painting are the depth that I was able to achieve with the boys' faces and how the boys sink into their own shadows.

One Girl, 2001. Acrylic and charcoal on canvas, 30" x 24". *Collection of Lisa Kaplan.*
The glowing white of the dress makes the girl feel like a ghost.

123

Raymond Saunders
Stephen Wirtz Gallery, San Francisco

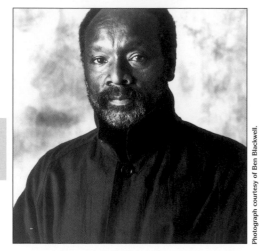

The language of seeing is sometimes not talking. When I speak what do I say? When I paint what do I say? And the audience, not myself, what do they say? Art for me is doing in totality of self and other. I don't like talking about it. And other people's art? I like looking, seeing and… whatever.

The following is from an interview with a first grade class in Oakland, California:

Where did you get the idea of the seven doors?*
Where are there seven doors?
I saw it in the museum…
I got *X* number of doors and then I had one and then I needed another one, and then I needed another one, and when it got to seven I thought probably that's enough!

*The seven doors are in a work that the Oakland Museum owns called *The Gift of Presence*.

Untitled, 1999. Mixed media on board, 96" x 48". *All photographs courtesy of Ben Blackwell and Stephen Wirtz Gallery.*

124

Untitled, 1999. Mixed media, collage on board, 78.75" x 48".

The Real Thing: Shazam, 1999. Mixed media on slate, 72" x 48".

Mother and Child, 1994. Mixed media on wood and tin, 70" x 70".

125

Mary Snowden
Braunstein/Quay Gallery, San Francisco

I want people's curiosity. Since my paintings are somewhat narrative, I hope viewers get something from the narrative, but also are curious enough to put something of their own into it.

I began painting as a young child in Pennsylvania. I was fortunate that I met a local artist, a woman who gave me some instruction. Because of her I fell in love with painting. She and I painted together for ten years.

I remember my first one-person show many years ago. I had looked forward to it *so* much. But once it went up I thought, "Is that all there is?" From that point on I realized that I painted because I loved doing it. I paint to communicate. Shows and attention aren't what sustain me.

Levittown, 2001. Painting on board, 84" x 60". *All photographs courtesy of Braunstein/ Quay Gallery.*

Art should go beyond entertainment. Art should touch people. It should challenge, prod, disturb, and provoke them.

My paintings started with an exploration of the role of women in the 1940s and 1950s—the decades I grew up in. As I got deeper into the topic, I became aware of the role women played, informing the consumer society and the subculture that continues to this day. I purposely use female comic book characters because they shed a particular light on that time. Orphan Annie is the most interesting because she was a complex, prophetic character. I see Annie as serving the same purpose as the chorus in a Greek tragedy. She echoes, reflects upon, and sometimes explains the situation to the viewer. She is an ambassador from the past, helping us connect the then and the now.

A painting usually starts with an image or character that I find in old magazines, Home Economics texts, illustrations from children's stories, history books, newspaper clippings, and photos that I take. The image suggests some narrative that intrigues me. I roll it over in my mind, often for several months. If I eventually feel committed to it, I start a painting. As the painting progresses the narrative usually becomes clearer and clearer to me. At some point I feel at one with what it is saying and I can't think of anything else that it needs.

I think I am responding to certain cultural realities—"The American Dream" and its ironies and contradictions. I am not interested in staying exclusively in the 1940s and 1950s, but in mixing time frames and making connections between the past and the present. I'm not specifically trying to get at my inner life. I hope my paintings resonate in some way with everyone's life.

Going on 4 O'clock, 2001. Acrylic, latex, and house paint on panel, 70" x 47".
I'm not trying to explore or project myself or a particular person. I have a theme that I'm exploring, which interests me because I like it, but the theme is not specifically about me.F

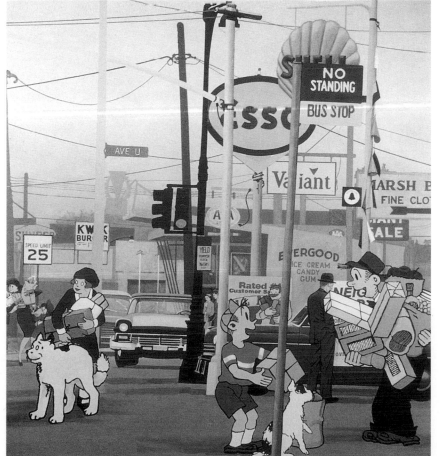

Avenue U, 2002. Acrylic, latex, and house paint on panel, 78" x 72".
Although my work is narrative, I work a lot on instinct. I search for something until it "clicks." Clear thinking isn't a factor. If anything, my work is just the opposite—strong feelings are looking for the right image.

Inez Storer
Catharine Clark Gallery, San Francisco

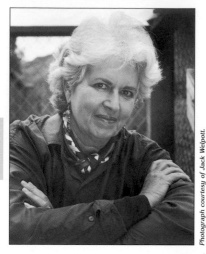

Being surprised while painting is the reason I keep going with it. Throughout my career I have worked two and three dimensionally, on paper, board, and canvas; and with found materials and oil paint. I approach my paintings by making marks. These marks suggest an idea which results in a painting.

My earliest memory of making things is pushing sticks into a sandbox at the age of three. Much later, at the University of California, Berkeley, I made stage sets for the *Mask and Dagger Review*. My images that refer to theatre and stage sets are, in part, rooted in working for the UC Berkeley theatre and owe something to my father's profession as a Hollywood art director.

In addition to the stage or proscenium presence in much of my work, there is often an aspect of implied history—a history that is suggested but did not necessarily happen. Objects and images enter my life from various places: my own repository from family, effects from my husband's family, or flea market finds. One of my favorite pastimes is

Having Savoire Faire, 2002.
Oil on canvas, 60" x 48".
Courtesy of the artist and Catharine Clark Gallery.
This work is a signature one in that it is a talisman for my interest in collecting cast-off and abandoned objects. A framed, found painting and other personal collections are housed on the dressing-table. In my paintings, images of tables and dressers, house toys, mementos, and personal articles.

Today's Art Lesson, 2002. Mixed media on canvas, 48" x 60". *Private collection, Kentfield, CA.*
I have recently been interested in lined backgrounds, sometimes horizontal, sometimes vertical. They serve as a decorative device while also making reference to my early childhood memories of art lessons.

Puzzling Aspects, 2002. Oil on canvas, 48" x 36". *Courtesy of the artist and Catharine Clark Gallery.*
In my paintings I love to embed references to mystery for which there may be no obvious explanation.

On Guard, 2000. Oil on board, 48" x 36". *Collection of Gerald and Sandra Eskin, Chicago, IL.*
I use references to juggling and circus acts as a metaphor for being on the edge emotionally or physically and for the act of having to multi-task and juggle life's responsibilities.

searching and acquiring cast off and abandoned objects. These objects, or facsimiles of them, become part of the subject matter, grist for new work. They also form part of my "studio" collection—an assortment of visual articles and images that I keep as source material for future paintings or which may become collaged onto my painting surfaces or sculptural assemblages. Looking through my collection of found material is like going shopping all over again. The experience of revisiting these objects inspires new stories and I create these stories to try and make sense of the objects. For this reason, I align myself with those artists interested in narrative. At times I even use found and invented texts to further the story line, to imply something without stating the obvious. In this way, real and invented histories are combined to result in a kind of historical fiction.

William Swanson
Heather Marx Gallery, San Francisco

Parks & Recreation (detail), 2000. Acrylic on canvas, 44" x 50". *Collection of Thomas Campbell. Photograph courtesy of Mark Farwell.*

Art is my love and my practice, a daily meditation, a routine. It is a place I go to test ideas and make real my visions.

Communications Array, 2002. Acrylic on canvas, 72" x 88". *Courtesy of Heather Marx Gallery. Photograph courtesy of John White.*

Being an artist is laden with failures. Some big, some small. I get nervous if I don't fail once in awhile. It is part of the process—a part that no one else sees unless they find out how many paintings actually go off the rails and never get back. For me this is part of the equation. To produce X number of paintings I will have Y number of flops.

Art can transcend everyday life, but the art that interests me most embraces life and its multitude of realities. My work tends to function on several levels. One is the familiar—the image that comes to your visual cortex like an old friend, or even just an acquaintance. Another level is an underlying or subconscious one—abstract patterning, thought processes, associations with multiple references, and so on. Still another is the unknown, the element of mystery, the thing that evokes questions of greater scope. There is no exotic profundity to this unknown. It can be as simple as the geometry I put into an organic landscape.

I like to present a hypothetical composite of the familiar and the imagined, a composite that can be approached from many vantages, which suggests modes of perception on the most basic levels, and provides an afterimage of the massed information streaming by in reality today.

Wildlife Preserve, 2002. Acrylic on panel, 23.5" x 39". *Collection of Heather and Sanjay Jain. Photograph courtesy of John White.*

Domestic Growth, 2002. Acrylic on canvas, 54" x 54". *JP Morgan Chase Art Collection, San Francisco. Photograph courtesy of John White.*

I more and more consider the viewer's stance as I develop a body of work. Reviews and being accepted by galleries, nominated for juried and curated shows, those confirm that what I do is accepted on levels that I respect. Being involved in the local art community continues to hold greater importance to my development as an artist.

I start a body of work by conceptualizing its format. The size, shape, and color palette dictate how I eventually arrive at the imagery. The first piece (or sometimes a piece finished earlier) usually sets the tone for a series, becomes the benchmark. Such a piece may ask questions of me and suggest directions for other paintings. If all goes well, each piece leads into the next, like a series of interconnected maps in a painted geography.

I have a pretty loose definition of my work. If someone desires to define my work, that definition is their view, whether or not I think it's right. The critic's role is to define images in the scope of their own experience and the circles of art criticism. The public knows the image is there simply to be experienced, without any layers of interpretation. I assume there will be a reaction or association in their mind that sparks a thought process. My work only suggests. It doesn't try to tell.

131

Kris Timken
Pulliam Deffenbaugh Gallery, Portland

Courtesy of Robin H. Reynolds.

I am drawn to photograph what can't be seen. I am fascinated with pinhole photography because I prefer its expressionistic quality. I began my experimentation by poking holes with various size needles into squares cut from disposable turkey basting pans, creating a "lens" with an "aperture." The smaller the hole the sharper the image.

I would tape these lenses onto various "cameras" that I made out of things like cigar boxes (thirteen lenses), cardboard oatmeal containers, breath mint tins, Easter egg containers, and so on. I started off using paper negatives instead of film so I could expose them individually. Then I would run to the darkroom and develop them quickly to see what the camera had captured.

The ability to get vignetting and distortion with the pinhole was very exciting. Eventually I refined the process

Pre Emergent, 2001. Iris print, 30" x 30". *All photographs courtesy of the artist.*
It is ironic that I photograph my images with the most primitive form of photography but print them using the most modern technology. I don't manipulate my work with a computer. It is all done in the camera.

by adapting a medium-format camera that enabled me to use roll film and take many images at a time. Because it was light-tight I was able to work with color film. Using this camera, I lost the distortions imposed by the convex shapes of my homemade cameras, but my real fascination was with the unlimited depth of field.

When I was working with the paper negatives, I had to make very long exposures, usually outdoors. I needed to find a way to stabilize the camera, so I would prop it between rocks in the grass. I became enthralled with the low bug-like perspective. This view really reflected how I felt in the world—small, vulnerable and somewhat hidden.

After ten years living in Oregon, I moved back to California and there the light became much more important to me. I planted a garden and began to photograph in color. The vibrancy of the color combined with the low, skyward view was a reflection of my awe, fascination—and some times fear—of all the beauty in the world. For the *Breathing In* series I bought some dried butterflies and learned how to pose them.

The final step is using advanced computer technology to print my work. Since I am also a print maker, I am drawn to beautiful paper. Photography paper has always been a barrier that held back my work. I now have the original C-print scanned into a computer and printed out using pigments or dyes onto printmaking paper. This creates a more painterly image that explodes with color.

Lost and Found #4, 2003. Pigment print, 40" x 40".
Over time I learned to predict much of what the camera can "see," but there is always an element of surprise. Even now, I can only guess about sixty percent of what will appear in the image. The rest is random chance. It is from this randomness that arises the exciting, transcendent piece.

Lost and Found #1, 2002. Pigment print, 40" x 40".
There is a scene in *The Wizard of Oz* where Dorothy opens the door of her house after it has crashed down in Munchkin land and she gasps in wonderment how her world goes from black and white into lush surreal beautiful color. That is how I feel when I make my work.

Lost and Found #2, 2002. Pigment print, 40" x 40".

Catherine Wagner
Stephen Wirtz Gallery, San Francisco

For over twenty years I have been observing contemporary culture. My process involves the investigation of what art critic David Bonetti calls "the systems people create, (in essence the human condition) of our love of order, our ambition to shape the world, the value we place on knowledge, and the tokens we display to express ourselves."

To this end, I have examined institutions of learning and knowledge, our homes, and all of the ways we display who we are, Disneyland, science labs including human genome research, and lastly, the structures that support art for museums.

Research generated by science produces new information that continually changes the course of humankind. The Human Genome Project invited some of the most powerful minds today to become the cartographers of our future. I ask the kind of questions asked by philosophers, artists, ethicists, architects, and social scientists. The questions revolve around one central theme: Who are we and who will we become? In the *Cross-Sections* series I have used the technology of the MRI to look into the structures of our bodies and of the objects we live with revealing visual microcosms that are otherwise invisible. I wondered what it might look like if I was to literally see through matter.

Definitely Not Sterile, 1995.
Gelatin silver print, 30" x 40".
All photographs courtesy of the artist and Stephen Wirtz Gallery.
I'm interested in the hyperrealism that photography allows. The photograph as a representation of the object allows for a new interpretation. In part, I choose photography as a medium as it is an appropriate tool to describe information.

Pomegranate Wall, 2000, from *Cross Sections*, San Jose Museum of Art, November 2001– January 2002. Installation view, backlit duratrans in curved arc, 8' x 40'.

I chose the pomegranate for its cellular looking structure as well as its cultural and historical reference. *Pomegranate Wall* is an 8' x 40' curved, illuminated wall, composed of backlit Duratrans images of the interior of a pomegranate digitally repeated thousands of times. The sequence of repeating images emulates the process of cell replication while acknowledging the fruits' corporeal symbolism. Seen at a distance, *Pomegranate Wall* evokes the experience of a first time visit to view the constellations at a planetarium. I am trying to reckon with the understanding of human development and the times in which we live.

Onion, 1998, Iris print, 10.24" x 44".

This image allows one to travel through the center of the onion. The spiral has been an archetype throughout art history but, here, is seen in a new light with the aid of the MRI, allowing one to see the cellular structure of the onion.

Alfred University, Science Classroom, Alfred, New York, 1987 from *American Classroom*. Gelatin silver print, 20" x 24".

The classroom experiments I photographed seemed to act as a model for much larger life issues. In this image, dead frogs float in a container of clear liquid formaldehyde, waiting for the college biology class to begin the study of life. The work in *American Classroom* as well as my current work asks questions about the construction of contemporary culture.

Darren Waterston
Haines Gallery, San Francisco

Photograph courtesy of Richard Barnes.

Painting has always been a form of meditation for me. It is a life long practice, a devotion that can be as frustrating as it is liberating. It is a point of entry; a portal into another state of consciousness. It is an experience and reminder of the inextricable link between the physical and the metaphysical. Art can be a way to articulate these phenomena.

Painting is also about alchemy. The transfiguration of matter and consciousness. Paint itself becomes charged with metaphor: cycles of rebirth and decay, negotiations of liquid and stone into gold, all things in a constant state of flux. An ongoing question that I continue to explore is, "How can these solids and fluids mingle on a canvas and express a state of being or actually induce or trigger a spiritual vibration?

In my earlier work there was often more concise representation, including references to landscape, natural forms and phenomena and the human or animal body. This approach required a certain amount of pre-meditation and a more conscious way of composing. In the last few years, figurative elements prominent in earlier paintings, have given way to abstraction. Organic shapes and patterned markings now form an

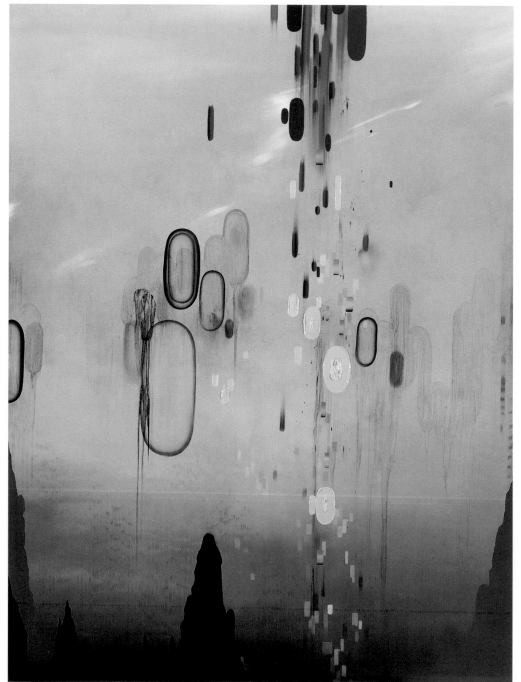

Linguistics, 2002. Oil on wood panel, 48" x 36". *Photograph courtesy of Ian Reeves.*

Some of my inspirations are the human body, Ernst Hackel, celestial charts, Rumi, botanical forms, Bjork, *Lepidopterai*, Matthias Grunwald's *Issenheim Altar,* Chinese landscape painting and calligraphy, Krishnamurti, Japanese woodblock prints, Frantisek Kupka, Buddhism, Ranier Maria Rilke, Phillip Glass, Beatrice Wood, and cloud formations.

Marvels (detail), 2000. Oil on wood panel, 72" x 48".
Private collection. Photograph courtesy of Boomer Jerritt.
The process involves shutting down the analytical brain, never working in secure knowledge, and loving the element of chance.

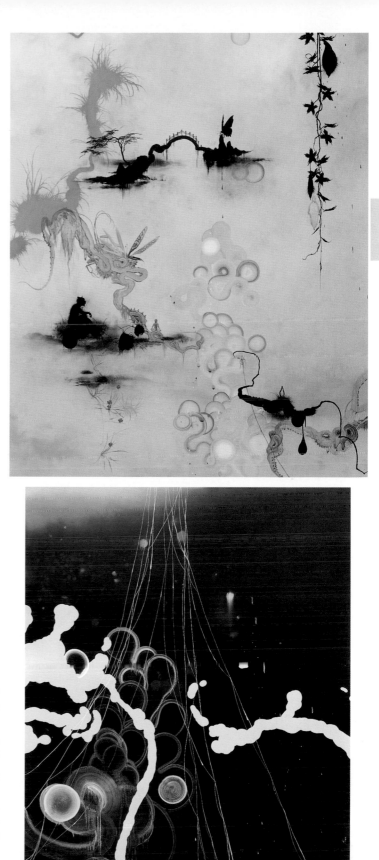

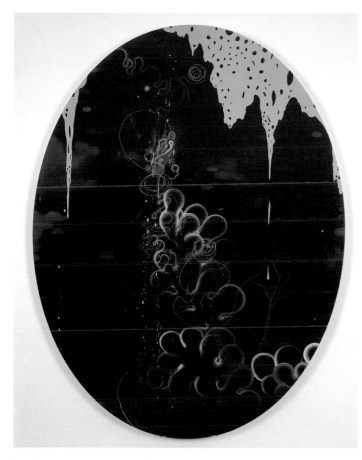

Body Nocturne, 2001. Oil on wood panel, 48" x 36" oval.
Photograph courtesy of Tony Cuñha.
The physical act of painting remains very mysterious to me. I find that paintings reveal themselves more to me than I do to them.

ever-shifting chain of associations, rather than a consistent symbology. Any specific reading of the paintings has become deliberately more ambiguous.

I begin each of the paintings with the same process of creating a pictorial space, often using several layers of paint, playing with both depth and flatness. The space created is open and unformed alluding at times to water, earth, air. At this point there is no set course. This requires letting go of any particular outcome, surrendering to my intuition as well as to the paint. I have to get out of my own way in order for this to happen.

I notice more and more that what goes on in the studio reflects itself in all areas of my life. The process of painting continues to teach me about how to live in a world where there are no absolutes, a state of incompleteness, about trusting and letting go.

Miracle, 2002. Oil on wood panel, 48" x 36". *Photograph courtesy of Ian Reeves.*
When people see my work, I want them to complete it. Only they can do that. I really don't want anything from them. Their own experience is unique to them.

William Wiley
Rena Bransten Gallery, San Francisco

& ... So... my art work... is it something I do on purpose, or does it just happen, if you (I) don't stop it? Some weird combination of both...

Everyone would be doing it if it didn't get editorialized out of you in the school system. Art?! What good (value) is that? Do something useful! I feel that a lack of creative imagination, in relationship to the world... and each other is our great suffering. Our dealings with our environment and other nations shows a distinct lack of creative imagination and empathy... as to my painting, drawing, music, etc. I try(?) to find a state of mind that will allow what seems to want to happen to happen, I try to stay out of the way and follow the impulse... as much as possible and not be afraid of serious humor.

What Beast is in the Middle Least, 2002. Acrylic and charcoal on canvas, 72.5" x 86.25". All works collection of the artist. *All photographs courtesy of Cesar Rubio.*

I sometimes describe the work as a mirror... and it is just reflecting through word and image... my response to and reflection of the world, its landscape, people, and events. (I also see that all of this explained as clearly and thoroughly as possible... still leaves it in mystery and enigma.) Given that I go on to say... most of the work has a witness who comments in word and image—who cajoles, threatens, and advises on current events and social and political situations and whatever the heart? soul? spirit seems to want to do... and reflect on mind, body, spirit, art, people, planet.

What hope do I have for the work or the viewer? It's hard, to be open to what's being offered or presented... to not be intimidated... or too quick to judge. I'm guilty of this I know... and often am not open to the gifts and proposals. If one can drop some of these attitudes and prejudices... some joy and learning happens. And one feels grateful... and that feeling of gratefulness is hard to beat... There is an art to it.

The Canister Under the Banister, 2002. Acrylic and charcoal on canvas, 31.5" x 37.5".

Time as a Daredevil & Two Abstractions, 2002. Acrylic, charcoal, and ink on canvas, 79.5" x 72".

And So Everyone on the Planet Now Is a Prisoner of War, 2002. Acrylic and charcoal on canvas, 60.5" x 61".

Masami Teraoka
**Catharine Clark Gallery,
San Francisco**

Region 3
Hawai'i

There is no rich life without art. Art helps people see themselves, see other people, see the world. It enables us to pass through life with hope.

Conceiving an idea is the fun part of creativity. A work or series evolves in a radius around me, depending on what I'm concerned with at a given moment in time. Social, cultural, and historical issues have always been the core of my visual thought. Each painting I've done reflects my thoughts, imagination, and interpretation of other people's views and philosophies. It is wonderful when viewers share my thought process and aesthetics. They can see how the two integrate to become a narrative.

Art is my life. It is the passion that inspires me to live. Being able to support myself with my art allows me to pursue my vision. I'm grateful for all the support I have received and all the people who have believed in my work.

Aids Series/Geisha and Ghost Cat, 1989/2002. Aquatint and sugar lift etching with direct gravure and spit bite printed from six copper plates in seventeen colors on hand-made Sekishu Kozo paper. Edition of 35. Plate and print size 27.5" x 19.75". *Printed by Paul Mullowney, published by Tokugenji Press, Japan. Courtesy of Masami Teraoka, Paul Mullowney, and Catharine Clark Gallery.*

In art, as in life, there is a fuzzy area where verbal communication stops and poetic expression begins. It is the poetic expression that makes art—and life—so uplifting.

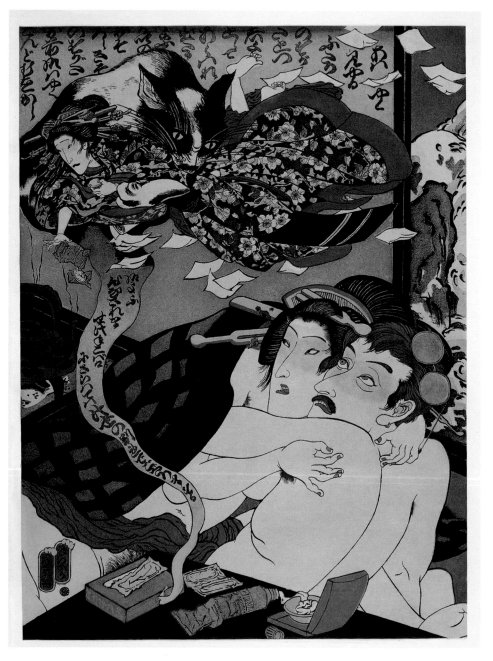

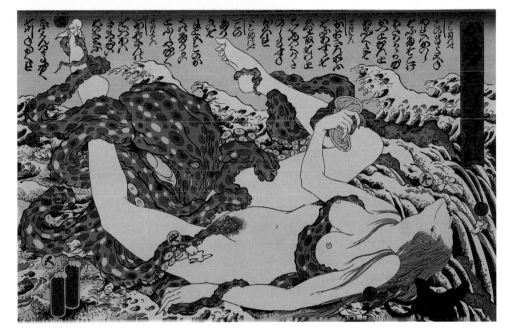

Cloning Eve/Viagra Falls, 1999. Oil on linen, 89" x 149.5". *Courtesy of Masami Teraoka and Catharine Clark Gallery.*

For me, the meaning of life is being continuously inspired.

Below:
Sarah and Octopus/Seventh Heaven, 2001. Original woodblock printed from 29 blocks in 29 colors on Hosho paper. Edition of 200. Paper and image size 10.35" x 15.65". Printed by Mr. Tadakatsu Takamizawa at the Ukiyo-e Research Center, Tokyo. *Courtesy of Masami Teraoka and Catharine Clark Gallery.*

A straightforward expression of my mental processes structures my work. The hidden unimaginable or unthinkable within myself continues to motivate me.

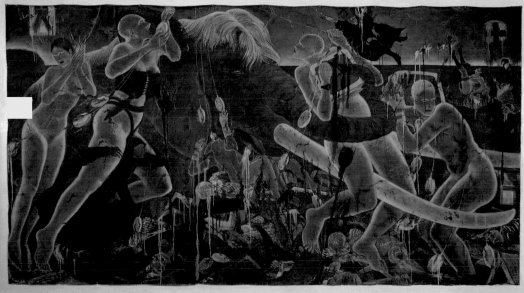

Above far left:
London Tube Series/Camden Eve, 1993. Watercolor on paper, mounted as a scroll; image size 87.5" x 42", scroll size 119.5" x 56.75". *Courtesy of Masami Teraoka and Catharine Clark Gallery.*

Adam and Eve/Web Site 2000, 1997/2003. Oil and watercolor on canvas, 83.5" x 152.6". *Courtesy of Masami Teraoka and Catharine Clark Gallery.*

141

Jay Backstrand
Laura Russo Gallery, Portland

Region 4
Oregon

I wake to sleep and take my waking slow,
I learn by going where I have to go.

These lines are from a poem by Theodore Roethke, *The Waking*. If there are any words that better express my current feelings about my art, I don't know what they would be.

The implication is acceptance of change and the risks that go with it. I have been an artist for over forty years and have been pushed and pulled by every shift in aesthetics during that time. Through all of those shifts, one thing did not change for me: my desire to do something more than just decorate. I have not always been able to define that "something" even to myself, but it has always been there.

My art has been a roller coaster ride. Often I have lost the thread and had to start over. Whether it is my age or simply a willingness to accept limitations, the work seems to come more easily and more consistently.

I draw my ideas from many sources—other artists' work, photographs, a line from a poem. I juxtapose, I layer. I respond to a color, a passage, a texture.

I have an artist friend who says, "I have to hallucinate in order to work." My interpretation of that is that I must be completely immersed in my work. My work is at its best for me when it fills my field of vision, the larger the better. I feel a physical engagement when that happens. It is a gift to be able to immerse yourself in work you love, with or without external reward.

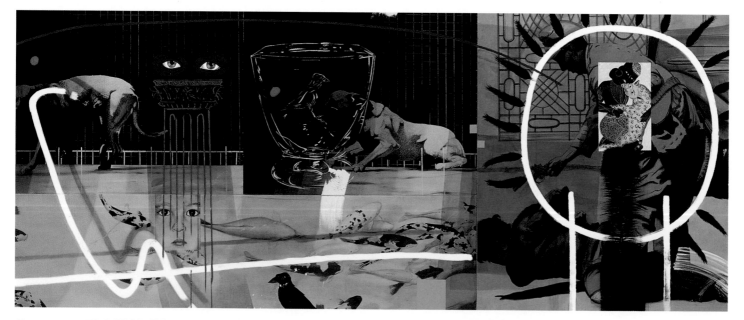

Transparent Bird, 2001. Oil on canvas, 78" x 186.5". *All photographs courtesy of Bill Bachhuber.*
A man being shot; a dog, alarmed, leaves the picture. A school of fish moves back across the picture plane. All are held in place by another layer of images—complimenting, contradicting, creating an epic tale of anxiety. Linear elements of saturated light create synaptic energy to make reasonable what is not.

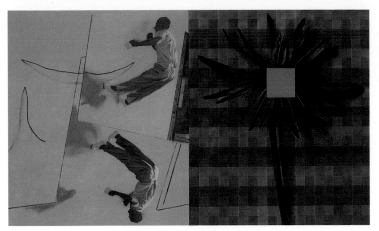

Wired, 2002. Oil on canvas, 71.5" x 119".
Parallels supporting and yet opposing each other, side by side, like right brain, left brain. Formal and informal, a dance of cognition.

Caffeine, 2002. Oil on canvas, 64" x 112".

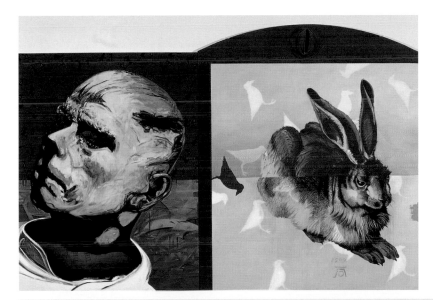

The Hare and the Hat, 2001. Mixed media, 92.5" x 138.8".
Homage to Joseph Beuys whose persona was fixed in my mind by a photograph taken of him seated on a wooden chair, his head covered with honey and gold leaf, holding a dead hare while giving a lecture on painting. Drawing from a small black and white photo of him and a beautiful reproduction of Albrecht Dürer's drawing of a hare, I have built a bigger than life image of a bigger than life persona with the raven as witness.

Oskar Had a Tin Drum, 2001. Mixed media, 90" x 181" x 11.75".

143

Michael Brophy
Laura Russo Gallery, Portland

Photograph courtesy of Bill Bachhuber.

I am a landscape painter—not of idealized nature but rather of landscape altered by human endeavor and filled with the by-products of westward expansion. I deal with the tensions of human-made things impacting on nature. This is a pretty broad subject and one could take it anywhere. In the 19th century, landscape painters like Albert Bierstadt felt that landscape painting was a pristine thing, remote from the activities of humans. Their work assumed a powerful moral authority because it was considered purer or better or higher.

The Beaver Trade, 2002. Oil on Canvas, 78" x 84". **All photographs courtesy of Bill Bachhuber.**
This series of three paintings deals with iconic images of the Northwest, the myth of the area, the raw open space but also the slash and burn and consumption.

I don't buy that. I've rarely been in a place where there isn't some mark of humanity—the road we drive on, the trail we hike. A pivotal shift occurred in my work in the early 1990s when my parents retired to the Oregon coast. To visit them, I drove through the coastal mountain range on a small spur highway. Over the course of many trips, I watched an old-growth forest slowly get cut down. One day I drove around a bend and before me was a scene of utter and immense destruction. A fresh burned-off clear-cut stretched to the horizon, smoldering like a giant ashtray. I pulled over and made a series of drawings that later developed into an ongoing series of paintings of clear-cut forests. Prior to this, I had included distant hill-cuts in my paintings, but suddenly they loomed from background to foreground, like an extra in a film emerging from the distance to suddenly be seen as the main character.

The clear-cut was—and still is—terrible and awesome at the same time. I began to see the landscape as a constructed place, defined not by nature but by work, infrastructure, resource extraction and, more recently, tourism. Over the last ten years I have been painting an ongoing portrait of the Pacific Northwest region; its environment, landscape, history, and people. I try to present these images without polemics.

When I start to think about a new body of work, I'll use any source materials I can get my hands on—documents and images archived in the Oregon Historical Society, even written descriptions that strike me with their poignancy. I often give myself assignments—small works in gouache on paper on which I piece together what comes to mind as I sort through my boxes of photos. The process is wide open. I do whatever it takes to get the image together. In a way, all my paintings are painted collages.

Wooden Rome, 2002. Oil on canvas, 78" x 84".
I believe art should help people be more deeply engaged with life. I hope my paintings provide a place where they can begin their own narrative, where they will feel something without their brains turning off.

IMNAHA!, 2002. Oil on canvas, 74" x 79".
I'm bothered when people take themselves too seriously. I think you can deal with a serious subject in a humorous way. Maybe it's my character; I'm kind of goofy. I like that element in this work.

Left:
Pacific Wonderland, 2002. Oil on canvas, 78" x 84".
I am not interested in preaching. I am exploring who we are and how we got here. Although a city guy by nature, I am fascinated with nature on the edge, nature with people pressing up against it.

145

Sally Cleveland
Augen Gallery, Portland

I began painting the landscape in the early 1990s, when I was teaching at Western Oregon State College. This college is located in a farming and cattle region about ninety miles away from my Portland home. I taught an early class and the sun was just coming up as I hit the farmlands. I could see vast expanses of gray sky, gray roads, and gray ground. These areas were broken up by rain-filled ruts and an occasional vapor trail in the sky. I found this low contrast to be incredibly moving. I loved the challenge of arranging a composition with so few elements.

I began to leave the house earlier and earlier so that I could park my car and sketch. Pretty soon, whole weekends were taken up with road trips to rural spaces. I brought along a camera to capture the quick atmospheric changes. I found that a photograph often imparts unsuspected dimensions to the image, such as the occasional glare and the quick sorting out of large spaces. I brought these images back to the studio to use as references for my finished paintings.

My work is a fusion of strong emotional tie to subject matter and careful consideration of formal elements. Before attending an art school, I had little first-hand exposure to visual art. Reproductions in books were my inspiration. When I grew up and began to see the original works of art, I was often disappointed. I missed the preconceived craftsmanship and I often preferred the smaller reproductions for their intimacy and convenience. This was art I could put into my purse and take out again to ponder.

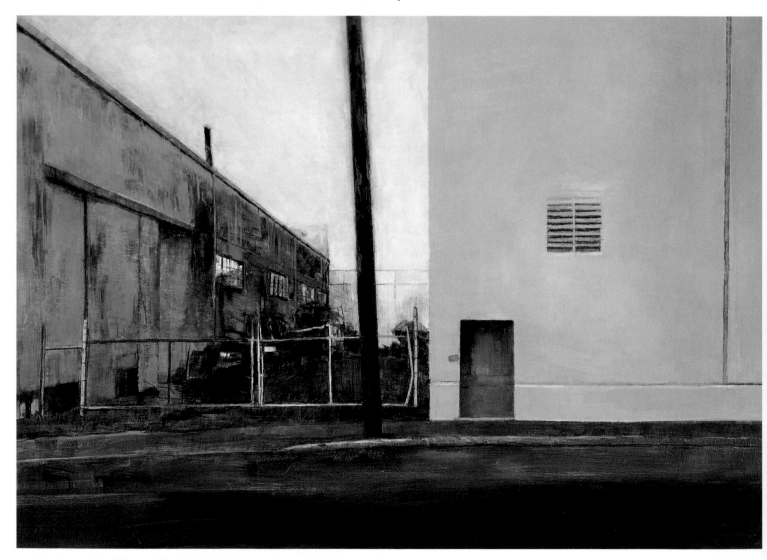

Northwest Buildings / Dusk, 2002. Egg tempera and oil on paper, 6.5" x 9". *All photographs courtesy of David Straub.*

146

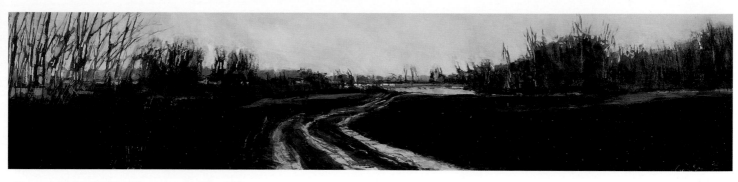

Turned Field, 2002. Oil on paper, 3" x 13".

Now, most of my work is fairly small. As I paint, I get lost in the image. Faces, cityscapes, land masses. It's all the same. I look for something unassuming and honest. I keep maps in my studio and my titles are specific to locale. Even with portraits, my work is journalistic in nature. It is note-taking with line, form, and color.

I believe that all forms of art intersect and parallel each other. When I think of the artists who have influenced me the most, they would be Bach, Bonnard, Cheever, Diebenkorn, Lopez-Garcia and Hank Williams. All of these artists bring a certain order to the disorder of experience, while retaining the integrity of flaw.

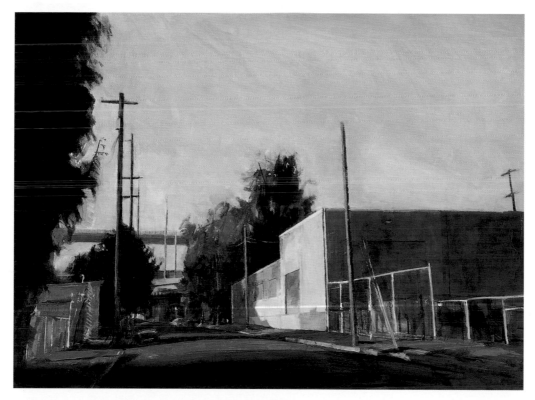

Afternoon / Street / Northeast Portland, 2002. Oil on paper, 6.5" x 9".

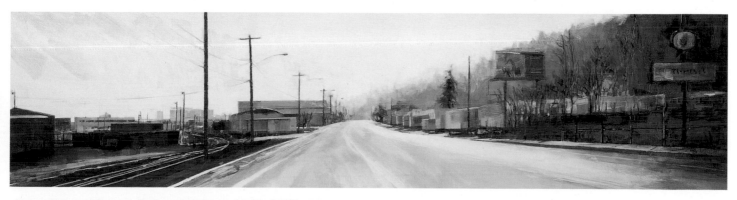

About Fifteen Minutes Before Sundown / I–30, 2002. Oil on paper, 5" x 20".

Allen Cox
Butters Gallery, Portland

Photograph courtesy of Jim Wells.

I've been painting for over twenty years. I was born and raised in the Pacific Northwest and did my art training at the University of Oregon. I can't recall a time when I didn't want to be an artist. Over the years I've done a lot of other things besides art, of course—you have to pay the bills somehow. Early on I worked as an archaeologist, for instance, an occupation that had a clear impact on how I think about painting.

Historically the artists from this region have been somewhat separate from the mainstream of American contemporary art. There's a certain independence of vision that I enjoy.

Mephisto, 1999. Oil and wax on linen, 78" x 120". *Private collection. Photograph courtesy of Bill Bachhuber.*

I like to keep my work in a constant state of evolution, which results in multiple tracks of imagery and, sometimes, noticeable changes in how I paint.

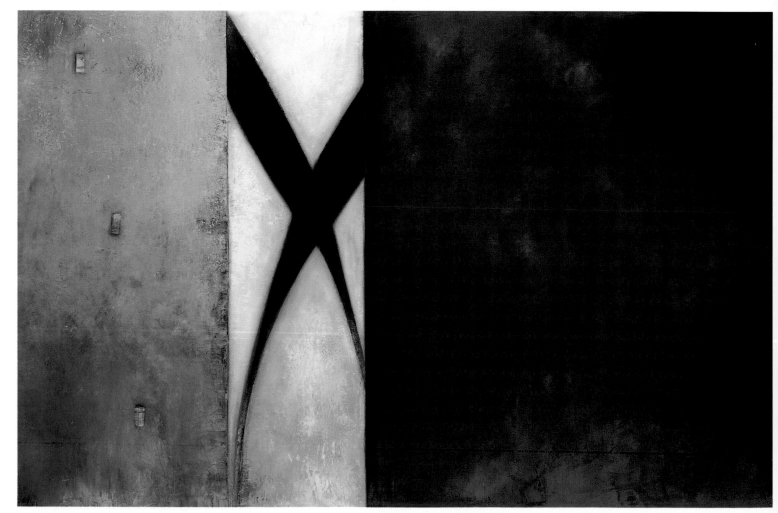

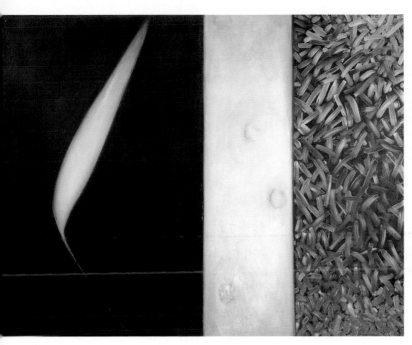

The Light–The Heat, 1999. Oil and wax on linen, 60" x 78". *Courtesy of Imago Galleries. Photograph courtesy of Hideki Tomeoka.*

Getting started can be the most difficult step for any project. A blank canvas is a *tabula rasa*—anything is possible. To forestall the paralysis of unlimited opportunity I simply dive in and make some marks on that virgin surface. I find that laying out almost any sort of composition will do. Once the thing is rolling, the painting more or less dictates its own direction.

Fire Down Below, 2003. Oil and wax on linen, 60" x 48". *Courtesy of Margo Jacobsen Gallery. Photograph courtesy of Jim Wells.*

Art historians, critics, and writers tend to look for work that serves their professional agendas as writers. I create art that serves my own agenda, not someone else's. Generally, I don't expect a whole lot from art writers, and I'm rarely disappointed. I'm comfortable with the idea that writers will occasionally perceive something in my work that corresponds to their own interests.

I use abstraction as a visual structure within which to present non-abstract symbols and information. The combination seems very expressive to me. I like the openness of possibility this provides. I can take it any direction I have a mind to. As a basis for the work, I address things that interest me personally. In the end though, the painting has to go out and capture the interest of someone else. My paintings constantly evolve in terms of imagery. Depending on the requirements of the painting, I'll change the visual references, the conceptual direction, or even the way I use the paint.

I'm often asked what my paintings mean. The answer is that they have many different meanings, some of which are unique to me as the artist, and some of which only become apparent when another person considers the work. It's what you actually make of it that counts.

I don't see my work as a venue for explaining or introducing myself. That is not crucial to my intentions as an artist. I certainly don't want to be absent from the work (I enjoy the personal presence of the artist in the art) but at the same time I don't want my presence to be the overriding factor of the painting. I can't help but inject my own sensibilities into the final result, of course, but I don't look at my painting as a way to present myself to the world.

It Don't Mean a Thing, 2003. Oil and wax on linen, 34" x 30". *Courtesy of Margo Jacobsen Gallery. Photograph courtesy of Jim Wells.*

149

Jacqueline Ehlis
SAVAGE, Portland

Photograph courtesy of Paul Foster.

I build objects for the 22nd Century. My work is a more pleasurable category of experience captivated by the now, motion, speed, the open road, and ones' ability to change. I use drips, pours, wood panels, and uninterrupted color; acrylic, and latex paint; automotive paint, powder coating, diamond plate, steel, lines reminiscent of pin striping, and horizontal flats, not just as representations but the reality of the skin of cars and motorcycles, the flash and grab of scenery at ninety miles per hour. Most things don't happen fast enough for me. These paintings assert themselves as architecture reconfiguring space. I like to get in front of an object and forget where I am but not who I am. I'm responsible to create something of worth, something that engenders trust in the beholder. The efficacy of the objects I create is central to the work. The meeting of the object and the beholder has an effect, thereby changing the world.

Malibu, 2002. Acrylic and vinyl on birch panel, 24" x 24". *All photographs courtesy of SAVAGE Gallery.*
Perpetual flux and change.

150

Tempest, 2002. Acrylic and vinyl on birch panel, 24" x 24".
Fury, Spark, Ignite, Endurance.

Escort, 2002. Acrylic and vinyl on birch panel, 24" x 24".
Tactile, Threat, and Seduction.

Anna Fidler
Pulliam Deffenbaugh Gallery, Portland

Magic Garden (detail), 2002. Paper collage, 5" x 29.5". *Courtesy of Pulliam Deffenbaugh Gallery.*
I also play and record music, which is broadly electronic. I feel that people can be influenced by what they are listening to when they make art. It can go both ways: My music is sometimes influenced by my art.

If I had to define myself, it would be "Millennial Tropicalist." This might come from my earliest artistic experience. I went to Hawai'i when I was three and soon after began to obsessively draw hula dancers and palm trees. All the time I was growing up, I had much more fun making things than buying them. I spent many hours in my room creating things out of my imagination. I made things ranging from a line of fashion to a board game to murals that covered my walls.

Today my work is more of a design style than anything else. By abstracting the basic elements of nature into an assembly of arcs, ovals, undulating stems, and so on, I find a boundless creative system. Making art has a meditative quality. At its best, I find myself surrounded by scraps of paper and puddles of glue without even noticing what a fantastic mess I've made.

I start with color, sorting through my paper pieces, gathering a pile of scraps that have appealing yet challenging color combinations. Sometimes I limit myself to a smaller palette and other times the color pile takes over a large section of my desk. I don't look to actual plants or trees for inspiration. Instead, I prefer to remember what they look like in their most basic forms: circles, ovals, lines, etc. At this point, an art piece becomes more like a puzzle. I work on one side at a time and constantly go back and forth to balance the color and shapes, and how they relate to one another. It's fairly mathematical. If one side has arching shapes that pull towards the left, then the other side must have arching shapes that pull to the right.

The Rain Machine (detail), 2002. Paper collage, 5" x 30.5".
Courtesy of Pulliam Deffenbaugh Gallery.
I like looking at lamps. The basic form of a lamp with its stem-like neck and blossom-like bulb reminds me of the shape of a flower.

It's not always easy to know when a piece is "done." Sometimes I trick myself into seeing it differently by pretending that I've never seen it before. If it still looks good, I throw it in a drawer and stop looking at it for a while. A week or two later I'll take another look. If it still looks good, it's done.

When a person looks at my work, I hope that their mood will elevate; that they feel transported away from the spot where they are standing and find themselves in a more vibrant place, full of color and optimism. I can't think of a more worthy cause than helping people enjoy life.

Chris Kelly
Augen Gallery, Portland

Listening to my internal dialogue and creative expression has always been a part of my life within. I am in awe of the interconnectedness of Nature and fascinated by the way our memories mesh to define who we are. As I developed as an artist my inspiration came from Nature, memory, and emotion. To me emotion is like water, a life-giving force, something to be reckoned with. In making my work the need and the result are abstract. Listening to my intuition opens doors that I regard with a certain amount of irreverence. Maybe there is some truth in not trusting a piece that is going well.

I usually work using the medium of encaustic. This consists of beeswax melted with a small amount of resin, with pigment added to achieve the color I want. I work on a palette made from quarter-inch aluminum suspended over a hot plate and heated to two hundred degrees Fahr-

Necklace from Tangier, **2002. Encaustic on linen and panel, 22" x 18".** *All photographs courtesy of Richard Strode.*
The trance of working and creating can be addictive. Time evaporates and leaves me squinting in the dust.

enheit. The beeswax, pigment, and Damar resin are melted together in muffin tins on top of this palette plate and applied to the substrate with warmed bristle brushes, palette knives etc. As each molten layer of paint is applied to the substrate it is "burned in" with a heat gun to fuse it to the previous layer.

Encaustic seems to coax the work from within. Often I feel like I'm on an artistic walkabout. Because pure pigment is suspended in the medium, the intensity of the color leads you, in a roundabout way, to where you want to be. I like the fact that encaustic is hard to control. That is what I want from a medium, the surprises and the tantrums, all keeping the experience interesting. Working with encaustic is a collaboration between myself and itself.

My most recent paintings are about mark-making and color. Most of the shapes in them are based on the natural marks of the brushes, sort of the voice they were born with. I know the piece is done when I have an emotional response from the work, when the final polished surface pleases my eye.

I hope viewers find the primal symmetry in a piece. My titles give them an entry point into the work, a clue. (A chuckle also can be helpful.) If I can get the viewer to break the web of daily life, even for a moment, then I have done my job. And in a sense they have done theirs. The ideal is if someone who knows my work sees a piece they never saw before, they'll realize, "Clearly, this is by Chris Kelly."

Left:
Crossing the Equator, 2001. Encaustic and gold leaf on panel, 15.5" x 12.5".
My work is about layers and their relationship to each other. I add. I subtract. Wax on. Wax off. As a piece progresses I will scrape back into the previous layers, exposing the surprises created by the merging of their colors and shapes. In a way it's like an archaeological dig.

A Peculiar Way of Aging, 2000. Encaustic and gold leaf on panel, 27" x 22".
I love staring at a blank canvas in the studio, as in a meditation. Staring opens my eyes to the possibilities.

Spring Peepers, 2001. Encaustic on panel, 27" x 23".

155

Dianne Kornberg
Elizabeth Leach Gallery, Portland

Photograph courtesy of Jack Hart.

Although I was trained as a painter, my medium, for the last twenty years, has been photography. I work with the aesthetics and metaphorical ideas I find in the natural world. For the past decade, the subjects of my work have been biological and botanical specimens collected for scientific study in laboratory settings. I have been exploring, within the palette that photography offers, the range of ways in which narrative, as well as the elusive, mysterious, or ephemeral elements in these specimens can be expressed.

My working process begins with the collection of specimens from science laboratories and "found" materials. I depend on fleeting impressions as well as close observation to generate ideas for the work. For example,

Laminaria sinclarii 2

Halymenia schiaymenioides

Four images from *Herbarium 1–23*, 2002. Eleven carbon ink jet prints, 31" x 24"; one carbon ink jet print, 40" x 24"; eleven pigment ink jet prints, 19" x 13". *All images courtesy of the artist.*

This work encourages a close and sustained look at the plant specimens by restoring a sense of their aesthetic power. In inkjet prints, unlike in gelatin silver prints, pigment lies on the surface of paper—one no longer looks through a gelatin screen. In the color images the physicality of ink on paper so closely mimics the thinly pressed specimens that one might imagine mistaking the print for the object.

Alaria marginata

Prionitis lyalii

the diagonal lighting in a series titled *Jack-in-the-Box* recreates the visual impression I had when I opened the door of a shed in the arctic, and saw a shaft of sunlight fall across the bleached skull of a horse. The idea for *The Cartwheel Suite* came in a similar way. I had stored the disarticulated bones of a calf in a corrugated box used to package mat board. The evening light in my basement studio transformed the bones into a luminous figure, suggesting to me a "dance of death." By re-arranging and re-photographing the bones, and by making alterations to the box, the "cartwheel" movement developed and I was able to make the piece.

My starting point is in my visual response to the materials. In *Herbarium*, since I am concerned only with restoring the aesthetic power of the plant specimens and not with narrative content, I completely isolate them on the surface of the paper. I usually work with images in a series because I can make use of visual relationships between the pieces. The scale of the work is an important consideration. Unlike most of my work, the *India Tigers* have to be relatively small to suggest the weightless fragility of the insects, and to support the sense of movement between the pieces.

I find myself returning to life forms and processes as a way to address the resonance between the structural complexity through which nature encodes and renews itself and the metaphors we reach for to make sense of our own lives.

Gloiosiphonia verticillaris *Pulsatilla ludoviciana* *Postelsia palmaeformis*

Three monochrome images from *Herbarium 1–23*, 2002.
These photographic images take on the attributes of graphic media such as, ink wash and charcoal. Narrative space is stripped away and the residual beauty and aesthetic power that survives the collected state is restored. *Gloiosiphonia verticillaris* suggests both graphic and photographic representation as the stem sinks, like charcoal, into the paper.

India Tiger 1 **India Tiger 3** **India Tiger 5** **India Tiger 7** **India Tiger 10**

India Tigers 1–12, 1995. Toned gelatin silver prints, twelve 14" x 11" prints.
These butterflies and moths from India were preserved in triangular paper wrappings. They were photographed so that the wrapping appears to extend out from the picture plane, as might the wing of the insect. The direction of the light changes from one print to the next, suggesting a delicate sense of movement.

Laura Ross-Paul
Froelick Gallery, Portland

I've done something creative almost every day. My earliest memory is a feeling of connection between my right hand and my eyes. In grade school I made classroom murals; in high school I was the yearbook artist, and in college my drawings protesting the Vietnam War illustrated an underground newspaper. This range of experiences encouraged me to take my art seriously, and guided me in achieving a Masters degree in fine art.

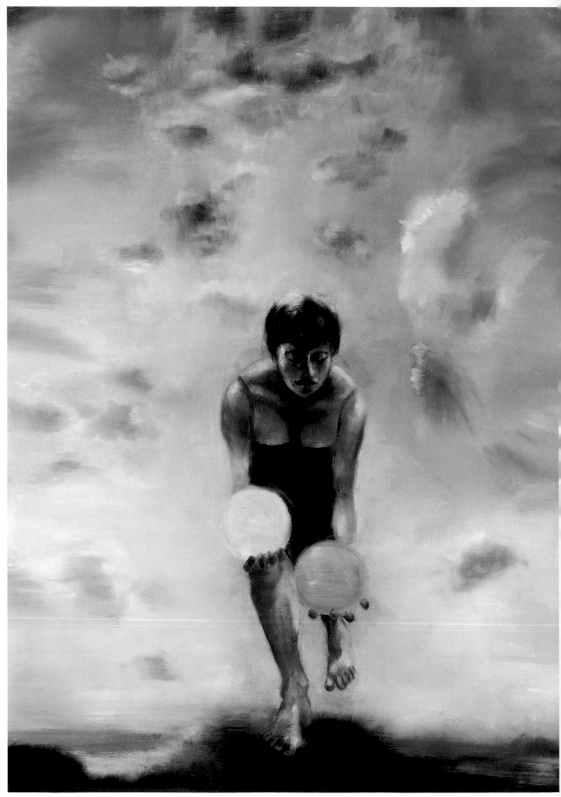

Juggle #4 (Decision), 2003. **Oil and wax on canvas, 60" x 40".** *All images courtesy Froelick Gallery. Photographer: Jim Lommasson.*
I want people to feel comfortable with a painting's luminosity and the inviting way the light works. I want them to identify with the body language of the figure, then to notice that the abstract shapes and intensified colors are incongruous with the depiction. The painting looks "right" but wouldn't exist that way in reality.

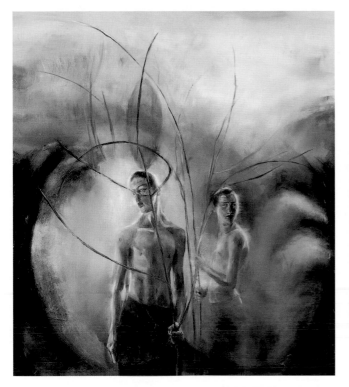

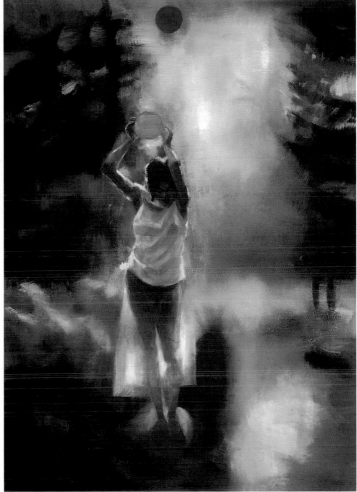

Left:
Tangle, 2002. Oil and wax on canvas, 40" x 36".
Collection of Vance Ewald, Portland, OR.
The setting for all my figurative work is nature. A huge motivator for me is the alignment of the figure with its surroundings. The changing flux of nature is an attempt to be in the present moment, giving life much grace.

Circles, 2001. Oil and wax on canvas, 36" x 26". *Collection of The Jordan & Mina Schnitzer Foundation, Portland, OR.*

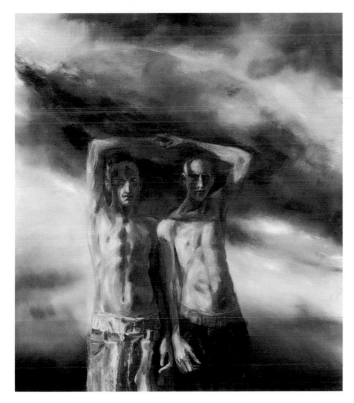

Left:
Join, 2002. Oil and wax on canvas, 40" x 36".
I use challenges in life for inspiration. Painting helps me stay centered and sane. My biggest satisfaction is just showing up at the studio every day.

My paintings evolve from a mixture of emotionally symbolic devices including color, abstract shapes, and the human form. Intense colors can have psychological and emotional effects, and might alter a viewer's awareness. Geometric shapes and my models' postures are presented to echo natural elements. Rectangles reflect the horizontal form where earth meets sky. Circles mimic the glowing power of the moon and sun. The shapes begin to represent thoughts and feelings. The gesture of an arm may balance with the sway of a tree branch. These shapes and gestures are looking for alignment with nature. I try to capture pregnant moments with body language. I watch dancers for revelations unveiled in a fleeting moment. The figure's relationship with nature is the work's essence. Depicting the awareness created by an interaction of one's self and the bigger world is my goal.

Naomi Shigeta
Augen Gallery, Portland

When I was young, I was always waiting to become myself. One day, I realized a voice was forming inside of me. That voice turned out to be my art.

What makes art meaningful to me is its truth from the heart. I can always find some connection with artwork I like. The connection is not necessarily related to the material or how perfectly it is crafted. I am more interested in the artist's intention to tell the truth. If a piece of art speaks to me without doubt, I believe it. It doesn't matter whether it is video, a performance, or some kind of high-tech material the artist uses.

In my mind's eye I'm a bee, looking for the flowers where I stand. Every day, petal by petal, I paint my thoughts and feelings. As in life itself, I ask questions and search

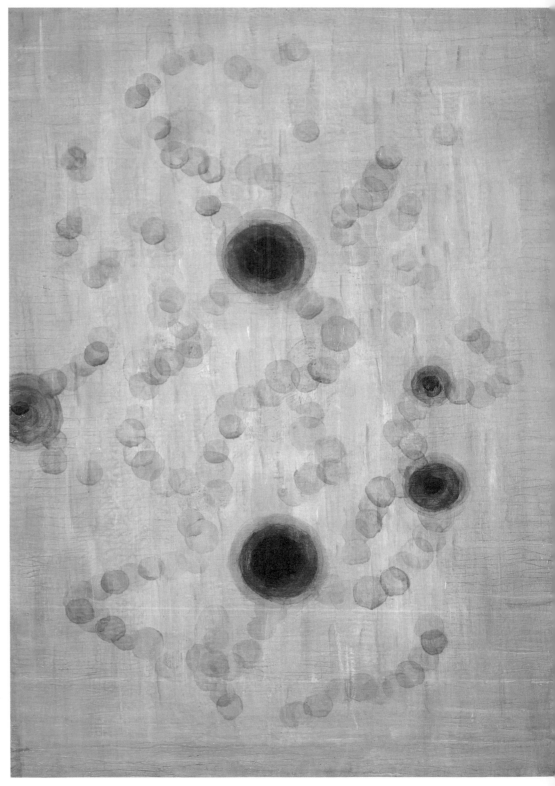

Proving Past, 2002. Oil on canvas, 15.5" x 11". *All photographs courtesy Richard Strode.*

Art is something that comes directly from one's own heart, something we can share. There is no right or wrong. It is the pure form of a person's soul. Art is always something I carry with me and care for, just as I do with a best friend.

for answers. Sometimes, things are not easy. Sometimes I make mistakes. Yet I try to find a way to get through these while leaving some trace of myself in my work. Documenting my thoughts in art is similar to writing a diary. I don't erase or modify a work. I just accept, adapt, and move on to the next piece, just as I do in my life. The simple act of pursuing my art is success in itself.

Art should help people enjoy life. It can stir emotions, send a message, move people to take action. Listening to music, seeing performance, reading a poem or story can fascinate and provide happiness. Sometimes, though, we encounter a piece of art that directly hits the heart. Then it moves beyond enjoyment. It becomes a part of one's spirit.

Mixed feelings are a part of living. There are struggles, confusion, searches for answers. Clear thinking is being aware of those concerns and paying attention to life. My art is my way of understanding these things. In painting, I try to document those feelings and thoughts. When I begin repeating my thoughts over and over, it is time to stretch a new canvas.

I try not to categorize myself, or identify myself with a particular genre. I do not want to belong to any particular group or class of artist. My influences come from various influences both East and West.

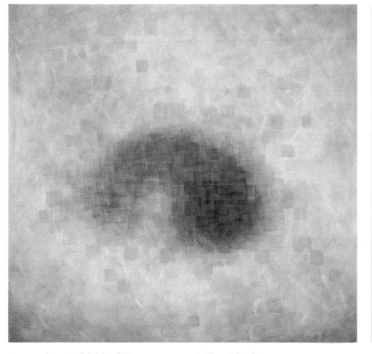

Amorphous, 2002. Oil on canvas, 20" x 20.5".
As I paint my everyday thoughts, I picture my inner life as it is in the present. Yet the present is but a reflection of my past and the future. In trying to visualize my inner life at each moment, in one picture is the past, present, and future.

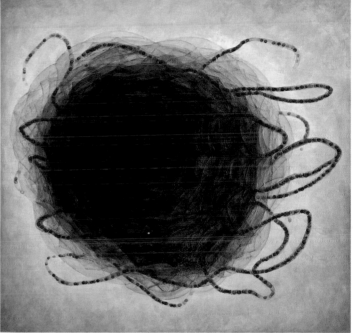

Parameter, 2002. Oil on canvas, 38" x 40".
Even though we all have different life experiences and values, I think we can understand each other through very simple feelings or thoughts. In my work I try to create a common space where we can connect through my art.

Heartstrings, 2002. Oil on canvas, 14" x 23".

Mark R. Smith
Elizabeth Leach Gallery, Portland

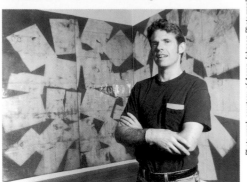

I have always seen myself as a painter, but the work on these pages has been created mainly with recycled clothing. Fabric is a challenging color medium because it arrives in every imaginable size, texture, pattern, and color. Cloth can be as fluid and spontaneous as paint.

These wall-mounted works begin with segmented plywood armatures. I cover them with tautly-stretched vinyl and stuff each section with clothing through holes in the under side, until there is no room left for compression. There is a visceral thrill transforming porous, airy textile into dense, richly colored pigment.

These artworks address transitory culture. Their segmented contours are based on the actual floor plans of public facilities—massive structures such as stadiums, cathedrals, and concert arenas. These are permanent sites for temporary communities. People gather there for momentous, fleeting events and then disperse. I want to cap-

Arena Recline, 2001.
Clothing, vinyl, and
plywood; 92" dia. x 5".
Photograph by Aaron Johanson.
*All artworks courtesy of Elizabeth
Leach Gallery.*

This piece is based on a standard design for a basketball and ice hockey sports complex. The concentric bands evoke the central playing court and surrounding zones where the audience sits. The palette consists mostly of neutral hues organized in darker to lighter values from outer rim to the center. The title puns an arena's alternating active or inactive status.

ture the residual traces of humanity that permeate such vast architectural spaces.

I arrived at this approach while sorting laundry in front of a television set tuned into sports events and other public spectacles. Sports have a universal appeal that leaps cultural boundaries. I am drawn to both the cultural-festive sociology of mass events and the undercurrent of latent violence lurking under the enthusiasm. Music events invite a similarly intense, sybaritic celebration where there is a form of officially overlooked abandon in the mosh pits close to the performers.

The arena, and my art, are metaphors for human behavior at its most expressive and excessive. For me, selecting and stuffing cloth into art works is a way of tangibly linking with the eccentric and extreme variations of fellow humans.

Mosh Pit, 2000. Clothing, vinyl, and plywood; 76" x 92" x 4". *Photograph by Aaron Johanson.*
In much of music culture, people come together in part to experience collective release. The controlled setting provides a safety net of sorts in which participants can enjoy sanctioned abandon without social or moral disapproval. They are charged environments, potentially violent and celebratory.

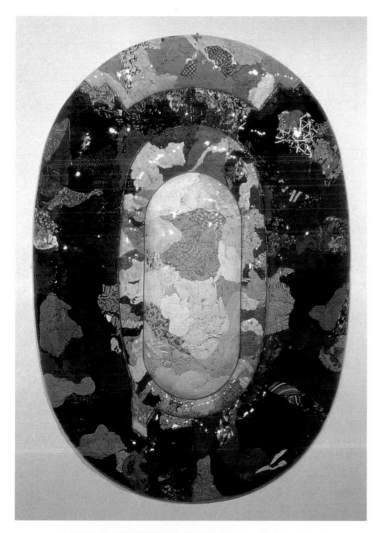

Exposition Park, 2001. Clothing, vinyl, and plywood; 88" x 60" x 5". *Photograph by Bill Bachuber.*
Exposition Park was the original name of the Los Angeles Coliseum. This work's lozenge-shaped configuration was taken from the original plan. The stadium was built in an optimistic time, so the colors I chose are more harmonious, reflecting that era's positive vision of the future.

Rooted Basilica, 2001. Clothing, vinyl, roots, and plywood; 56" x 48" x 5". *Photograph by Bill Bachuber.*
Thanks to weather and time, older architecture acquires a quality of gravity or rootedness. Here, the apse of a medieval church is shown as a stuffed reliquary filled with implied ghosts and real roots interspersed with bleached-out garments.

Libby Wadsworth
Elizabeth Leach Gallery, Portland

My paintings explore ways in which visual and verbal language systems interact, forging new relationships by merging historical and contemporary cultural ideas. As a woman artist, I also search for ways to voice my identity amidst a cultural framework created and dominated largely by men. I ask viewers to reflect on how words and images work together, how each affects the other, and how they affect the piece as a whole. When we observe rather than speak words or images, we

an, 2002. Oil on canvas, 40" x 12". *Private collection. Photograph courtesy of the artist.*

I like how the word *anathema* breaks up, becoming separate, apparently random little words whose meanings are so unlike the whole word's insistence on denunciation. This visual breaking up of the word emphasizes the arbitrary but productive nature of relations between words and meanings. The precarious and impossible arrangement of the still life's components—apple, teacup, saucer, and egg—again highlights the fragile and yet prolific relationships that can be made between images and their associations.

Left:
ep, 2003. Oil on canvas, 18" x 11". *Photograph courtesy of the artist and Zolla Lieberman Gallery.*
In this painting I wanted to draw a series of parallels between the broken teacup, the dissected word, the split canvas, and the content of the words.

here, 2002. Oil on canvas, 22" x 14". *Private collection. Photograph courtesy of the artist.*

I have recently been including white domestic objects in my paintings. I particularly like the teacups because of their references to femininity, domesticity and cultural ritual. The overlaid gridded words seek to question those ideals, expectations and rituals.

comprehend them as objects in themselves and as vehicles for re-presenting information. My paintings investigate how this process informs our aesthetic experience.

Still life, for me, is a very rich genre. It evokes the domestic realm, enabling me to merge the many worlds I traverse in my daily life. My cups and apples can be read as portraits, but also as actors on a stage negotiating many identities and traditions.

I use grammar-school sentence diagrams to place the words I choose into the visual space of a still life. Sentence diagrams convert the component words of a sentence into visual objects, while at the same time deferring the content the viewer expects. They invite viewers to reflect on the conventions (and conventionality) of visual and verbal language.

Recently I have introduced another layer of verbal content to my still-lifes—phrases or words broken up into grids that often form other words, while still retaining their initial meaning. The grids function similarly to the sentence diagrams: they slow and extend the reading process, highlighting the visual rather than verbal content of the letters.

All this takes place in the context of different—at times dissonant—painting styles within the same piece. The still-life objects are depicted with Old Master realism, but the ground is applied with a less controlled, often expressionistic, sometimes drippy manner. I keep the composition of the still lifes fairly spare. When combined with the gridded letters, their minimalist look evokes historical precedents, hinting at further layers of content.

By mixing different styles, my work emphasizes different approaches to representation. One transparently depicts objects. Another draws attention to the medium itself. Juxtaposed, they encourage viewers to read "style" within the painting. For me, "style" is a fusion of visual grammars whose meanings and implications are highly codified, and, like parts of speech, often overlooked.

sim, 2002. Oil on canvas, 40" x 11". *Photograph courtesy of the artist and Elizabeth Leach Gallery.*

kitchen floor: poured, 2001. Oil on canvas, 52" x 20". *Private collection. Photograph courtesy of the artist.*

165

Theresa Batty
Theresa Batty Studio, Seattle

Region 5
Washington

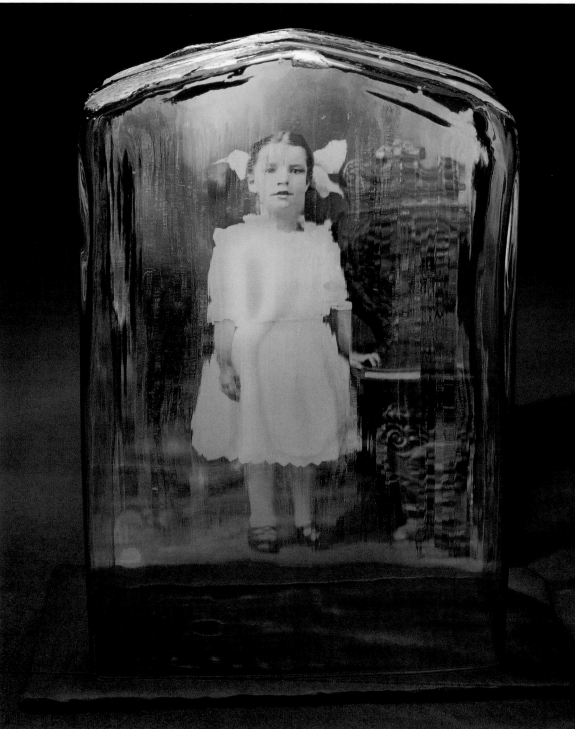

Malitta, **1998. Photo emulsion and blown glass, 12.5" x 8" x 4".** *All photographs courtesy of the artist.*

This was part of a series completed during a one-year residency at the Art Academy and School of Design in Stockholm. I was given sixteen hours with a professional glassblower to make whatever I wanted. I made house-shaped wooden molds for him to blow the glass into. As the wood burned it gave the glass an unpredictable texture. I then put photo emulsion on the inside surface and printed through the glass.

When I was in high school I got my first 35mm camera and fell in love with film. That camera was an irresistible calling to photography and film-making. Then I saw my first Fellini films, and then Kurosawa's. I was completely enchanted and fascinated. When I got access to film making facilities and teachers, it became my passion.

I have no set formula or system for how I conceive and do a particular series. Ideas can come to me in my sleep or as I'm driving, but those are just accidental gifts. Even after I get a particular idea for a series, I don't always follow a specific direction. Photographic images are endlessly intriguing and I'm fascinated with many materials. Even though I've been working quite a bit with glass over the past few years, it is not the only material I'm drawn to. Rubber, lead, wax, nylon chiffon, copper, tar, and many others have a resonant beauty to me. I want the materials and the processes to reveal something that I couldn't anticipate.

I'm lucky to live in an area where it's relatively easy to get access to hot glass, so I've been able to work quite a bit with it. For me, casting with glass is like being a schizophrenic lover—one day it's the most exciting, beautiful thing in the world and you are completely seduced, and the next day you hate everything about it.

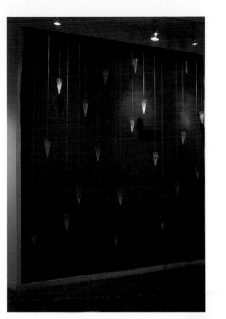

In the Middle of the Night, **2001. Cast glass, acrylic, pastel, and paper, 144" x 96" x 10" (dimensions vary depending on installation).** I had a show coming up. It came together so easily that it was strange. I didn't really understand where it came from, it wasn't like anything I had done. Then two nights before the show went up, I was shocked awake by an enormous fire burning outside my window. It was an old elementary school three stories high with fire shooting out above it. I went out and watched as it gently rained. It was incredibly beautiful. I realized then that it was this piece.

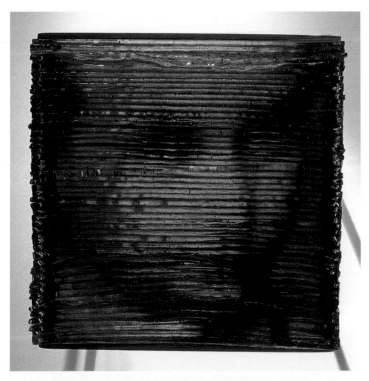

Tektite–Amber II, 2001. Fused glass and photo emulsion, 7" x 7" x 1.75". *Collection of Lou and June Cuevas.* This was part of a series made at the Bullseye Glass Factory in Portland. The factory makes sheet glass for use as stained glass. I fused the trim cut off the edges of the glass billets to a colored piece of glass, which was then coated with photo emulsion. (A tektite is a natural glass of meteoric origin; I liked the idea of finding an object like this that might be a fossil from space.)

What kind of artist am I? I don't think there should be so much emphasis on categorizing artists. I know it's been done forever, but I don't think there are enough categories for all the different kinds of work being done today. Nobody would have defined Picasso or Renoir by what kind of brush or paint they used. Those details have no relevance to the content or meaning of the work. Robert Rauschenberg, one of my favorite artists, once wrote, *"The outcome of a work is based on the amount of intensity, concentration, and joy that is pursued in the act of work. The character of the artist has to be responsive and lucky… it's extremely important that art be unjustifiable."* If I had to choose a doctrine of any sort it would resemble this attitude.

If you wanted to categorize me, I'd prefer to be defined as a "post future modern photo minimal semi-realist mono-colorist." It's not in the textbooks.

Susan Bennerstrom
Davidson Galleries, Seattle

I was raised in a philosophy that denied the reality of the physical world. For years I thought of my work as a rebellion against that ideology, since my inspiration came from landscape and other particulars of my tangible environment. Recently, though, I've come to see that I haven't traveled so very far from the philosophy of my childhood at all, that my work is in fact about the connection between the physical and metaphysical worlds in the form of light.

My grandmother in Chicago was a painter and sculptor. I didn't see her often, but she was a big presence in my mind. She represented an idea to me: that a woman could be a serious artist. I was one among many grandchildren, but it meant a lot to me that she paid attention to my interest in art. When I was ten or eleven she sent me a set of oil paints for Christmas, and I felt like I was on

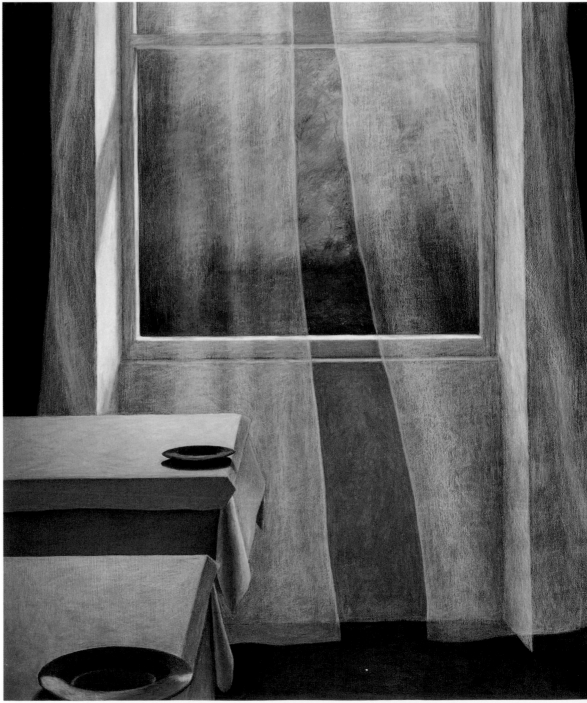

Red Pair, 2002. Oil pastel on panel, 27.5" x 23.5". *Private collection. All photographs courtesy Al Sanders.*
I want people to look at my work and say, "I know that place." Even if the specific place I'm depicting is somewhere they've never been and may never go to, I hope viewers will recognize in the painting a spot familiar to them, perhaps even a region inside of themselves.

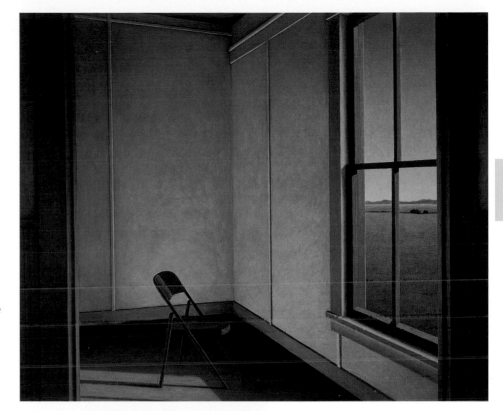

Expect to Wait, 2001. Oil pastel on panel, 35.5" x 42". *Collection of the Whatcom Museum of History and Art, Bellingham, WA.*
At first glance my paintings are about mundane objects—beds, tables, walls, partially open doors—within perfectly ordinary spaces. But those objects and spaces serve as foils for my real subject, light.

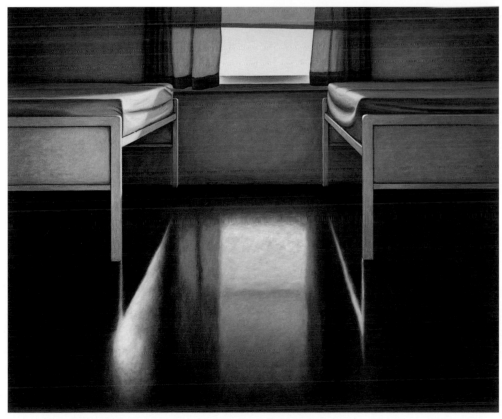

Between Us II, 2002. Oil pastel on panel, 38" x 46". *Private collection.*
I like to think my paintings go beyond depiction. I pay attention to things that are easily overlooked: the way light falls in a bathtub, the reflections of chair legs on a shiny floor, the interaction of light from a bare bulb with a shaft of sunlight from a window.

my way. I compulsively drew and constructed things from the time I was very little. It never occurred to me that I wouldn't continue to do that all my life.

My work starts with traveling. Travel pries open my senses and provides the impulse behind my work; when I'm outside my everyday environment I am reminded that my job is to see. I bring a camera everywhere and take loads of snapshots, which serve as sketches when I get back to the studio. I draw directly on the paper or gessoed panel, taking ideas for composition from the photos. I don't copy the photos literally, but use them as a springboard into imagination and memory.

Mark Calderon
Greg Kucera Gallery, Seattle

Courtesy of Diane Isley.

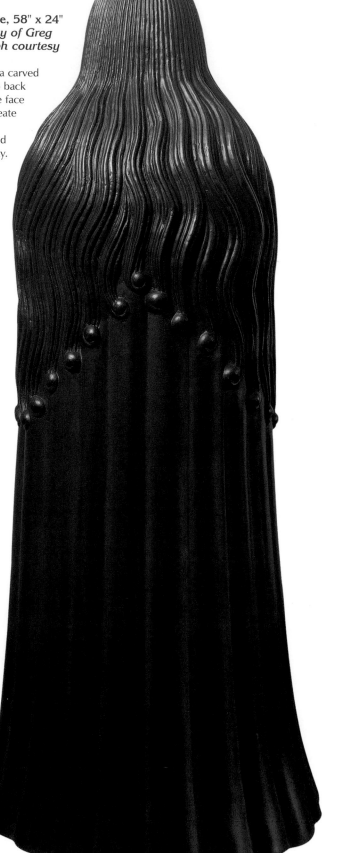

Madrina, 2000. Cast bronze, 58" x 24" x 24". *Edition of 5, courtesy of Greg Kucera Gallery. Photograph courtesy of Eduardo Calderón.*
This sculpture was inspired by a carved ivory Madonna. I fused the two back halves together to eliminate the face altogether. My intent was to create something that expressed my experiences with the elusive and ephemeral aspects of spirituality.

One of my principal interests is the study of ancient cultures. One recent body of work was inspired by the hairstyles found on Japanese Buddhist sculpture from the 12th and 13th centuries. I found the various forms incredibly beautiful, and wondered if by separating any particular element from a religious sculpture, for example the hair, it would retain its sense of being sacred. At what point does that sense disappear?

A second interest is the natural world, and more specifically, how forms are developed in nature. Some fascinating examples that formed my sensibility are the spirals in nature that correspond to the mathematical order known as the Fibonacci sequence.

Often when I find something that intrigues me, I incorporate it into my work, usually combining it with other ideas and forms to make it less specific and more abstract. As I develop a new idea, it usually transforms in my head many times until I have a very clear vision of what I want to create. The challenge lies in trying to bring that clarity of vision into the physical world. One time I found a *melongena* shell from the South Pacific with a spiraling double row of spines. The end result was a piece that bears a striking resemblance to the Sacred Heart or a crown of thorns.

As my work continues to evolve it becomes even more difficult to define what I do. For the last few years I have produced abstract, sensual, three-dimensional forms inspired by the human body. They often have a spiritual or sexual component—sometimes both. I love it when both aspects are included in a single piece—such a natural combination yet seemingly at odds in our present culture. At times my ideas are less abstract, but I enjoy the diversion of producing figurative or two-dimensional work—as long as I feel strongly about the imagery. I learn so much more that way about the various ways of expressing myself and of reaching a diverse audience.

Medulla, 1995. Cast bronze, 15.5" x 9.5" x 9.5". *Collection of the Seattle Art Museum. Photograph by the artist.* This is a work inspired by the hairstyles of Japanese Buddhist sculpture, although its shape and texture suggest many forms. When the viewer has multiple references to draw upon, I feel a work has a better chance to convey both familiarity and mystery. To me these give an art work aesthetic vitality and longevity.

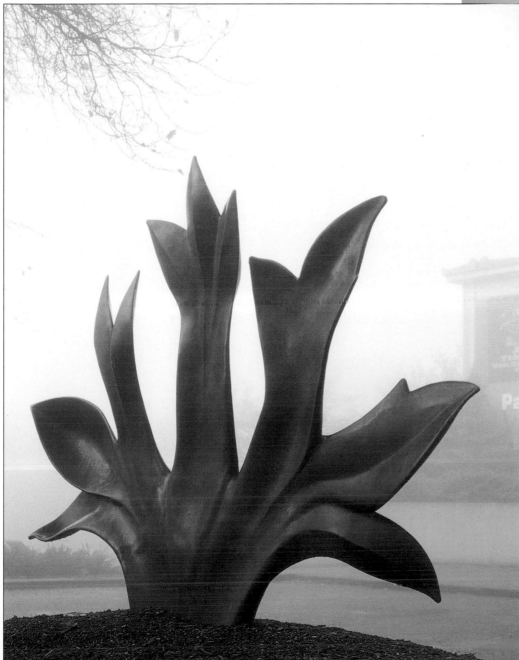

Pluma, 1999. Cast bronze, 84" x 120" x 15". *Collection of the Burke Museum of Natural History and Culture, Seattle. Photograph by the artist.* When I began my art studies at San Jose State University, a whole new world opened up for me. I was exposed to new ways of exploring and experiencing art. My work became both more complex and abstract, and I became more confident about developing stronger ideas and making the work more convincing. For the first time, I began to understand art.

171

Jaq Chartier
William Traver Gallery, Seattle

Photograph courtesy of Dirk Park.

My work is driven by an innate curiosity about materials and process, combined with an interest in science. Each painting starts as a test, often including notes written directly on the front or sides of the painting to document the results.

Currently I'm exploring the migration of water soluble inks, dyes, and chemical stains through layers of clear acrylic gels and various paints. While a piece is still wet, some of the stains melt and migrate upward into the overlayers in unpredictable ways, while others are buried or ghosted by what I've painted on top. The mutation of the stains as they develop over time evokes a life of its own, reminiscent of microorganisms growing in a petri dish.

Carbon Blue, 2001. Acrylic, stains, and paint on wood panel, 12" x 14". *Private collection.*

I'm interested in how the products of technology can be adapted for use as art materials. Technology not only opens fresh territory to explore, but also can infuse seemingly barren or overworked areas with new life. We can look at materials and effects more closely and with greater wonder, as they reflect life itself.

8 Reactions, 2003. Acrylic, stains, and paint on wood panel, 7" x 7". *Collection of the artist. All photographs courtesy of Dirk Park.*
I make each painting simply to see what will happen. This small piece is an intimate view of how some of my materials interact, each stain having its own peculiar chemistry with the various white paints and resin layered on top.

Stain Chart (9/02), 2002. Acrylic, stains, and paint on wood panel, 28" x 35".
I'm fascinated with pictures of gel electrophoresis and DNA research, as well as other scientific imagery which parallel my aesthetic and conceptual focus. This painting archives every stain and color mixture I had been working with up to the time of its making, including a sample of various paint interactions.

Tip Test (1/03), 2003. Acrylic, stains, and paint on wood panel, 23" x 23".
This piece compares stains that were tipped off the panel while drying with stains that dried undisturbed.

4 Reactions, 2002. Acrylic, stains, and paint on wood panel, 10" x 13".
Many of my stains are mixtures of more than one ink, dye, or chemical. I'm curious about how they will separate and migrate under differing conditions.

John Cole
Lisa Harris Gallery, Seattle

I grew up in London during the wartime bombing. In 1951, at the age of sixteen, I immigrated with my parents to the United States. As early as the age of eight I remember painting and drawing, imagining I might be painter some day. By the time I was forty-five I considered myself a professional artist.

I don't work from photographs, which seem static to me. I work on site from the beginning, either sketching or painting directly. Whether it is a new place, or a location I have visited before, my process is the same. I camp near a river or lake, fly fish, and hike. I begin sketching, not sure of what attracts me, but open to the wide variety of information nature itself can suggest. After a few days I try a couple of small paintings. I don't worry if the paintings are good; I just do them. I stay a couple of weeks if I

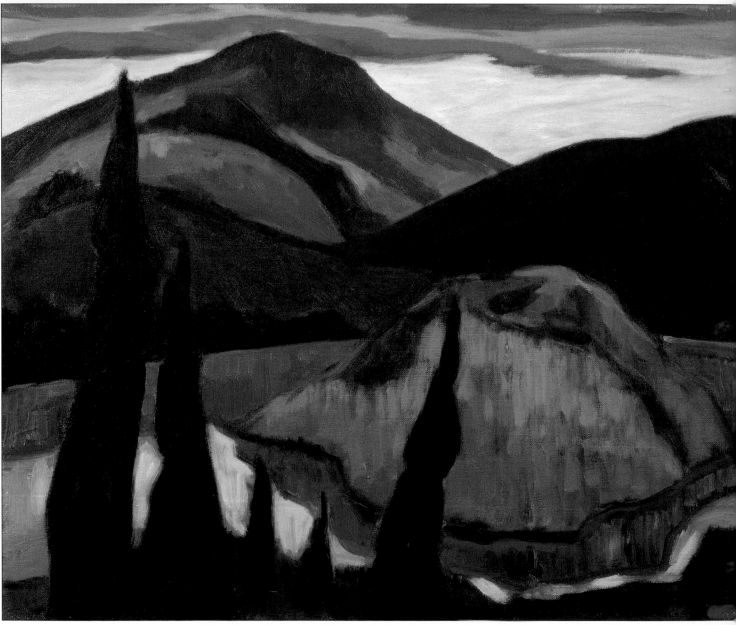

The Island, 1998. Oil on linen, 20" x 24". *All photographs courtesy of Lisa Harris Gallery.*
I believe my work is a picture of my inner life—past, present, and hopefully future. External validation imparts self-confidence, and self-confidence imparts fortitude.

can, which adds up to a lot of material. Back at the studio, I begin reworking it right away. A painting may be started unsure of what the final outcome will be, but clear in the sense of what it should be.

Outdoor painting has built a solid foundation for my work over the years. Confronting and working with nature presents some hardships, but is immensely rewarding. To interpret and record a fleeting moment; to recognize form; to provide the viewer with a sensory and intellectual communication, is to achieve success.

A composition will not be unalterably determined by the initial observation, but rather by the magic involved in the process, revealing time, a place, a mood.

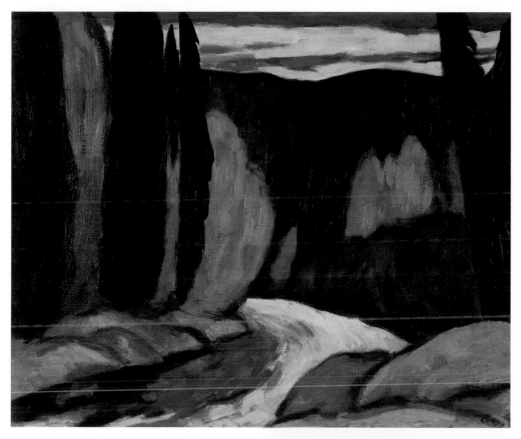

Nooksack Scene, 2002. Oil on linen, 20" x 24"
I would have to be termed an "Expressionist," which may be an overly broad term, but is the only one that really fits me in today's world. Being an Expressionist artist is being a law unto oneself.

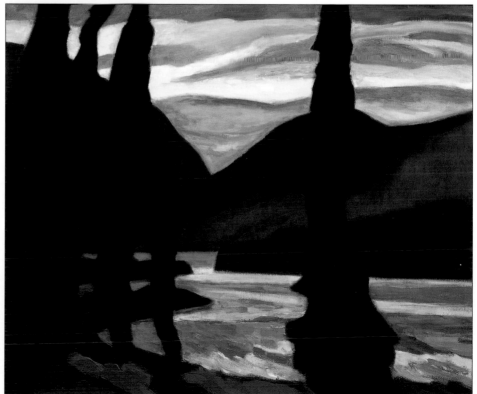

Chilko Lake, 1997. Oil on linen, 40" x 48".
I've heard all kinds of explanations of my work over the years. People who go to museums and frequent the local art show circuit are generally unafraid to ask questions. I appreciate questions more than I do explanations.

Marita Dingus
Francine Seders Gallery, Seattle

Photograph courtesy of Spike Mafford.

I was born in 1956 in the Pacific Northwest and had almost no contact with an African American community. That changed when I entered the Immaculate Conception High School in Seattle in the 1970s during the Black Power movement. The school's ethnic make-up reflected a diversity to which all institutions should aspire. My consciousness was raised by people like Angela Davis, William A. Little, and the students of Immaculate High School.

I went to the University of Washington but Seattle was not diverse enough. I wanted a larger black population to get inspiration from, and I wanted more direct contact with art. I chose Philadelphia because the East Coast was an art stronghold and I wanted to be in a more diverse community. I attended Temple University Tyler School of Art. This University had a campus in Rome, Italy which I attended for a semester.

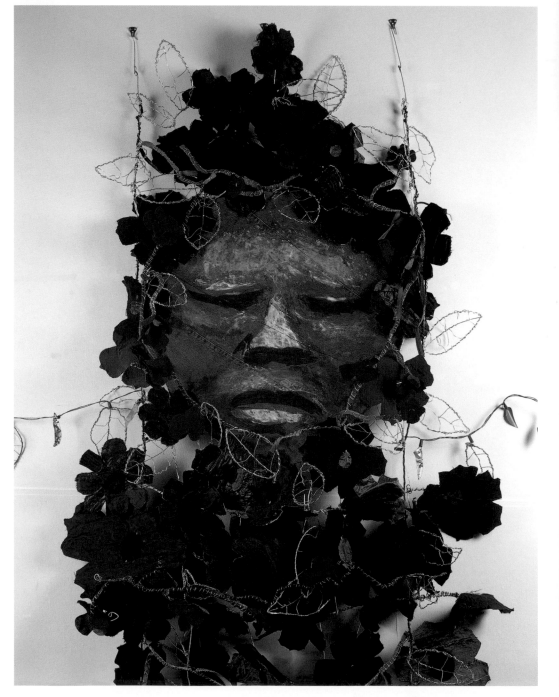

Woman as the Creator (detail), 2002. Mixed media, 216" x 216" x 6". *Courtesy of Francine Seders Gallery. Photograph courtesy of Richard Nicol.*
I haven't bought any art materials since 1982. Everything I use is either given to me or salvaged. My materials are things like strips of cloth, pop tops, pull tabs, computer innards, film negatives, plastic bottles, shells, stones, buttons, eyeglass lenses, telephone wires, crime scene tape, drains, and battered baking tins. I cut, sew, tape, paint, and hot-glue them into sculptures.

Later I went to Morocco for a summer to study art. There I was jolted into reality. There were rats as big as cats and they would bite babies. I had heard about such things in the United States, but in Morocco, I saw the real rats. I decided on no pretty-picture art for me, my art would be political, progressive, and devoted to social issues.

Then I worked three summers as a road crew supervisor. I learned about litter and recycling, and noticed that art could be made out of refuse. In 1983 I went to graduate school at San Jose State University, and began to make art out of junk. The Art Department allowed me to take classes in the African American Studies Department when I told them I was tired of studying European art.

I felt a need to see more of West Africa, so I spent a month in Nigeria. I discovered that racism is not unique to the United States, it is global. Of all the continents I visited, Africa has the most inadequate living conditions and that is no accident.

Today my many trips to Morocco, Nigeria, Ghana, and Egypt have given me the historical basis for my art, which is mixed media sculpture made from discards. They are sculptures and take the form of relics from the African Diaspora. I use discarded materials because I saw how people of African descent were used liked discards by the institution of slavery. The goal of my art is to show how to not only survive but actually prosper under the most dire circumstances.

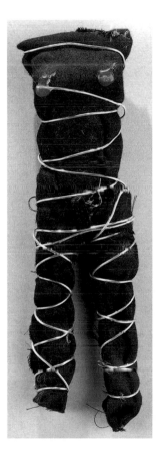

200 Women of African Descent (detail, torso), 1994. Mixed media, approx. 10" x 3" x 1". *Private collection. Photograph courtesy of Spike Mafford.*
When I saw the Castle Elmina in Ghana where men and women were shackled in stifling overcrowded rooms waiting for their boat to the new world, I didn't start crying. I came home and thought about those barely ventilated rooms where hundreds of women and men were held for weeks or months.

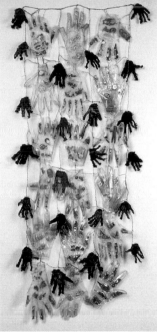

Fence with Many Hands, 2000. Mixed media, 55" x 26" x 2". *Collection of University of Washington Medical Center, Seattle.*

Red Quilt, 1996. Mixed media, 61" x 52". *Collection of Harborview Medical Center, Seattle. Photograph courtesy of Richard Nicol.*
When I went to college, I didn't get the message that art was about getting money. I thought the purpose was to study something you loved. That's what I did.

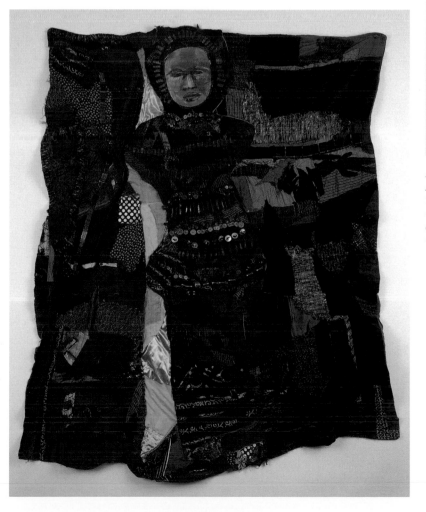

Claudia Fitch
Greg Kucera Gallery, Seattle

My sculpture plays with images from popular culture, such as vernacular architecture or decorative statuary. I am inspired by "ordinary" as well as the "outrageous" ornament in our day-to-day world. How can something like wallpaper be reinvented to have an unexpected, charged presence? Ornament chooses to reveal and conceal. High, low, royal, vernacular, Victorian, modern—every "style" alludes its own era's idea of social significance and taboo. I love to study, play off the different images of ornament and related popular iconography from a variety of eras and cultures, and to bring to the surface their subconscious undercurrents.

In my studio I work intuitively with an ongoing "junk pile" of visual jetsam and flotsam culled over the years—media photos, personal photos, art history photos, postcards, drawings, studio experiments in various materials, found display props, written memories of dreams. For me the junk pile frees. I can explore without feeling that the result must fit the demands of a particular end. I can shift direction with the unexpected juxtaposition, the unplanned connection between things. Something I have looked at for years will suddenly appear in an entirely fresh way. I study it, answer to it, respond to the enigma it poses.

Colossal Heads series, 2002. Fiberglass, auto body paint, powder-coated steel; each work approx. 72" x 49" x 50".
Top left: *The Girl Next Door;* Top right: *Ivory Coast Man;* Bottom left: *Sleeping Spectator;* Bottom right: *Dutch Elvis. All four photographs courtesy of Eduardo Calderon.*

The four images in this group are part of a six-piece *Colossal Heads* suite made for the Seahawks Stadium in Seattle, where these photographs were taken. This artwork was acquired through First and Goal, Inc. for the Washington State Public Stadium Authority. My initial inspiration was the monumental statuary of the Roman civic stadiums, which I wanted to reinvent for the contemporary arena. Each sculpture references a specific formal style, culture, historical era, and color. I wanted the suite to have the cartoon-like graphic boldness of street signage, corporate logos, and festival masks. In them are idiosyncratic interpretations of different cultural icons—the huge puppet-like masks of Rio de Janeiro's Carnival, sculptural signs from Coney Island penny arcades, theatrical masks from a variety of African and Asian traditions, and familiar photographs of movie stars from the twentieth century.

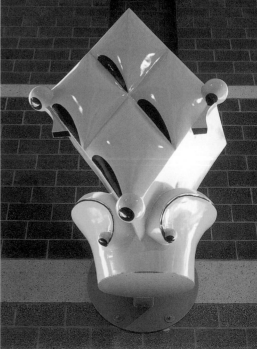

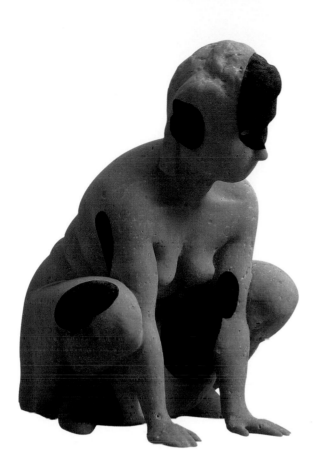

In this process, I can hit on a relationship of images that really touches a nerve. My best work is that which initially makes me really uncomfortable—some childhood or adolescent taboo or vulnerability is being revealed. Or a particular combination of materials will suggest a whole chapter in my life's history. Now I see all these different things only as visual starting points. They carry the emotional tinge of their time. The cultural icons of childhood have accumulated additional layers of experience. I have a passion for the icon that is part memory and part present experience. Though certain specific images still have a charge and urgency, my junk pile is the great, often humorous equalizer.

Left:
The Sphinx in Dappled Shadow (Self Portrait), 2002.
Cast polyester resin with black flocking, 19" x 14" x 15".
Variable edition of 3, courtesy of Greg Kucera Gallery.
My process is to encourage the subconscious to unmask itself.
This is the true intent of my art-making endeavor.

Water Wallpaper, 2002. Collage with wall paint, wrapping paper, flocked paper, graphite, and glue on seven paper panels, 72" x 42" each panel, 72" x 11' total. *Installation at Greg Kucera Gallery, 2002.*
My work teases, pokes fun at the notion of "cultural significance" and at my own gullibility about being "worldly."

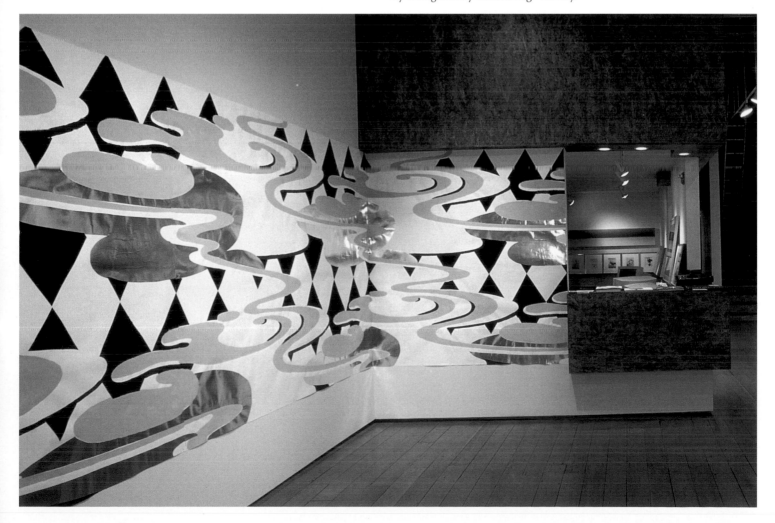

Pam Gazelé
Pam Gazalé, Seattle

Photograph courtesy of Nicole Laverty.

My interest in working with salt as a sculptural material was inspired by a documentary on the Sahara Desert salt traders. Rich in history, metaphor, and life itself, the element that is hewn from the earth is like no other. I'm attracted to the purity and fundamental attachment we have with it along with the meaning we've given salt over the ages.

I have dedicated eleven years of my life to the study of it and the sculpture is the result of my findings. I have chosen to hand carve the solid material in the same manner as classical marble sculpture. I play on the irony that there is a similarity in appearance as marble. The objects I chose to carve and their combinations have a connection with salt's history.

Often, questions concerning the permanence of my art work are asked. I like to reply that salt has been here since the beginning of Earth and will remain in one form or another until the very end. As for my work lasting, depending on the care it is given, why wouldn't it?

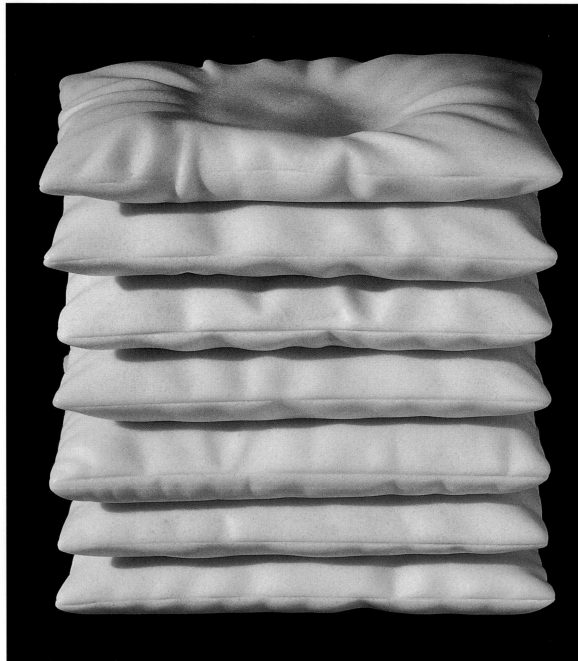

Trousseau # 2, 2000. **Salt, 9.5 " x 7.5".** *Private collection. All photographs courtesy of Russell Johnson.* Seven stacked pillows mark each day of the week.

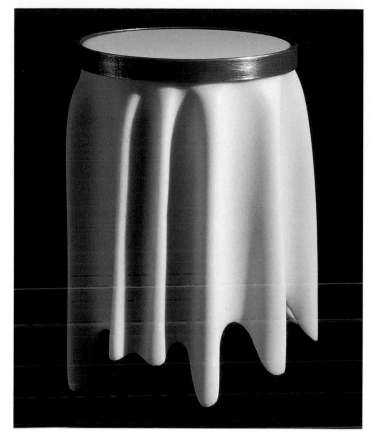

Tambour, 2000. Salt, steel, 9.5" x 7" x 5". *Private collection.*
Tambour is a French colloquialism for embroidery.

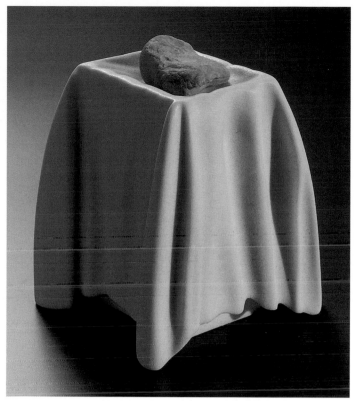

Daily Bread, 1999. Salt, stone, 12" x 7" x 7". *Private collection.*
The stone in this piece was found on a beach and I remarked its resemblance to a crust of bread.

"U", 2000. Salt, flower petals, 12" x 9". *Collection of the artist.*
This piece is meant to resemble cloth that has been released and relaxed from an embroidery ring.

John Grade
Davidson Galleries, Seattle

Photograph courtesy of Jeanne Gabriel.

I begin a sculpture by studying an unfamiliar landscape. I stare, listen, walk, and draw, absorbing what presents itself as most compelling or confounding, and then imagine forms and narratives that I am unable to perceive. Memories of similar and dissonant places that I have explored shadow the new landscape, a landscape which is inherently layered with identifying historical and cultural information. The inhabitants of a landscape are integral to the sculpture. The human body is almost always a point of reference for me. Other life and movement—marine animals, the traffic routes of leaf-cutter ants, the breathing of plants, the slow cracking and melting of a glacier—form inspirations that overlap with remnants of funerary architecture, narrow slats in a drain, shadows cast by irregular stairs, or patterns made by

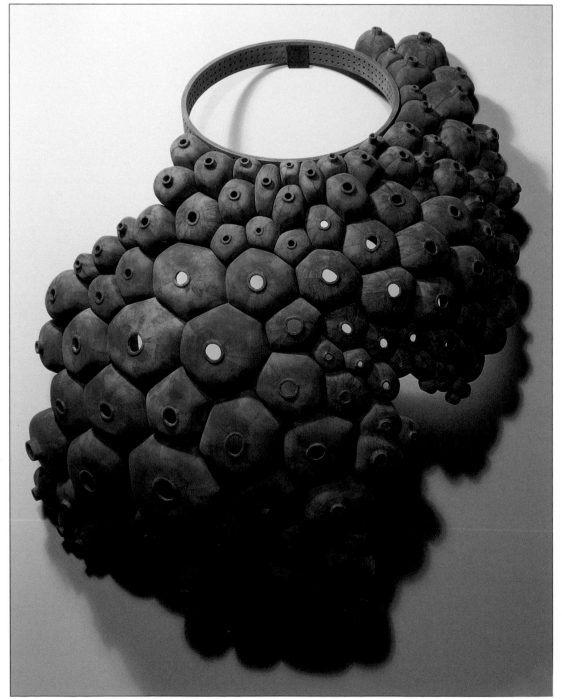

Bone Shoal Sound, 2003.
Wood, 40" x 29" x 13".
Courtesy of Davidson Galleries.

A sculpture is finished, not when the contradictions and overlapping questions that a landscape poses are resolved, but when the questions solidify and I feel that a small mystery is encapsulated.

dunes of sand. Written history and stories have led me to the landscapes of Peru, the Middle East, India, Vietnam, Eastern Europe and North Africa, as well as up into the mountains closer to home. Sometimes my process works the other way around; the shape of a seed or the pattern on a piece of discarded plastic slowly opens out into an imagined landscape to be transformed and mapped into a piece of sculpture.

Each sculpture frames an empty space. A skin, shell, or carapace is wrapped around a visual silence. Repeating forms—marks, ridges, teeth, arcs, lips, or voids—accumulate and compose a whole. During the layering and building of these forms, each small segment acts as a voice exerting a weight, perhaps steering the final object slightly off its original course. These individual influences form moments that retain the memory of a preceding voice, which they support, filter, absorb, or penetrate.

Traces, worn edges, veiled moments, and sealed or opening voids within a sculpture suggest a past function or imply a future use. A shift in the direction of wood

grain or radiating pour lines within resin allude to the way an object bears weight, sinks through water, filters air, or redirects liquid. Exposed bare nubs may be remnants that once hosted something fleshy or an acoustic form designed to channel sound. I select materials to convey buoyancy, longevity, the passage of light or heat, or to balance associations between other aspects within a sculpture. Scale and shape reference a relationship to particular parts of the human body or imply a capacity to engulf its whole.

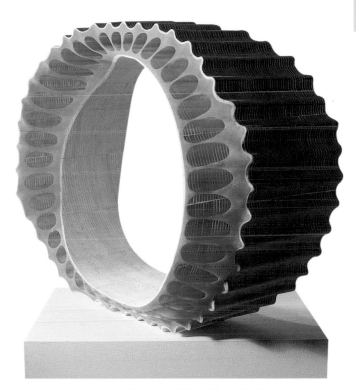

Stem, 2000. Wood and resin, 30" x 37" x 16". *Private collection, Boise, ID.*
At the center of my work lies a consideration of the ways we distance ourselves from absence and create stories which veil and obscure emptiness.

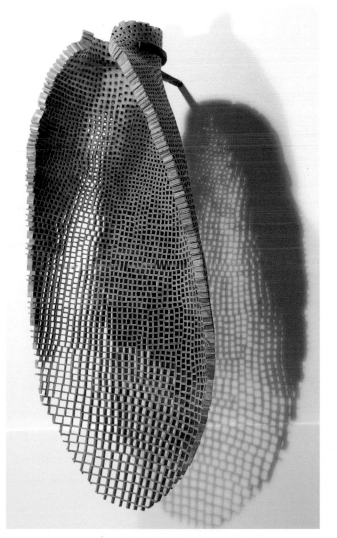

Hide, 2002. Wood and resin, 64" x 26" x 14". *Private collection, Seattle, WA.*
In the end a completed sculpture opens a space for quietly cued interpretation and reflection.

Mouths, 2002. Rubber (back lit), 33" x 63" x 3". *Private collection, Boise, ID.*

183

Gaylen Hansen
Linda Hodges Gallery, Seattle

Photograph courtesy of Gordon Brown.

I grew up on a farm. It mystifies me why I wanted to be an artist. There certainly was no encouragement. The only art around was illustrations in books and magazines. Seeing these I somehow wanted to be an illustrator. My perception of what art is and what it means to be an artist changed over the years. The artist I am is not what I envisioned as a youngster. Today art is both my love and a good friend. I feel particularly fortunate to be involved in an activity that continues to challenge, excite, and surprise.

I think of my art as a Cro-Magnon cave painter capturing the energy and life force of a bison. If someone says my animals are not realistically rendered I say I'm not a taxidermist. I try to capture the essence of the animals. I do not pretend to duplicate the real thing.

August Wolves, 1999. Oil on canvas, 60" x 60". *Collection of Gary Larson and Toni Carmichael.*
While painting I concentrate on painting. Thoughts of fame or fortune corrupt the process. I am pleased by the recognition my work has received over the past twenty years. I am delighted people like my work enough to collect it. During the preceding forty years there were very few sales.

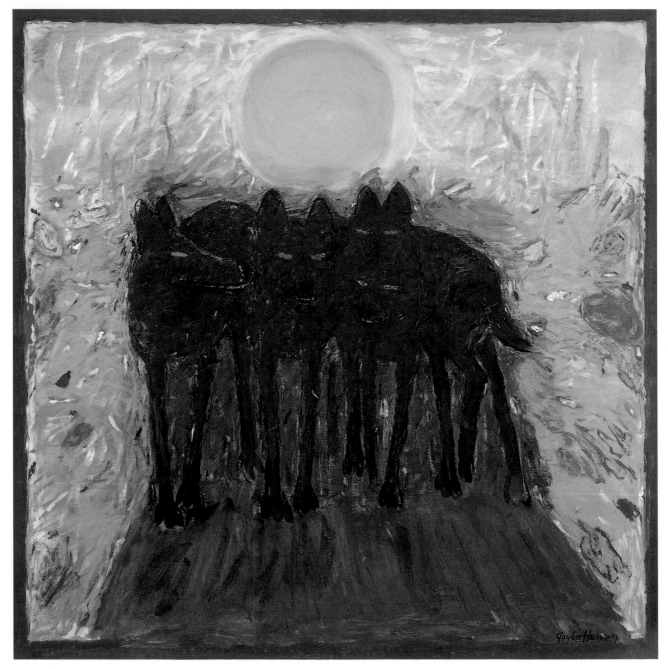

I do not preconceive what a finished painting will look like. I do a lot of simple ink drawings to stimulate ideas for paintings, and am open to change as a painting progresses. The finished work comes as a revelation. Often I do more than one painting of the same subject. By comparing one to the other I get a clearer idea of what I'm doing. Failures can get me back on track. Some of my best paintings follow bad ones.

I have no formula for knowing when a piece is finished. I might think I have completed a painting and it looks good. The next day it does not look so good and needs revisions and more work. There are times I keep on painting when I should quit. Sometimes my wife Heidi, who is also a painter, catches me before I go too far and ruin what I'm doing. Other times a painting has great energy that I don't want to lose, but it is still not fully realized. Eventually though, a good painting lets me know it is what it wants to be, and lets me quit.

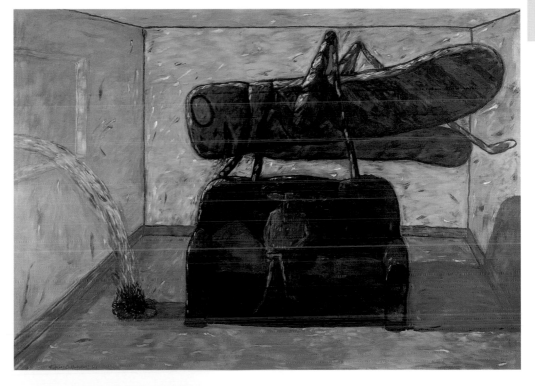

Interior with Maroon Sofa, 1992. Oil on canvas, 60" x 84". *Collection of Northwest Museum of Arts and Culture, Spokane, WA.*
I expect viewers to react first of all to the overall effect and presence of my paintings. Then they might notice the animals in unusual places and juxtapositions. Then their larger-than-life scale. Other things they might respond to are the humor, enchantment, exuberance, the impulsive act. Beyond these, I hope they notice the expressive color, space, scale, and paint handling of my work.

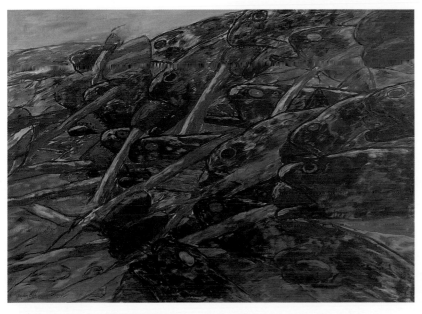

Fish Swimming Through Tulips, 1990. Oil on canvas, 60" x 72". *Collection of Linda Hodges.*
There are art and non-art experiences. Sometimes the two connect. I enjoy fly fishing and I do paintings based on fly fishing. The paintings may enhance my fly fishing experience, but the feelings I have fly fishing are not the same as those I have looking at a painting of fly fishing.

Kernal Riding with Knight #1, 1999. Oil on canvas, 60" x 60". *Collection of Tom and Sue Ellison*

Christopher Harris
Lisa Harris Gallery, Seattle

Canola Field, Sander Road, Nez Perce County, 2001. **Chromogenic print mounted on aluminum, 30" x 30".** *All photographs courtesy of the artist.*

I've always begun with an idea of what I want, then experimented with processes until what I get comes close to my vision.

Some people tag me as a pinhole photographer. That misses the point. The point is the picture. As an interest in itself, I hardly care about the technical aspects of photography. I'd use dishwashing detergent to produce my images, if dishwashing detergent achieved them more easily than the pinhole photo process. The technical side of my art is important only in getting the results I want.

A series begins as a vague, yet to me compelling, idea. That leads to an extended period experimenting with techniques that might transform the idea into photographs. It took a year of many failures before anything worthwhile emerged in the Palouse photographs presented here. Once I find a suitable technique, I work with it, using the technique and the idea to modify each other. An important part of my work is unexpected discovery. I know to stop when a niggling little inner voice stops niggling at me. If it never stops, I discard the image.

Several years after my family moved to the Pacific Northwest, two realities at first conflicted, then converged. One was the clash between the Nature I naively expected to find, and the sprawl and crowds (even in Nature) that are increasingly part of the region. Many would say the region's growth has overshadowed its beauty. At this time I was also inspired by a newly discovered and lasting admiration for the work of Robert Adams, who has photographed the results of migration into the West. Adams helped me see the West as it is. Today we can recall only with difficulty that our love of pristine Nature blinded us to the actualities of sprawl. Yet I had a deepening sense that photographers of the "New West" too easily discarded the sense of the West as a landscape of possibility. I thought this was unjustifiable. The West continues to embody something essential about the American spirit.

Spring Field, Abbott Road, Whitman County, 2000. Chromogenic paint mounted on aluminum, 20" x 20".
My work is contemplative, rooted in the actuality of Pacific Northwest land, light, and weather.

Early Morning, Barbee Road, Whitman County, 2000. Chromogenic print mounted on aluminum, 40" x 40".

Left:
Noon, Barbee Road, Whitman County, 2000. Chromogenic print mounted on aluminum, 30" x 30".
No one has identified me with a school. That is something of an honor. Among Pacific Northwest artists, being hard to categorize is a tradition. That said, I will admit to influences. Rothko is one. More distantly is early-to-mid 19th century American painting, especially the Luminists.

187

Sherry Markovitz
Greg Kucera Gallery, Seattle

Photograph courtesy of Peter Millett.

The artist with her piece *Looking Up*.
Recently I have been working on prayer doll/saint busts that look up into the sky. They are beaded, sewn, and glued. I began working on this particular piece as a conventional upright head. While I was gluing the crown on the head, I paused to dry the head upside down and realized that the head reflected my memory of childhood. I was trying to convey being free to imagine the world upside down.

Artwork gives my life dimension and feeling. There are three phases in the history of my work. The earliest explored my identity. Then came work attempting to sustain an idea over long periods of time. Today's work responds to the world around me while simultaneously recapturing the spirit of my early childhood play.

I am always thinking about images. I envision several works of art in my head every day, at least on a good day. I spend a lot of time wandering and looking, thinking about nothing, exhausting myself, getting lost in the nothingness of the moment. Much of making art is at once soothing and uncomfortable.

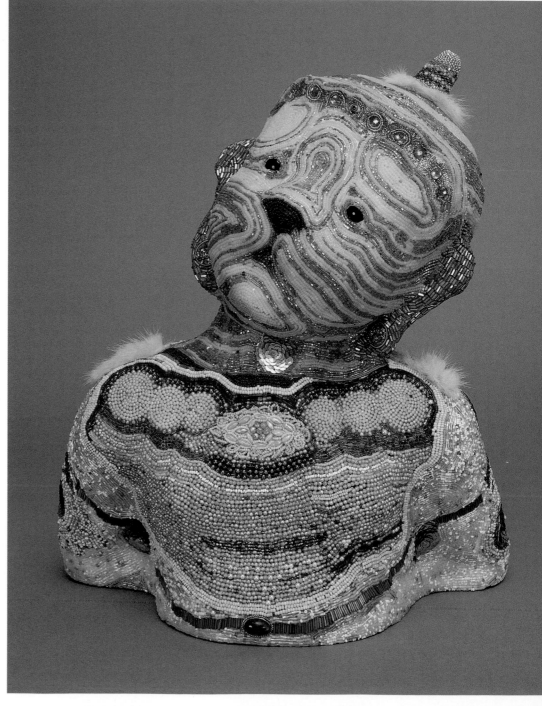

Breasted Buddha, 2002. Mixed media, paper mâché, beads, sequins; 15" x 13" x 9". *Courtesy Greg Kucera Gallery and the artist. Photograph by Peter Millett.*
This sculpture recalls a painting titled *Breasted Buddha* I made fifteen years ago. It is a reincarnation of the Buddha as a goddess, and was part of the doll/saint/prayer series that I was doing.

When I begin to work, much of the imaging making has already been done in my mind's eye. Pieces start in various ways, some by accident, some deliberate. I like to have several works in various phases of completion going on in the studio. I might go to something that I have been trying to work out for five or six years, or I might start an idea that appears fresh to me that day. The creative process is an enigma.

Once I have something concrete to work on I usually sail on it until just before the end. Achieving that last touch of satisfaction is the most difficult part. I have had pieces come together instantly while others take ten years to finish. I usually don't know what I feel about a piece until I complete it.

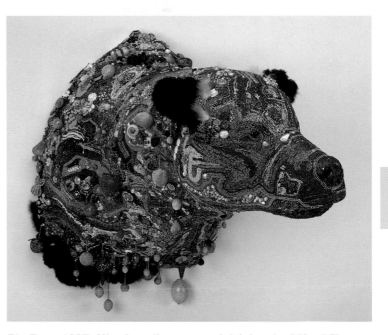

Below:
Search for Enlightenment, 2001. Water media on paper, 42" x 50". *Courtesy Greg Kucera Gallery and the artist.*
This title and image suggest my search for myself and the joking edge of that search. The eyes gazing up on these somewhat ridiculous figures juxtaposed with the dark Buddha figure express the dynamic between humor and seriousness.

Big Bear, 1997. Mixed media, paper mâché, beads; 35" x 26" x 30". *Courtesy of the Corning Museum of Glass. Photograph courtesy of Nancy Hines.*
I sometimes like to make things that are large and spectacular. The detail work in this large bear unifies scale with grandeur. I find beauty like this as soothing to make as to look at. It reminds me of the days when artists had time to make works of great intricacy.

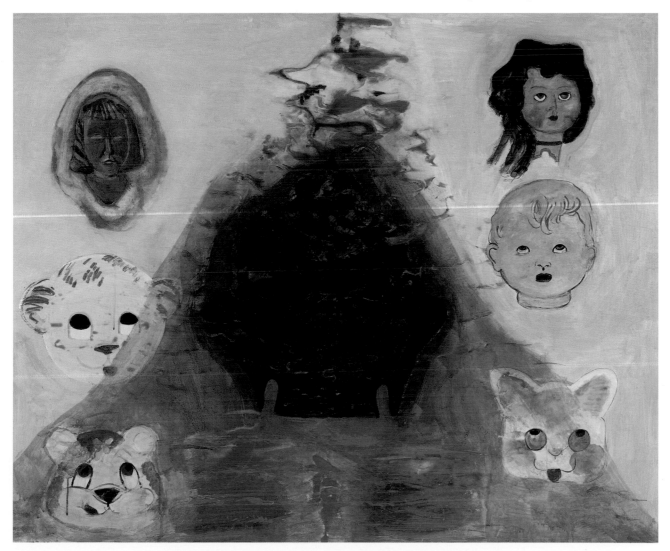

Peter Millett
Greg Kucera Gallery, Seattle

Photograph courtesy of Sherry Markovitz.

If I had to define my images to my outside self, instead of feel them within me, they would be my explorations, my investigations. I explore shapes and materials with no idea where they will lead. It's the unexpected that is exciting, that is the real leader.

I hope that people approach my work with the same kind of openness, as though they're detectives asking, "What's going on here?" That kind of reaction. The same as if you've heard a bird sing but can't quite identify either the song or the bird. That is what I offer. A song, sometimes humor, sometimes tension, maybe an expression of love, maybe of devotion. But always a song.

I've always been aware of a consuming need to work from imagination. Creating spaces, making artwork. As a child I preferred to play alone, setting up creations of little figures and objects. I haven't changed much. I still like to work alone. I am still composing objects whose relationship is to space.

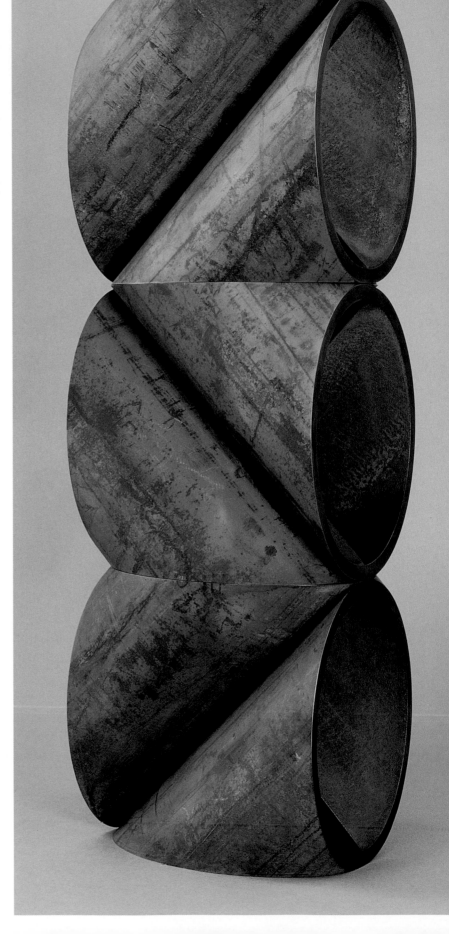

David's Post, 1999. Steel, 36" x 12" x 9". *Private collection. Fabrication: The Gulassa Co., Seattle. Photograph courtesy of the artist.*

Great art is an abstraction of complex feelings. It is a distillation, a concentration of idea and ideal. It works not as simplification, not as reduction. It is a focus on everything, but at high resolution.

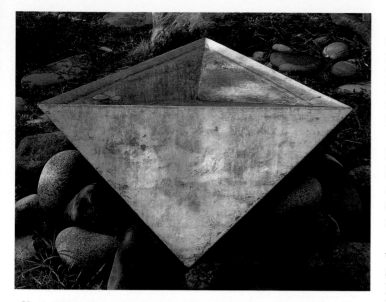

Yoni, 2002. Galvanized steel, 12" x 33" x 33". *Collection of the artist. Fabrication: Aaron Palmer and Ace Galvanizing, Seattle. Photograph courtesy of the artist.*
For the inspiration that originates in instinct, I unerringly go to water. Rains, waves in Lake Washington, ripples in a stream. I love to watch it. When I travel, I seek out sacred spaces, sites of miracles, ancient places still alive with the presence of former lives.

Success gives me more time in the studio. That was my dream of a lifetime when I was a young artist. Not the monetary rewards, but the real rewards that come from making a work. The sensation of sanding the edges of a big bronze form. The amazement of coming up with an unexpected shape. The sheer terror and high drama when I put the brush down and watch the paint dry.

My process is intuitive. It works best when the work leads me. I try to be open to whatever revelation surfaces. It's like creating visual music. I work with shapes in space as if they were notes on air, intervals of space that create a rhythm. I seek the harmonic chord that build a resonance.

A piece is never finished. Eventually I reach a point where the work just refuses to get any better. Yes, I could always do something new to it, try to make it different, but that wouldn't necessarily make it better. On the other hand, if I don't walk away from it, I can't start a new one.

I think of my work as an ever-changing reflection of my inner life. Neither is static. My work constantly shifts and changes perspective, just as I do.

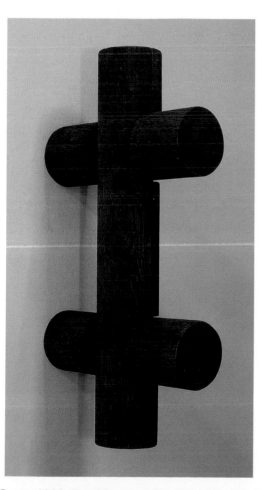

Double Cross, 1999. Graphite on cedar, 34" x 17" x 6". *Collection of the Seattle Art Museum. Photograph courtesy of the artist.*
I guess I'm a Modernist in that I work with abstract forms. But I'm not a Minimalist, I do not shun reference. Just the opposite: I try to load my work with signposts that point to reference.

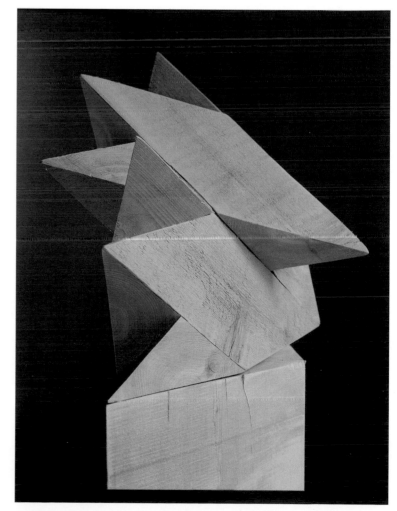

#4 Blast, 1996. Painted cedar, 14" x 9" x 9". *Collection of Lawrence and Dr. Merilyn Salomon. Photograph courtesy of the artist.*
A study of energy and explosion.

191

Richard Morhous
Lisa Harris Gallery, Seattle

As a kid, I was continually drawing and painting airplanes, creating chaos in the kitchen of our Billings, Montana home. After various moves, colleges, and jobs—such as gravedigger in North Dakota (a dead end), teacher in Australia (a dream), and Christmas trinket photographer in Seattle (a bore)—my childhood interest in art revived. Art won out over my other fantasy, that of international airline pilot (too up and down).

Over the last six years I have become interested in quirks of memory and the abstract visualizations of reality that occur during recall. When I first began to make images in the late 1970s, they were fairly realistic life-size charcoal portraits coupled with gestural interpretations of the sitters' energy. Slowly my work has evolved towards supercharged color, bold shapes, black outline-delineated forms, and, occasionally, tightly cropped spatial compo-

Scrabble, 2001. Acrylic on paper, 25.5" x 34". *Private collection. Photograph courtesy of William Wickett Fine Art Services.*
Many experiences are universal—the challenge is to grab those commonalties and paint the essence.

Heat, 1999. Acrylic on paper, 34" x 25.5". Private collection. *Photograph courtesy of William Wickett Fine Art Services.*
Due to the ever-changing and maturing nature of the artist, a work is never finished. It will only feel complete during the period it is initially crafted.

Sunburn, 2001. Acrylic on paper, 18.75" x 26.5". *Permanent collection of the City of Portland, Oregon. Photograph courtesy of the artist.*
Color palettes vary, rhythms alter. All, like memory, reflect differently with time.

sitions. If one thinks all seas are blue and all trees are green, a realistic image of place is neither present nor necessary. Color can create an emotive state in any shape and shade desired. Viewers then can add their own experiences and interpretations to the scene. Judgment of technique ceases. Something more personally satisfying evolves.

My subject matter starts with observing the day-to-day visuals surrounding me that pique my interest, curiosity, and enjoyment. "I wonder where that stair goes? Look how the light bends through those trees! What great shadows those buildings throw! I wonder if anyone else has noticed how that laundry glows?" Interests change daily, but once a subject has been decided, composition and process come into play, distilling, changing, exaggerating, like dance steps rhythmically flowing, each movement leading to another. Reality ends and, via color, interpretative memory begins.

Eden, 2002. Gouache and watercolor, 6" x 6". *Private collection. Photograph courtesy of the artist.*

William Morris
William Morris Studios, Stanwood, Washington

Photograph courtesy of Russell Johnson.

I knew since I could walk that I would be an artist. From the very beginning the arts spoke to me, just as do the mountains and outdoors. In high school I had an incredible mentor, Lloyd Baskerville. He created an environment for us where the creative source could take over. He had us read poetry, philosophy, we visited museums, did experimental firings with ceramics, meditated, said chants. He pointed me in the direction to where I am now.

I don't accept the notion that artists are something special. I see human works as a product of nature. Everything we create is product of nature. Nature is infinite, there's something in it for everyone. I'm always amazed at what people see, it is always a reflection of themselves, not of me or the work itself.

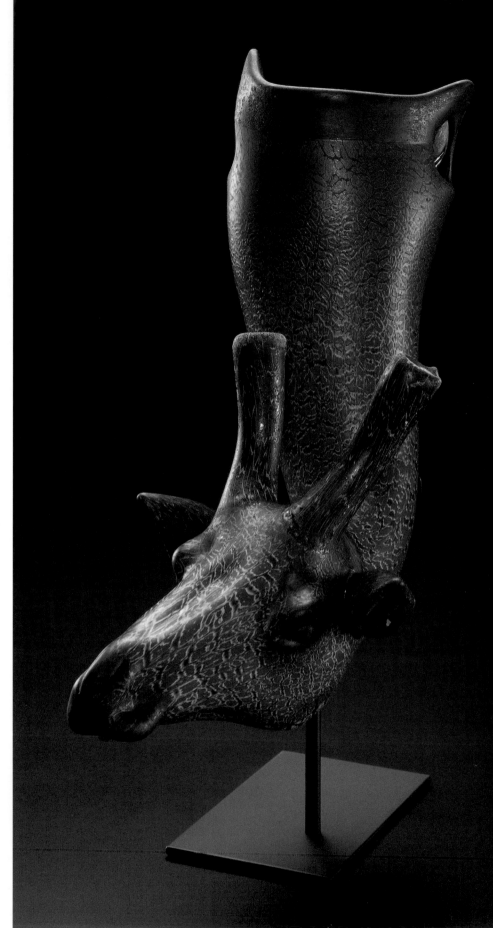

Giraffe Situla**, 2000. Blown glass, 22" x 18" x 10". **All photographs courtesy of Rob Vinnedge.
The *Situla* series is about bringing animal characteristics into our most common of objects. I have so many mythic encounters in the natural world—crows, ravens, deer, elk. They are messengers that denude us of the real world. Every time I go to create an animal, I am revealed into the character of the animal. Every time I see the animal after that, my world is enriched.

194

When everything I see is being stirred up within me, I feel wondrous. When I get an inspiration, the impulse comes at very high speed. My mind gets hold of the inspiration, chews on it till it manifests itself. My eye sees the impulse differently, connects it with previous impulses. They build on each other. I translate the impulses quickly, get myself task oriented, engage in action and reaction. The piece simply manifests itself. It doesn't matter how I start or what I do, when I have something in front of me, I respond.

My mind wants to take credit. It preoccupies, it always edges aside the creative impulse. Creativity is all impulse. The mind is not an impulsive entity, it does what it is familiar with. The moment of clarity can come in a word, a painting, a poem, a song. The trick is not getting attached. I use the discipline of craft to close the gap between my impulses and my mind, and between my mind and my doing. If I have a point to make, a sledgehammer makes no sense. I have to head toward it without attachment, go as chance happens, deviate if the path takes me to a new place.

It's hard to say specifically what success is. My basic law is to show up. When you buy into ego, it causes trouble. You don't get to fame without acquiring some megalomania. I don't talk about fame, don't listen to it. It's just sparklers and seduction.

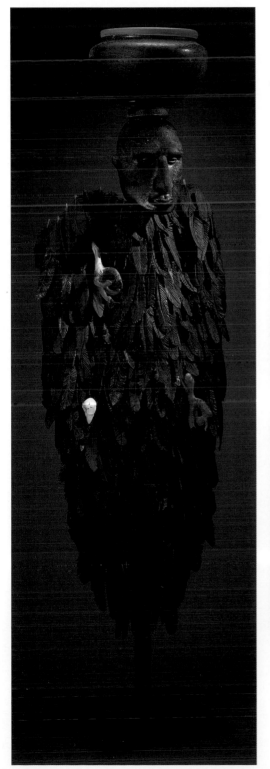

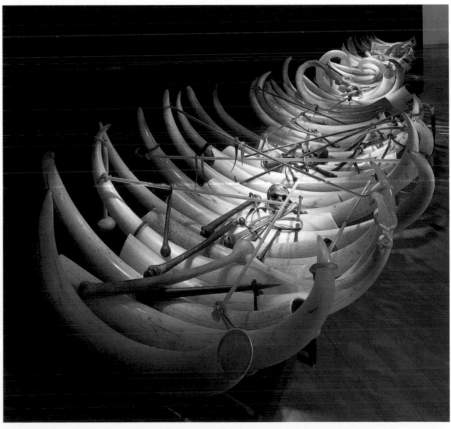

Hupa Shaman, 2001. Blown glass on steel stand, 74" x 22" x 19".
The *Man Adorned* series is about how adornment affects our environment and beliefs. I view all my work as a spectator. When I started *The Man Adorned* series, I never thought I would end up making human faces. The idea was to focus on adornment, humans as adorned by environment, where we live, what we eat, the way the sun shines on us. All these forms of adornment are from the inside out. Another time I started to do a bird, but it turned into the Indian god Ganesha. We worked on it two days trying not to play god, and what we got was a god.

Cache, 1993. Glass, wood, metal; 5' x 6' x 32'.
This installation is a cultural commentary about the devaluation of ceremony. I believe we are connected to all things, The Force, the All, the One, Brahma, if you want to put it that way. We are a part of the grandest whole. At times it is an endless flood. Anything that comes through us is part of the grandest whole. Whatever the unknown and unknowable is, it keeps me from being lonely and self-critical. And also from being conceited and non-self-critical.

Joseph Park
Howard House, Seattle

Photograph courtesy of Deborah Gassner-Park.

My work is almost a parody of myself, a reflection of what I've thought of, done, or dreamt of doing. In one painting, I see myself as an angel approaching arms outstretched to receive his audience. In another, my wife and I are caught playing Cowboys and Indians. Laying on the floor, my wife becomes a rabbit basking in the sunlight.

It is important that my characters feel "at home" in the environment of the paintings. For example, the painting of my wife takes place on the second floor of my grandmother's house in Korea. A rabbit takes a smoke break in a market I frequent. An elephant becomes an odalisque (her parlor modeled after one by Ingres, who himself was fantasizing the look of the "Orient"). These slightly comic and slightly exotic characters inhabit settings with an air of familiarity, whether from my personal experience or from a cultural memory of well-known images.

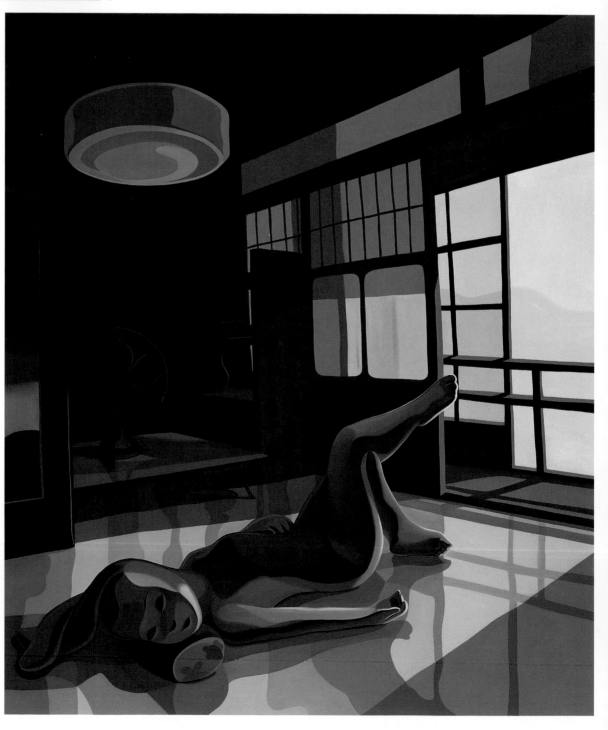

La Belle, 2002. Oil on linen, 52" x 43". *Collection of Kimberly Bodnar. Courtesy of Roberts and Tilton, Los Angeles. Photograph courtesy of Roger Schreiber.* Depending on how specific the image will be, my process involves a lot of pre-visualization. I make most of my choices during the drawing phase. There I compose the image, make color choices, and so on. I usually paint it with very few changes.

My preoccupation with animals has much to do with their place in today's vernacular. We grow up with bunnies telling us what cereal to eat, what chocolate milk mix to drink. In comic books and cartoons certain animals reflect certain psychological traits. They also enable me to slip past racial impressions or stereotypes. More simply, some animals look good in turbans.

I set no agenda as to what a viewer should realize or understand. A high degree of specificity in a picture makes it easy for viewers to accept the piece at first glance, even when the "meaning" is ambiguous. The princess is bewildered, but why? A painting angel arrives on the scene, to accomplish what? I want the combination of simplicity and ambiguity to encourage viewers to enter the work and complete it on their own terms.

Great, 2000. Oil on canvas, 52" x 43". *Schwartz Family Collection. Courtesy of Roberts and Tilton, Los Angeles. Photograph courtesy of Arthur Aubry.*

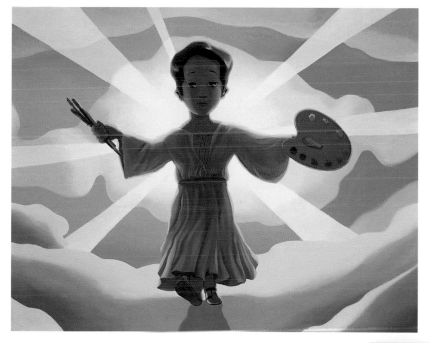

Arrival, 1998. Oil on canvas, 24" x 30". *Collection of Chris and Joanie Bruce, Seattle. Photograph courtesy of Arthur Aubry.*
Friends say my work has a coy or wry quality. That is fairly accurate. I make pictures that I want to enjoy. They may have a little twist of some kind, but they do not satirize, and since they are so often about me, they never criticize.

La Grande Odalisque, 2001. Oil on linen, 30" x 36". *Collection of Ben and Aileen Krohn. Courtesy of Howard House, Seattle. Photograph courtesy of Roger Schreiber.*
This painting was inspired by a trip to the zoo. The impossibly elongated spine of Ingres' *Odalisque* popped into my mind as I stood there looking at a reclined elephant with it's seemingly unending vertebrae.

Francesca Sundsten
Davidson Galleries, Seattle

Photograph courtesy of Karen Moskowitz.

I try not to make my work too specific or to display my intentions too didactically. The nature of any painting is its passivity and its ability to resonate silently through time. The skin of a piece is composed by craft as a lure—the substance lurks more quietly. I hope that the viewer will find various levels on which to interpret the work: esthetically, narratively, metaphorically, personally, culturally.

I usually find myself working in a series format where the idea is in place all at once for twenty or so works. The idea usually encompasses a wide spectrum of possible tangents. Each individual painting is therefore a puzzle piece that adds up to the overriding theme, but also will stand on its own. The work grows out of itself. The ideas

Monster Sheephead, 2002. Oil on panel, 36" x 36". *Private collection. All photographs courtesy of Spike Mafford.*
I never think of my work as reflection of myself. Mostly I think of it as something that's already there and its my job to pull it out.

are never completely new or random. Rather, they are an extension of or sequence to the work before. I don't see any end to the thread I'm following, and I find that very exciting.

Over the last few years the work has changed in subject from the narrative figure, to animals, to weather, to situational metaphor, to portraits of the hero. These now coalesce in the isolate or double figure in its environment. The theme I'm working with at present is the recurrence of animal/human hybrids in world myth and the myth of the double, both of which coincide with the bugaboos of gene manipulation and cloning. The ancient meets the future.

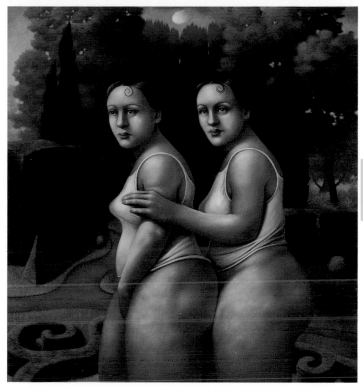

In the Garden, 1997. Oil on linen, 36" x 34". *Private collection.*

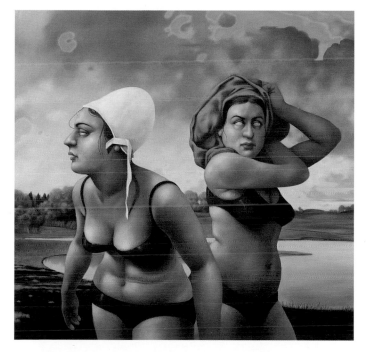

Blind Swimmers, 1997. Oil on linen, 36" x 36". *Private collection.*
A piece is finished when no one part detracts from the whole.

Blind Deer, 1999. Watercolor and acrylic on clayboard, 18" x 24". *Private collection.*

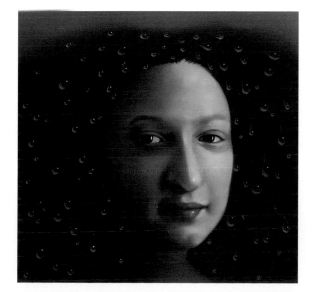

Dissolution, 2002. Oil on panel, 15" x 15". *Private collection.*
I prefer to work from found references as a way to advance what I already know or am able to construct.

Gillian Theobald
Linda Hodges Gallery, Seattle

Photograph courtesy of L. A. Heberlein.

I had intellectual parents who took mysticism seriously. My own first experiences of the mystical were as a child when alone in nature. Our family attended Quaker meetings. Quakers are concerned with being still and going inside to wait for The Light. Now I can see that my life as a painter has been looking for that Light. I hope when people look at my work they experience a place of internal stillness. The unique quality of attention that both the artistic and meditative process share is the slowing down and peering into the nature of an instant, each reminding us how compelling this kind of awareness can be.

Left-brain sequencing and language are so foreign to me that I seek and process large amounts of visual input to understand where I fit in the larger picture. Success has never been a part of my agenda; though being a part of the community of fellow artists where I live is important to me. I feel strongly that I am not a landscape painter; in fact, the work I revel in is often very different from my own—Martin Puryear, Mark Rothko, Leon Golub, Kerry James Marshall, James Turrell, and Bill Viola.

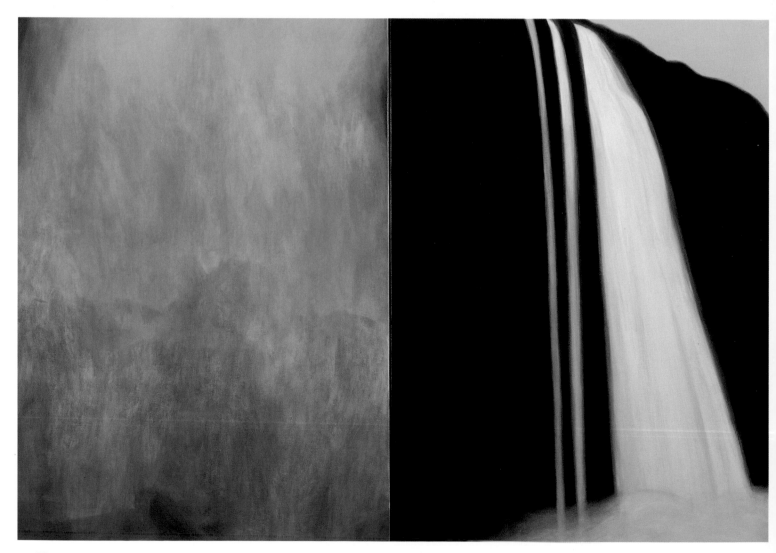

Elements: Fire and Water (Mist), 2001. Alkyd and oil on canvas over panel, 60" x 84". *Collection of Jeff and Kim Seely.*
Today what happens on the canvas is separate from the natural world I see, but not from how that nature can make me feel.

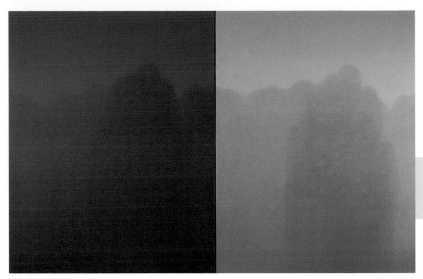

Night and Day (Aspen), 2000. Alkyd and oil on canvas, 48" x 74" (diptych). *Photograph courtesy of Colleen Hayward and Cirrus Gallery, Los Angeles.*
I feel it is important to risk ruining the work in order to feel at peace with it.

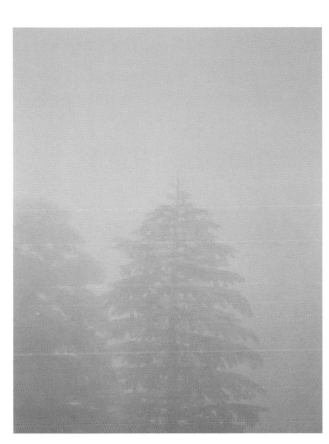

Day (Lone Pine), 2001. Alkyd and oil on canvas over panel, 46" x 35". *Photograph courtesy of Richard Nichols and Linda Hodges Gallery.*
There was a time when my family was concerned about the amount of black in my work. To me that work was about the light, which the dark paint only served to demonstrate.

Earlier in my life I was influenced by Abstract Expressionist teachers and mentors. Even now I often begin by moving paint around until I find an image. I am visually drawn to what has archetypal resonance. Sometimes color is very much an element in a particular series; but there have been times when it seemed important to deny color its full range in the service of the concept. Other times alternate images suddenly suggest themselves in a piece that up to then had seemed resolved. There have been occasions when I am unsure whether I am doing one piece, three pieces, or a long series, so I proceed in multiple directions until one of them seems to have more energy and so wins out. I hone/alter, hone/alter, hone, until I feel no discomfort when I look at the piece. At some point, when I walk into my studio and see nothing in a piece that bugs me, it's done.

Bend, 1986. Enamel on canvas over wood, 48" x 66". *Collection of Irene Williams. Photograph courtesy of the artist.*

Lisa Zerkowitz
Bryan Ohno Gallery, Seattle

Photograph courtesy of Boyd Sugiki.

I often think my path was chosen for me. As a child I imagined some-day being an artist, but did not really understand what that meant until much later. Even after graduate school I did not really grasp the course of my life if I became an artist.

Though my emphasis in college was printmaking, it was in my sculpture courses where I began to come closer to expressing my thoughts via a medium. In time, I moved away from two-dimensional work to sculpture, and was drawn to glass, which became my material of choice. Several years later I had the opportunity to work in a print shop, and began combining printmaking with my love of glass.

My work often deals with the complexities of memory. About five years ago I commenced a body of work based on childhood memory. School-child imagery, playground equipment, and objects associated with children became metaphors for innocence. I wanted to comment on the loss of innocence humans undergo with experience, to return the viewers' minds to the freedom of youth. I hoped to trigger memories of a place or event in their past, fragmented though they might be.

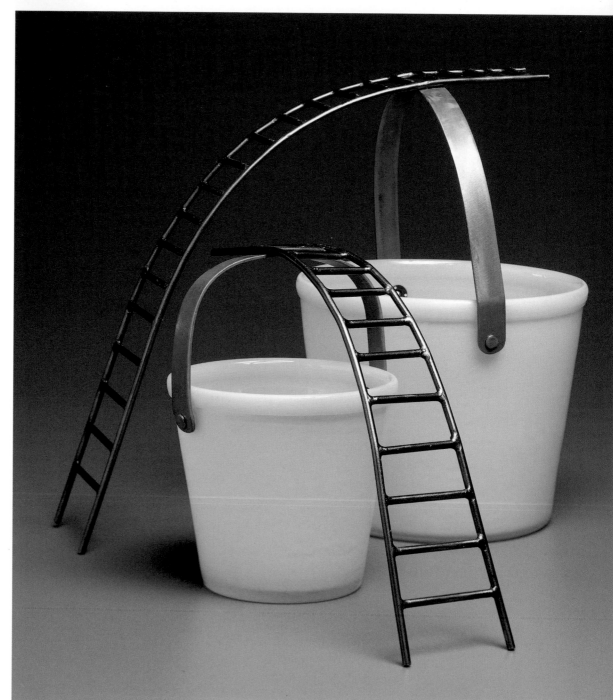

Hide & Seek, 2001. Blown glass, steel, and ink; 16.5" x 18" x 21".

202

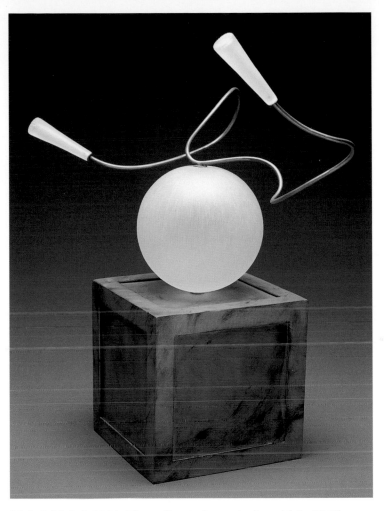

Side by Side, 2001. Blown glass, steel, and ink; 30" x 17" x 4". *All photographs courtesy of Michael Seidl.*
Nothing is ever made in vain.

Mabel, Mabel, 2001. Blown & cut glass, steel, and ink; 25.5" x 21" x 20".

Today I look back on previous pieces and note what sets especially successful works apart from the others. Ironically, it is the less successful pieces that drive me to work harder, they are the path to my most exciting work.

Making art for me always begins with an idea or thought. I do quick sketches and write down words associated with those thoughts. The combination of word association and sketches helps me define form, color, and composition. Then I begin working with the glass and steel directly, with little or no model making. I am always amazed how materials in their original state can be manipulated into something that takes shape, form, and meaning.

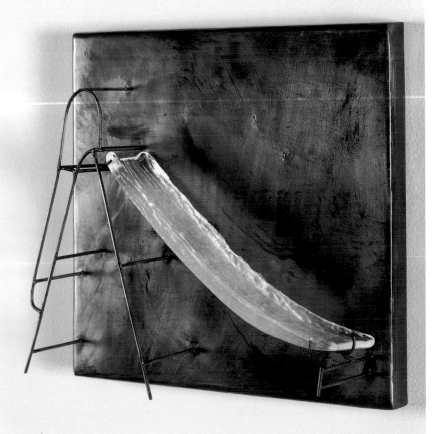

Feat First, 2000. Kiln cast glass, steel, and ink; 10" x 10" x 4".
It is an indescribable feeling to create something out of what seems like nothing, and to transform words into a visual language that viewers find interesting, thought provoking, and challenging.

Margaretha Bootsma
Linda Hodges Gallery, Seattle

Region 6
British Columbia

Points of View, 2002. Silver print, aluminum, acrylic paint, wax, and plaster on wood panel, 24" x 24". *Private collection. All photographs courtesy of the artist.*
My work is a way of re-seeing the world. The photograph points to outer reality, whereas painting evokes the inner world.

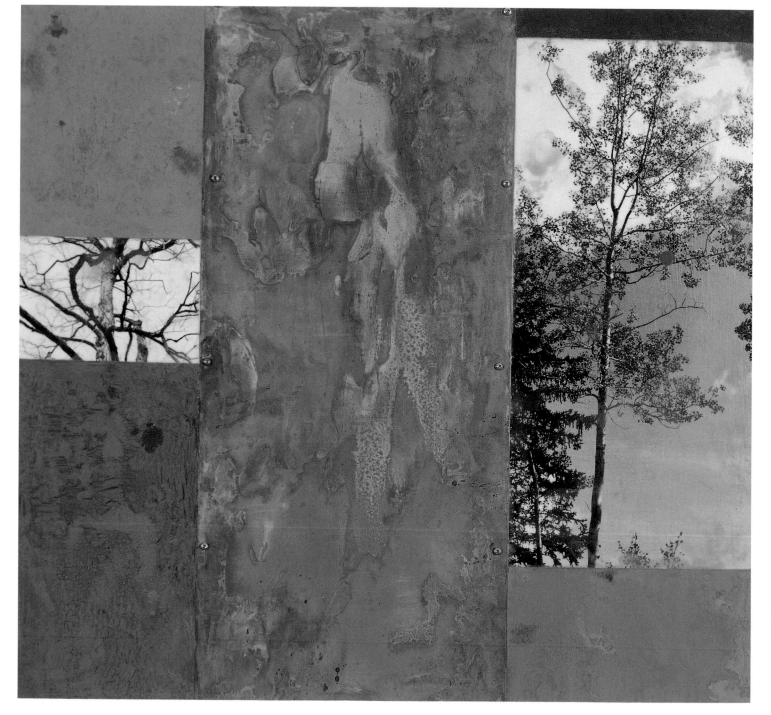

Ancient (River) Shore—Fraser River, 2001. Silver print, steel, acrylic paint, wax, sand, and plaster on wood panel; 36" x 39.25".

I think of myself as a Matter Painter, someone who works with the physicality of materials to imply processes such as decay or reclamation.

Sky Turning, 2002. Silver print, steel, acrylic, and wax on wood panel; 24" x 20". *Collection of Jerry Dahlke, Tacoma.*

For me, material is secondary to outcome. A good picture transcends its material.

I seek ideas everywhere. Nature is a powerful impetus, a recurring theme in my work. It nourishes me, opens infinite possibilities. My pieces distill the landscape as I experience it. Their formal pictorial arrangements convey human intervention in the landscape and evoke the coexistence of order and chaos. There is so much more to them than paint. I use materials such as corroded metal, branches, leaves, roots, earth pigment, or wax to suggest the earthly processes of growth and decay. The results are more re-constructions of a site than paintings.

I want people to not simply look, but participate in a work, to make relationships between forms of representation in painting and photography, to experience a sense of place that is more unconscious than conscious. By extension, I want people to be reminded that human existence is aligned with all living things.

But, being art, this evolves all the time. Recently I had a clear idea of something I wanted to do, but technically wasn't sure how to do it. I explored the process, circling it ever closer, until it simply "became." What I wanted was there all along, I just needed to explore where it was. Other times a work is conceived through a more rational approach. This often happens simply by arranging the components I will use in the work—the metal, the photo, the objects. I explore all the possible directions this idea could go conceptually or technically, until they evolve into a physical piece. I rely on the "accident" or "chance" of my lack of control over the paint during the creation phase. Things happen that I could not conceptualize straight off the top of my head. Then I adjust the work—usually the color and surface—until it acquires enough "history" created by adding and subtracting subsequent layers of paint, and by processes such as corroding, sanding, scraping, and so on.

Distant Summer, 2002. Silver print, steel, copper, earth, acrylic, wax, and pigment on wood panel; 48" x 48". Collection of Deloitte and Touche, Seattle.

Enough of these and I have a series. To me a series is a dialogue between paintings, an idea that is turned over and over and looked at from different angles. An idea usually can't be completely captured in a single visual assertion. It is more like a novel or short story. The series runs its course, leading me to something new that engages me even more. That becomes the distillation point of the next series.

Lori-ann Latremouille
Augen Gallery, Portland

Art is a spiritual remedy, the calm in the eye of life's storms. It is a powerful and magical tool that helps me to uncover and experience what lies within my subconscious mind. With it I can realize and heal myself. Great art comes from the heart. It is about clear feeling and insight. Logic just gets in the way.

I believe these spontaneous images exist independently, ready to be revealed. Not just for myself but anyone who finds the key to their door. I have in a sense woven a net that enables me to fish from the waters of the subconscious. These waters are constantly in flux, changing and evolving. But within the teeming chaos I find limitless sets of order, patterns which give shape and cosmos to all forms, creating a universal wholeness. Separation is a kind of mental illusion. Whether we perceive it or not, all things spiritual and material are inextricably linked.

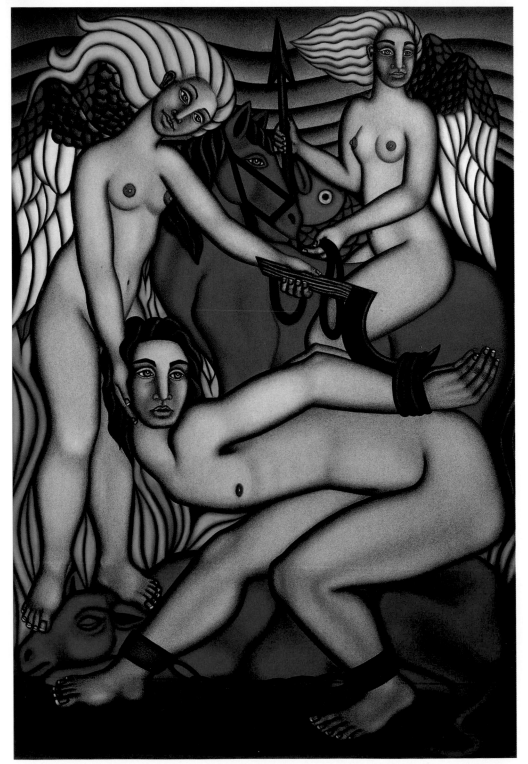

Freeing the Slave, 1994. Charcoal
and pastel on paper, 30" x 22".
Private collection.
I want people to bring their own
thoughts and feelings to my drawings. I
want my artwork to be a mirror,
reflecting and inspiring their
subconscious state.

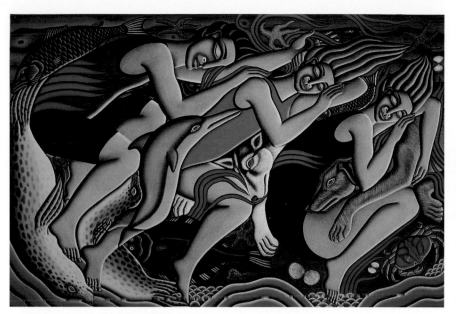

Sea Dreams, 2002. Charcoal and pastel on paper, 46" x 68". *All photographs courtesy of Angus Bungay.*

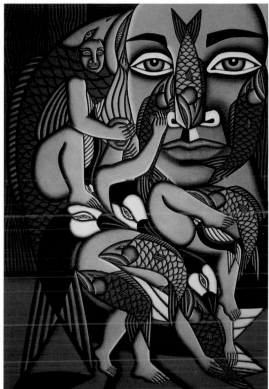

Salmon Man, 1997. Charcoal and pastel on paper, 66" x 44". *Collection of University of British Columbia.*

My drawings are dream images that emerge from my subconscious. Like the visions of a shaman who has descended into the underworld to return with glimpses of eternity.

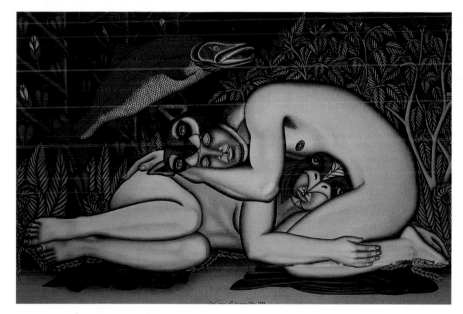

The Return, 1993. Charcoal and pastel on paper, 32" x 41". *Private collection.*
While creating my drawings I often experience a sense of joy, a peaceful plenitude. A piece is done when all is in it that it must have, and all that is in it is clear.

Every time I look at a work I've done, my reaction to it changes as my inner vision develops. Sometimes there is a feeling or event, an image, a dream, a memory, or an object that inspires a work. Other times, I just start drawing lines to see what happens. Forms and figures appear and grow, then morph, and morph again. Within a human thigh a dolphin will appear. A bird, a moon, fish, paired figures, creatures; flora and fauna all entwining. A drawing that started soft and undefined darkens and sharpens into dimension and complexity.

I want people to grasp the subconscious nature of my work. My images are explicit visions of how experiences, dreams, thoughts, shapes, sounds and feelings, blend and unfold from our minds. My work displays that all individuals are linked to a vast subconscious pool. I want them to see the timeless, limitless and meditative quality of the work. I want them to see that the smooth dreamlike quality, with so much pattern and attention to detail, with everything flowing together so beautifully, beckons people's minds and touches their subconscious. I want them to see how powerful and valuable the intuitive process in art is, unfettered by the chains of reason. My figures are integrated spiritually and physically with all other creatures and forms. We are part of, and fit perfectly into, a vast and limitless life force. This is essential for our survival.

Where to Find These Artists

Southern California

Peter Alexander
www.peteralexander.com

Brian Gross Fine Art
49 Geary Street, 5th Floor
San Francisco, CA 94108
(415) 788-1050
www.briangrossfineart.com

Craig Krull Gallery
2525 Michigan Ave., B-3
Santa Monica, CA 90404
(310) 828-6410
www.artnet.com/ckrull.html

Peter Blake Gallery
326 N. Pacific Coast Highway
Laguna Beach, CA 92651
(949) 376-9994
www.peterblakegallery.com

James Corcoran Gallery
11418 Missouri Avenue
Los Angeles, CA 90025 USA
(310) 966-1010

Franklin Parrasch Gallery
20 West 57th Street
New York, NY 10019
(212) 246-5360
www.franklinparraschgallery.com

Imago Galleries
45-450 Highway 74
Palm Desert, CA 92260
(760) 776-9890
www.imagogalleries.com

Tony Berlant

LA Louver
45 N. Venice Blvd.
Venice, CA 90291
(310) 822-4955
www.LALouver.com

Lennon, Weinberg, Inc.
560 Broadway, Room 308
New York, NY 10012

Brian Gross Fine Art
49 Geary Street, 5th Floor
San Francisco, CA 94108
(415) 788-1050
gallery@briangrossfineart.com

Sandow Birk

Koplin Del Rio Gallery
464 North Robertson Blvd.
Los Angeles, CA 90048
(310) 657-9843
www.koplindelrio.com

Jo Ann Callis

Craig Krull Gallery
2525 Michigan Ave., B-3
Santa Monica, CA 90404
(310) 828-6410
www.artnet.com/ckrull.html

Carole Caroompas

Mark Moore Gallery
2525 Michigan Ave., A-1
Santa Monica, CA 90404
(310) 453-3031
www.markmooregallery.com

William Glen Crooks

Scott White Contemporary Art
7661 Girard Avenue
La Jolla, CA 92037
(858) 551-5821
www.scottwhiteart.com

E. S. Lawrence Gallery
516 East Hyman Avenue
Aspen, CO 81611
(800) 646-9504
www.eslawrence.com

Diane Nelson Fine Art
435 Ocean Avenue
Laguna Beach, CA 92651
(949) 494-2440
www.dianenelson.com

Alex Donis

Frumkin/Duval Gallery
2525 Michigan Ave., T-1
Santa Monica, CA 90404
(310) 453-1850
www.frumkinduvalgallery.com

Michelle Fierro

Brian Gross Fine Art
49 Geary Street, 5th Floor
San Francisco, CA 94108
(415) 788-1050
gallery@briangrossfineart.com

Roberts and Tilton Gallery
6150 Wilshire Blvd.
Los Angeles, CA 90048
(323) 549-0223
robertsandtilton@earthlink.net

James Harris Gallery
309A Third Avenue South
Seattle, WA 98119
(206) 903-6220
www.jamesharrisgallery.com

Prints of Michelle Fierro's works are available from:
Atelier Richard Tullis
Santa Barbara, CA
http://tullis-art.com

Robbert Flick

Craig Krull Gallery
2525 Michigan Ave., B-3
Santa Monica, CA 90404
(310) 828-6410
www.artnet.com/ckrull.html

Robert Mann Gallery
210 Eleventh Avenue
New York, NY 10001
(212) 989-7600
www.robertmann.com

Charles Garabedian

LA Louver
45 N. Venice Blvd.
Venice, CA 90291
(310) 822-4955
www.LALouver.com

Maxwell Hendler

Patricia Faure Gallery
2525 Michigan Ave., Building B-7
Santa Monica, CA 90404
(310) 449-1479
www.patriciafauregallery.com

Salomón Huerta

Patricia Faure Gallery
2525 Michigan Ave., B-7
Santa Monica, CA 90404
(310) 449-1479
www.patriciafauregallery.com

David Ligare
www.davidligare.com

Koplin Del Rio Gallery
464 North Robertson Blvd.
Los Angeles, CA 90048
(310) 657-9843
http://home.earthlink.net/~koplin/repres.html

Hackett-Freedman Gallery
250 Sutter Street, Suite 400
San Francisco, CA 94108
(415) 362-7152
www.hackettfreedmangallery.com

Frank Lobdell

Hackett-Freedman Gallery
250 Sutter Street, Suite 400
San Francisco, CA 94108
(415) 362-7152
www.hackettfreedmangallery.com

John Mason

Frank Lloyd Gallery
2525 Michigan Ave., B5B
Santa Monica, CA 90404
(310) 264-3866

Perimeter Gallery
210 W. Superior Street
Chicago, IL 60610
(312) 266-9473
www.perimetergallery.com

Sherry Leedy Contemporary Art
2004 Baltimore Avenue
Kansas City, MO 64108
(816) 221-2626
www.sherryleedy.com

Michael C. McMillen

LA Louver
45 N. Venice Blvd.
Venice, CA 90291
(310) 822-4955
www.LALouver.com

Memphis

La Petite Gallery
5524 W. Pico Blvd.
Los Angeles, CA 90019-3916
(323) 939-5055

Gallery 825
825 N. La Cienega Blvd.
Los Angeles, CA 90069-4707
(310) 652-8272
www.laaa.org

Latino Pop Shop
7985 Santa Monica Blvd.
Suite 102
West Hollywood, CA 90046-5073
(323) 822-9583
www.titaniametalarts.com/popshop.html

Ed Moses

LA Louver
45 N. Venice Blvd.
Venice, CA 90291
(310) 822-4955
www.LALouver.com

Brian Gross Fine Art
49 Geary Street, 5th Floor
San Francisco, CA 94108
(415) 788-1050
gallery@briangrossfineart.com

Imago Galleries
45-450 Highway 74
Palm Desert, CA 92260
(760) 776-9890
info@imagogalleries.com

Klein Art Works
400 North Morgan
Chicago, IL 60622-6538
(312) 243-0400
www.kleinart.com

Bobbie Greenfield Gallery
2525 Michigan Avenue., B6
Santa Monica, CA 90404
(310) 264-0640
art@bggart.com

Minoru Ohira

Bryan Ohno Gallery
155 S Main Street
Seattle, WA 98104
(206) 667-9572
www.bryanohnogallery.com

Noah Purifoy

Desert Art Museum
63030 Blair Lane
Joshua Tree, CA 92252
www.noahpurifoy.com

Sue Welsh
Tara's Hall, Los Angeles
(213) 382-7516, Fax: (213) 386-5034
tarashall@worldnet.att.net

Alison Saar

Jan Baum Gallery
170 S. La Brea Ave.
Los Angeles, CA 90036
(323) 932-0170
www.janbaum.com

Phyllis Kind Gallery
136 Greene Street
New York, NY 10012
(212) 925-1200
www.phylliskindgallery.com

Diane Villani Editions
271 Mulberry Street
New York, NY 10012
(212) 925-1075
www.villanieditions.com

Lezley Saar

Jan Baum Gallery
170 S. La Brea Ave.
Los Angeles, CA 90036
(323) 932-0170
www.janbaum.com

David Beitzel Gallery
476 Broome Street
New York, NY 10013
(212) 219-2863
www.beitzelgallery.com

Adrian Saxe

Frank Lloyd Gallery
2525 Michigan Ave., B-5B
Santa Monica, CA 90404
(310) 264-3866

Peter Shire

Frank Lloyd Gallery
2525 Michigan Ave., B-5B
Santa Monica, CA 90404
310-264-3866

S. K. Josefsberg Gallery
403 NW 11th Avenue
Portland, OR 97209
(503) 241-9112
www.skjstudio.com

Modernism
685 Market Street
San Francisco, CA 94105
(415) 541-0461
www.modernisminc.com

William Traver Gallery
110 Union Street
Seattle, WA 98101
(206) 587-6501
www.travergallery.com

Brad Spence

Shoshana Wayne Gallery
2525 Michigan Ave., B-1
Santa Monica, CA 90404
(310) 453-7535

Sush Machida Gaikotsu

Mark Moore Gallery
2525 Michigan Ave., A-1
Santa Monica, CA 90404
(310) 453 3031
www.markmooregallery.com

Marc Trujillo

Hackett-Freedman Gallery
250 Sutter Street, Suite 400
San Francisco, CA 94108
(415) 362-7152
www.hackettfreedmangallery.com

Patssi Valdez

Patricia Correia Gallery
2525 Michigan Ave., E2
Santa Monica, CA 90404
(310) 264-1760
correia@earthlink.net
www.correiagallery.com

Robert Walker

DoubleVision Gallery
5820 Wilshire Blvd., Suite 100
Los Angeles, CA 90036
(323) 936-1553
www.doublevisionarts.com

Jean Albano Gallery
215 West Superior
Chicago, IL 60610
(312) 440.0770
jeanalbanogallery.com

Patrick Wilson

Brian Gross Fine Art
49 Geary Street, 5th Floor
San Francisco, CA 94108
(415) 788-1050
gallery@briangrossfineart.com

Susanne Vielmetter Los Angeles Projects
5363 Wilshire Boulevard
Los Angeles CA 90036
(323) 933-2117
www.vielmetter.com

FUSEBOX
1412 Fourteenth Street NW
Washington, DC 20005
(202) 299-9220
www.fuseboxdc.com

Takako Yamaguchi

Jan Baum Gallery
170 S. La Brea Ave.
Los Angeles, CA 90036
(323) 932-0170
www.janbaum.com

Yek

Mark Moore Gallery
2525 Michigan Ave. A-1
Santa Monica, CA 90404
(310) 453-3031
www.markmooregallery.com

Rebecca Ibel Gallery
1055 North High Street
Columbus, OH 43201
(614) 291-2555
www.rebeccaibel.com

Angstrom Gallery
3609 Parry Avenue
Dallas, TX 75226
(214) 823-6456

Feigen Contemporary
535 W. 20th Street
New York, NY 10011
(212) 929-0500

Northern California

Timothy Berry

Hosfelt Gallery
430 Clementina
San Francisco, CA 94103
(415) 495-5454
www.hosfeltgallery.com

Christopher Brown

John Berggruen Gallery
228 Grant Avenue
San Francisco, CA 94108
(415) 781-4629
www.berggruen.com

Squeak Carnwath

John Berggruen Gallery
228 Grant Avenue
San Francisco, CA 94108
(415) 781-4629
www.berggruen.com

Enrique Chagoya

Gallery Paule Anglim
14 Geary Street
San Francisco, CA 94108
(415) 433-2710
www.gallerypauleanglim.com

George Adams Gallery
41 West 57th Street
7th Floor
New York, NY 10019
(212) 644-5665
www.artnet.com/gadams.html

Lisa Sette Gallery
4142 N. Marshall Way
Scottsdale, AZ 85251
(480) 990-7342
www.lisasettegallery.com

Anthony Discenza

Hosfelt Gallery
430 Clementina
San Francisco, CA 94103
(415) 495-5454
www.hosfeltgallery.com

Donald Feasél

Brian Gross Fine Art
49 Geary Street, 5th Floor
San Francisco, CA 94108
(415) 788-1050
www.briangrossfineart.com

Wilbert Griffith

The Ames Gallery
2661 Cedar Street
Berkeley, CA 94708
(510) 845-4949
www.theamesgallery.com

Doug Hall

Rena Bransten Gallery
77 Geary Street
San Francisco, CA 94108
(415) 982-3292
www.renabranstengallery.com

Feigen Contemporary
535 W. 20th Street
New York, NY 10011
(212) 929 0500
www.feigencontemporary.com

Mildred Howard

Gallery Paule Anglim
14 Geary Street
San Francisco, CA 94108
(415) 433-2710
www.gallerypauleanglim.com

Nielsen Gallery
179 Newbury Street
Boston, MA 02116 USA
(617) 266-4835
www.nielsengallery.com

David Ireland

Gallery Paule Anglim
14 Geary Street
San Francisco, CA 94108
(415) 433-2710
www.gallerypauleanglim.com

Christopher Grimes Gallery
916 Colorado Avenue
Santa Monica, CA 90401
(310) 587-3373
www.cgrimes.com

Jack Shainman Gallery
513 West 20th Street
New York, NY 10011
(212) 645-1701

Sherry Karver

Lisa Harris Gallery
1922 Pike Place
Seattle, WA 98101
206-443-3315
www.lisaharrisgallery.com

LewAllen Contemporary Gallery
129 West Palace Avenue
Santa Fe, NM 87501
(505) 988-8997
www.lewallenart.com

Greenwood / Chebithes Gallery
330 North Coast Hwy
Laguna Beach, CA 92651
(949) 494-0669
www.gcgallery.com

Michael Kenna

Stephen Wirtz Gallery
49 Geary Street, 3rd Floor
San Francisco, CA 94108
(415) 433-6879
www.wirtzgallery.com/main.html

Hung Liu

Rena Bransten Gallery
77 Geary Street
San Francisco, CA 94108
(415) 982-3292
www.renabranstengallery.com

Bernice Steinbaum Gallery
3550 North Miami Avenue
Miami, FL 33127
(305) 573-2700
www.bernicesteinbaumgallery.com

Cork Marcheschi

Braunstein/Quay Gallery
430 Clementina
San Francisco, CA 94103
(415) 278-9850
www.bquayartgallery.com

Morgan Gallery
114 Southwest Boulevard
(816) 842-8755
Kansas City, MO 64108
www.morgangallery.com

Barry McGee

Gallery Paule Anglim
14 Geary Street
San Francisco, CA 94108
(415) 433-2710
www.gallerypauleanglim.com

Kevin Moore

HANG
556 Sutter Street
San Francisco, CA 94102
(415) 434-4264
www.hangart.com

Ron Nagle

Rena Bransten Gallery
77 Geary Street
San Francisco, CA 94108
(415) 982-3292
www.renabranstengallery.com

Garth Clark Gallery
24 West 57th Street, Suite305
New York, NY 10019
(212) 246-2205
www.garthclark.com

Robert Ogata

Robert Ogata Studio
701 L. St.
Fresno, CA 93721-2904
(559) 237-1678
zogata@earthlink.net

Ira Wolk Gallery
1354 Main Street
St. Helena, CA 94574
iwolkgallery.com

Victoria Boyce Galleries:
3001 East Skyline Drive
El Cortijo, AZ 85718
7130 East Main Street
Scottsdale, AZ 85251
www.vboycegalleries.com

Fig Tree Gallery
1536 Fulton Street
Fresno, CA 93721
(559) 485-0460

Deborah Oropallo

Stephen Wirtz Gallery
49 Geary Street, 3rd Floor
San Francisco, CA 94108
(415) 433-6879
www.wirtzgallery.com/main.html

Ed Osborn

Catharine Clark Gallery
49 Geary Street, 2nd Floor
San Francisco, CA 94108
(415) 399-1439
www.cclarkgallery.com

Roland Petersen

Hackett-Freedman Gallery
250 Sutter Street, Suite 400
San Francisco, CA 94108
(415) 362-7152
www.hackettfreedmangallery.com

Nathaniel Price

Toomey Tourell Gallery
49 Geary Street
San Francisco, CA 94108
(415) 989-6444
www.toomey-tourell.com

Alan Rath

Haines Gallery
49 Geary Street, 5th Floor
San Francisco, CA 94108
(415) 397-8114
www.hainesgallery.com

Carl Solway Gallery
424 Findlay Street
Cincinnati, OH 45214
(513) 621-0069
www.solwaygallery.com

Rex Ray

Michael Martin Galleries
101 Townsend, Suite 207
San Francisco, CA 94107
(415) 543-1550
www.mmgalleries.com

Gallery 16
1616 Sixteenth Street
San Francisco, CA 94103
(415) 626-7495

Greg Rose

Hosfelt Gallery
430 Clementina
San Francisco, CA 94103
(415) 495-5454
www.hosfeltgallery.com

Catherine Ryan

HANG
556 Sutter Street
San Francisco, CA 94102
(415) 434-4264
www.hangart.com

Raymond Saunders

Stephen Wirtz Gallery
49 Geary Street, 3rd Floor
San Francisco, CA 94108
(415) 433-6879
www.wirtzgallery.com

Mary Snowden

Braunstein/Quay Gallery
430 Clementina
San Francisco, CA 94103
415) 278-9850
www.bquayartgallery.com

Inez Storer

Catharine Clark Gallery
49 Geary Street, 2nd Floor
San Francisco, CA 94108
(415) 399-1439
www.cclarkgallery.com

Grover/Thurston Gallery
309 Occidental Avenue South
Seattle, WA 98104
(206) 223-0816
www.groverthurston.com

William Swanson

Heather Marx Gallery
77 Geary Street, Second Floor
San Francisco, CA 94108
(415) 627-9111
www.heathermarxgallery.com/

Kris Timken

Pulliam Deffenbaugh Gallery
522 NW 12th Street
Portland, OR 97209
(503) 228-6665
www.pulliamdeffenbaugh.com

Traywick Gallery
1316 Tenth Street
Berkeley, CA 94710
(510) 527-1214
www.traywick.com

Catherine Wagner

Stephen Wirtz Gallery
49 Geary Street, 3rd Floor
San Francisco, CA 94108
(415) 433-6879
www.wirtzgallery.com

Gallery Luisotti
2525 Michigan Ave., A2
Santa Monica, CA 90405

Darren Waterston

Haines Gallery
49 Geary Street, 5th Floor
San Francisco, CA 94108
(415) 397-8114
www.hainesgallery.com

Michael Kohn Gallery
8071 Beverly Boulevard
Los Angeles, CA 90048
(323) 658-8088
www.artnet.com/kohngallery.html

Greg Kucera Gallery
212 Third Ave. South
Seattle, WA 98104-2608
(206) 624-0770
www.gregkucera.com

Equinox Gallery
2321 Granville Street
Vancouver, BC
V6H 3G3 Canada
(604) 736-2405

Inman Gallery
214 Travis Street
Houston, TX 77002
(713) 222-0844
www.inmangallery.com

Cowles Gallery
537 West 24th Street
New York, NY 10011
(212) 925-3500

William Wiley

Rena Bransten Gallery
77 Geary Street
San Francisco, CA 94108
(415) 982-3292
www.renabranstengallery.com

Hawai'i

Masami Teraoka

Catharine Clark Gallery
49 Geary Street, 2nd Floor
San Francisco, CA 94108
(415) 399-1439
www.cclarkgallery.com

Oregon

Jay Backstrand

Laura Russo Gallery
805 NW 21st Avenue
Portland, OR 97209
(503) 226-2754
www.laurarusso.com

Michael Brophy

Laura Russo Gallery
805 NW 21st Avenue
Portland, OR 97209
(503) 226-2754
www.laurarusso.com

Sally Cleveland

Augen Gallery
817 SW 2nd Avenue
Portland, OR 97204
www.augengallery.com

Davidson Galleries
313 Occidental Avenue S.
Seattle, WA 98104
www.davidsongalleries.com

David Straub Photography
2637 NE MLK Blvd.
Portland, Oregon 97212
www.straubphoto.com

Allen Cox

Jenkins Johnson Gallery
464 Sutter Street
San Francisco, CA 94108
(415) 677-0770
www.jenkinsjohnsongallery.com

Imago Galleries
45-450 Highway 74
Palm Desert, CA 92260
(760) 776-9890
www.imagogalleries.com

Jacqueline Ehlis

ehlis65@hotmail.com
info@savagegallery.com

Anna Fidler

Pulliam Deffenbaugh Gallery
522 NW 12th Street
Portland, OR 97209
(503) 228-6665
www.pulliamdeffenbaugh.com

Chris Kelly

Augen Gallery
817 S.W. 2nd Ave.
Portland, OR 97204
(503) 224-8182
www.augengallery.com

White Bird Gallery
251 North Hemlock
Cannon Beach, OR 97110
(503) 436-2681
www.whitebirdgallery.com

Dianne Kornberg

dkornberg@comcast.net
info@savagegallery.com

Laura Ross-Paul

Froelick Gallery
817 SW 2nd Avenue
Portland, OR 97204
(503) 222-1142
www.froelickgallery.com

Jenkins Johnson Gallery
464 Sutter St.
San Francisco, CA 94108
(415) 677-0770
www.jenkinsjohnsongallery.com

Naomi Shigeta

Augen Gallery
817 S.W. 2nd St.
Portland, OR 97204
(503) 224-8182
www.augengallery.com

Mark R. Smith

Elizabeth Leach Gallery
207 SW Pine Street
Portland, OR 97204
(503) 224-0521
www.elizabethleach.com

Libby Wadsworth

Elizabeth Leach Gallery
207 SW Pine Street
Portland, OR 97204
(503) 224-0521
www.elizabethleach.com

Washington

Theresa Batty

Theresa Batty Studio
P.O. Box 9614
Seattle, WA 98109
(206) 313-0930
tbatty1@hotmail.com

Susan Bennerstrom

Davidson Galleries
313 Occidental Ave. S.
Seattle, WA 98104
206-624-7684
www.davidsongalleries.com

Terrence Rogers Fine Art
1231 Fifth Street
Santa Monica, CA 90401
(310) 394-4999
trogart@aol.com

Mark Calderon

Greg Kucera Gallery
212 Third Ave S.
Seattle, WA 98104
(206) 624-0770
www.gregkucera.com

Nancy Hoffman Gallery
429 West Broadway
New York, NY 10012
(212) 966-6676
www.nancyhoffmangallery.com

Jaq Chartier

William Traver Gallery
110 Union Street, 2nd Floor
Seattle, WA 98101
(206) 587-6501
www.travergallery.com

Elizabeth Leach Gallery
207 SW Pine Street
Portland, OR 97204
(503) 224-0521]
www.elizabethleach.com

Frumkin/Duval Gallery
2525 Michigan Avenue, Suite T-1
Santa Monica, CA 90404
310-453-1850
www.frumkingallery.com

Schroeder/Romero Gallery
173A North 3rd St.
Brooklyn, NY 11211
(718) 486-8992
www.schroederromero.com

Cervini Haas Gallery
4200 N. Marshall Way, Ste 6
Scottsdale, AZ 85251
(480) 429-6116
www.cervinihaas.com

Limn Gallery
292 Townsend St.
San Francisco, CA 94107
(415) 977-1300
www.limn.com

John Cole

Lisa Harris Gallery
1922 Pike Place
Seattle, WA 98101
(206) 443-3315
www.lisaharrisgallery.com

Marita Dingus

Francine Seders Gallery
6701 Greenwood Avenue N.
Seattle, WA 98103
(206) 782-0355
www.sedersgallery.com

Claudia Fitch

Greg Kucera Gallery
212 Third Ave S.
Seattle, WA 98104
(206) 624-0770
www.gregkucera.com

Adam Baumgold Gallery
74 East 79th Street
New York, NY 10021
(212) 861-7338
www.adambaumgoldgallery.com

Pam Gazalé

Pam Gazalé Studio
707 S. Snoqualmie Street
Suite 4B
Seattle, WA 98108
(206) 412-7346
pgazale@mindspring.com

John Grade

Davidson Galleries
313 Occidental Ave. S.
Seattle, WA 98104
(206) 624-7684
www.davidsongalleries.com

Gaylen Hansen

Linda Hodges Gallery
316 First Ave. South
Seattle, WA 98104
(206) 624-3034
www.lindahodgesgallery.com

Christopher Harris

Lisa Harris Gallery
1922 Pike Place
Seattle, WA 98101
(206) 443-3315; fax 206-728-6294
www.lisaharrisgallery.com

PDX Contemporary Art
604 NW 12th Avenue at Hoyt
Portland, OR 97209
503-222-0063
www.pdxcontemporaryart.com

ClampArt
250 West 27th Street, Loft 1C
New York, NY 10001
(646) 230-0020
www.clampart.com

Sherry Markovitz

Greg Kucera Gallery
212 Third Ave S.
Seattle, WA 98104
(206) 624-0770
www.gregkucera.com

Ochi Gallery
119 Lewis Street
Ketchum, ID 83340
(208) 726-8746
www.ochigallery.com

Peter Millett

Greg Kucera Gallery
212 Third Ave S.
Seattle, WA 98104
(206) 624-0770
www.gregkucera.com

Ochi Gallery
119 Lewis Street
Ketchum, ID 83340
(208) 726-8746
www.ochigallery.com

Robischon Gallery
1740 Wazee Street
Denver, CO 80202
(303) 298-7788
www.robischongallery.com

Richard Morhous

Lisa Harris Gallery
1922 Pike Place
Seattle, WA 98101
(206) 443-3315; fax 206-728-6294
http://www.lisaharrisgallery.com

Margo Jacobsen Gallery
1039 NW Glisan
Portland, OR 97209
(503) 224-7237
www.margojacobsengallery.com

The Munson Gallery
225 Canyon Road
Sante Fe, NM 87501
(505) 983-1657
www.munsongallery.com

Anne Reed Gallery
620 Sun Valley Road
Ketchum, ID 83340
(208) 726-3036
www.annereedgallery.com

William Morris

Holle Simmons
William Morris Studio
31321 3rd Avenue North East
Stanwood, WA 98282
(360) 629-4423
www.wmorris.com

Joseph Park

Howard House
2017 Second Ave.
Seattle, WA 98121
(206) 256-6399
www.howardhouse.net

Roberts and Tilton Gallery
6150 Wilshire Blvd.
Los Angeles, CA 90048
(323) 549-0223
robertsandtilton@earthlink.net

Rena Bransten Gallery
77 Geary Street
San Francisco, CA 94108
(415) 982-3292
www.renabranstengallery.com

Francesca Sundsten

Davidson Galleries
313 Occidental Ave. S.
Seattle, WA 98104
(206) 624-7684
www.davidsongalleries.com

Gillian Theobald

Linda Hodges Gallery
316 First Ave. South
Seattle, WA 98104
(206) 624 3034
www.lindahodgesgallery.com

Cirrus Gallery
542 S. Alameda
Los Angeles, CA 90013
(213) 680-3473
www.cirrusgallery.com

Lisa Zerkowitz

Bryan Ohno Gallery
155 S. Main Street
Seattle, WA 98104
(206) 667-9572
www.bryanohnogallery.com

Jenkins Johnson Gallery
464 Sutter Street
San Francisco, CA 94108
(415) 677-0770
www.jenkinsjohnsongallery.com

British Columbia

Margaretha Bootsma

Linda Hodges Gallery
316 First Ave. South
Seattle WA 98104
(206) 624-3034
www.lindahodgesgallery.com

Bau-xi Gallery
3045 Granville Street
Vancouver, BC Canada
V6H 3J9
(604) 733-7011
www.bau-xi.com

Bau-xi Gallery
40 Dundas Street West
Toronto, Ont. Canada
(416) 977-0600
www.bau-xi.com

Lori-ann Latremouille

Augen Gallery
817 S.W. 2nd
Portland OR 97204
www.augengallery.com

Gunnar Nordstrom
127 Lake Street South
Kirkland, WA 98033
www.gunnarnordstrom.com

Further Reading

Alexander, Peter; Hickey, Dave; Vine, Naomi; Orange County Museum of Art; and Donna Beam Fine Art Gallery. *Peter Alexander: In This Light*. Manchester, Vermont: Hudson Hills Press, 1999.

Allan, Lois. *Contemporary Art in the Northwest*. Sydney: Craftsman House, 1995.

Allen, Ginny and Klerit, Jody. *Oregon Painters: The First Hundred Years, 1859–1959: Index and Biographical Dictionary*. Portland: Oregon Historical Society, October 1999.

Anfam, David and Benezra, Neal, et al. *Clyfford Still*. New Haven: Yale University Press, 2001.

Barron, Stephanie, et al. *Made in California: Art, Image, and Identity, 1900–2000*. Berkeley: University of California Press, 2000.

Berlant, Tony; Clothier, Peter; and Starrels, Josine I. *Tony Berlant: Recent Work, 1982–1987*. Los Angeles: Los Angeles Municipal Art Gallery Associates, 1987.

Tony Berlant: Recent Work April 16–May 21, 1988. Los Angeles: Lapis Press, 1989.

Birk, Sandow and Linton, Meg. *Incarcerated: Visions of California in the 21st Century*. San Francisco: Last Gasp, 2001.

Birk, Sandow. *In Smog and Thunder: Historical Works from the Great War of the Californias*. San Francisco: Last Gasp, 2002.

Bischoff, Elmer and Landauer, Susan. *Elmer Bischoff: The Ethics of Paint*. Oakland Museum, Orange County Museum of Art, and Norton Museum of Art. Berkeley: University of California Press, 2001.

Blum, Paul Von. *Other Visions, Other Voices*. Lanham, MD: University Press of America, 1994.

Boas, Nancy and Eldredge, Charles. *The Society of Six: California Colorists*. Berkeley: University of California Press reprint edition, 1997.

Booth-Clibborn, Edward, ed. *Scrawl: Dirty Graphics & Strange Characters*. Corte Madera, CA: Gingko Press, 1999.

Brown, Elizabeth A. and Rickels, Laurence A. *Lari Pittman: Drawings*. Santa Barbara University Art Museum, University of California, UCLA at the Armand Hammer Museum of Art and Cultural Center. Oakland: University of California Regents, 1996.

Brown, Joan; Tsujimoto, Karen; and Baas, Jacquelynn. *The Art of Joan Brown*. University Art Museum, Berkeley; University of California; and Oakland Museum of California. Berkeley: University of California Press, 1998.

Brunsman, Laura and Askey, Ruth, eds. *Modernism and Beyond: Women Artists of the Pacific Northwest*. New York: Midmarch Art Press, 1993.

California Art Review: An Illustrated Survey of the State's Museums, Galleries, and Leading Artists. Chicago: American References, 1989.

Callis, Jo Ann. *Jo Ann Callis: Objects of Reverie: Selected Photographs, 1977–1989*. Boston: Black Sparrow Press, 1989.

Carnwath, Squeak. *Squeak Carnwath: Lists, Observations & Counting*. San Francisco: Chronicle Books, 1996.

Castellon, Rolando, ed. *Mano a Mano: Abstraction–Figuration: 16 Mexican–American and Latin American*

Painters from the San Francisco Bay Area. Santa Cruz, CA: Sesnon Gallery, 1988.

Celant, Germano; Bertelli, Patrizio; and Prada, Miuccia. *Barry McGee.* Milano: Fondazione Prada, 2003.

Chagoya, Enrique and Gomez–Pena, Guillermo. *Friendly Cannibals.* San Francisco: Artspace Books, 1996.

Chagoya, Enrique; Gomez–Pena, Guillermo; and Felicia Rice. *Codex Espangliensis: From Columbus to the Border Patrol.* San Francisco: City Lights Books, 2000.

Davis, Bruce. *Made in L.A.: The Prints of Cirrus Editions.* Los Angeles: Los Angeles County Museum of Art, 1995.

Diebenkorn, Richard and Nordland, Gerald. *Richard Diebenkorn.* New York: Rizzoli International, 1988.

Di Rosa, Rene, ed. *Local Color: The Di Rosa Collection of Contemporary California Art.* San Francisco: Chronicle Books, 1999.

Dustin, Nancy. *California Art: 450 Years of Painting & Other Media.* Los Angeles: Dustin Publications, 1998.

Eagles-Smith, K. R. *Roland Petersen.* San Francisco: Wittenborn Art Books, 1989.

Edgar, Blake, et al. *William Morris: Man Adorned.* Seattle: University of Washington Press, 2002.

Flick, Robbert. *Robbert Flick: Sequential Views, 1980–1986.* New York: Aperture Foundation, 1989.

Fort, Ilene Susan and Skolnick, Arnold. *Paintings of California.* Berkeley: University of California Press reprint edition, 1997.

Fuller, Diana Burgess and Salvioni, Daniela. eds. *Art/Women/California 1950–2000: Parallels and Intersections.* Berkeley: University of California Press, 2002.

Gerdts, William H. and South, Will. *California Impressionism.* New York: Abbeville Press, 1998.

Gerstler, Amy. *Darren Waterston: Limited Edition.* Los Angeles: St. Ann's Press, 2001.

Hall, Doug and Fifer, Sally Jo, ed. *Illuminating Video: An Essential Guide to Video Art.* New York: Aperture Foundation, 1991.

Hennessey, Beverly. *On Art and Artists: Essays Thomas Albright.* San Francisco: Chronicle Books, 1989.

Hjalmarson, Birgitta and Gerdts, William H. *Artful Players: Artistic Life in Early San Francisco.* Glendale, CA: Balcony Press, 1999.

Hopkins, Henry; Jacobs, Mimi; and Bullis, Douglas, ed. *50 West Coast Artists: A Critical Selection of Painters and Sculptors Working in California.* San Francisco: Chronicle Books, 1982.

Hughes, Edan Milton. *Artists in California, 1786–1940.* Sacramento, CA: Crocker Art Gallery: 2002.

Isenberg, Barbara. *State of the Arts: California Artists Talk About Their Work.* New York: William Morrow & Co., 2000.

Johnstone, Mark. *Michael Kenna.* New York: Farrar Straus & Giroux, 1989.

———. *Contemporary Art in Southern California.* Sydney: Craftsman House, 1999.

——— and Holzman, Leslie Aboud. *Epicenter: San Francisco Bay Area Art Now.* San Francisco: Chronicle Books, 2003.

Jones, Caroline A. *Bay Area Figurative Art: 1950–1965.* Berkeley: University of California Press, 1990.

Kenna, Michael. *Night Walk, Untitled, 47.* San Francisco: Friends of Photography Bookstore, 1988.

———. *The Elkhorn Slough and Moss Landing.* Santa Monica, CA: Ram Publications, 1991.

———. *Michael Kenna: A Twenty–Year Retrospective.* Santa Monica, CA: Ram Publications, 1995.

———. *The Rouge.* Santa Monica, CA: Ram Publications, 1995.

——— and Haskell, Eric T. *Le Notre's Gardens.* Santa Monica, CA: Ram Publications, 1999.

———. *Night Work.* Tucson, AZ: Nazraeli Press, 2000.

———. *Easter Island.* Tucson, AZ: Nazraeli Press, 2002.

Korb, Edward L. *A Biographical Index to California & Western Artists: A Handbook Providing Reference to over 50 Books and Exhibition Catalogs As Biographical Source.* Bellflower, CA: DeRus Fine Art Books, 1983.

Landauer, Susan, ed.; Keyes, Donald D. and Stern, Jean, contribs. *California Impressionists.* Irvine Museum, Georgia Museum of Art, Atlanta Committee for the Olympic Games. Berkeley: University of California Press, 1996.

Landauer, Susan and Ashton, Dore. *The San Francisco School of Abstract Expressionism.* Berkeley: University of California Press, 1996.

Ligare, David; Junker, Patricia; and Krier, Leon. *David Ligare: Paintings.* Salinas, CA: David Ligare, 1997.

Lyons, Lisa. *Departures: 11 Artists at the Getty.* Los Angeles: Getty Trust Publications, 2000.

Marshall, Richard and Foley, Suzanne. *Ceramic Sculpture: Six Artists.* Seattle: University of Washington Press, 1982.

McClelland, Gordon T. and Last, Jay T. *The California Style: California Watercolor Artists 1925–1955.* Beverly Hills: Hillcrest Press, 1985.

McMillen, Michael C. and Ward, Diane Ward. *Portraits and Maps.* St. Paul: Consortium Book Sales, 1999.

McTwigan, Michael. *Ron Nagle.* Seattle: University of Washington Press, 1994.

Moore, Sylvia, ed. *Yesterday and Tomorrow: California Women Artists.* New York: Midmarch Art Press, 1989.

Nagle, Ron and McTwigan, Michael. *Ron Nagle: A Survey Exhibition.* Oakland: Mills College of Art Museum, 1993.

Nagle, Ron. *Ron Nagle.* Seattle: University of Washington Press, 1994.

Nixon, Bruce. *Sunlight and Shadows: The Art of Roland Petersen 1953–1990.* San Francisco: Wittenborn Art Books, 1991.

Obten, Vanessa. Guide to Artists in Southern California. Worcester, MA: Art Resource Publications, 1995.

Oliveira, Nathan; Selz, Peter Howard; Landauer, Susan, and Moser, Joann. *Nathan Oliveira*. San Jose Museum of Art. Berkeley: University of California Press, 2002.

Perrone, Jeff and Schjehldahl, Peter. *Adrian Saxe*. Columbia: University of Missouri Department of Art, 1987.

Petersen, Roland. *Sunlight and Shadows: The Art of Roland Petersen, 1953–1990*. San Francisco: Harcourts Modern and Contemporary Art, 1999.

Roberts, Mary Nooter and Saar, Alison. *Body Politics: The Female Image in Luba Art and the Sculpture of Alison Saar, Monograph Series, O. 29*. Berkeley: Univ of California Museum of Art, 2000.

Stiles, Kristine and Selz, Peter Howard, eds. *Theories and Documents of Contemporary Art: A Sourcebook of Artists' Writings, California Studies in the History of Art*. Berkeley: University of California Press, 1996.

Solnit, Rebecca. *Secret Exhibition: Six California Artists of the Cold War Era*. San Francisco: City Lights Books, 1991.

Saxe, Adrian; Lynn, Martha Drexler; and Collins, Jim. *The Clay Art of Adrian Saxe*. London: Thames & Hudson, 1994.

Shire, Peter; Drohojowska, Hunter; and Sottsass, Ettore. *Tempest in a Teapot: The Ceramic Art of Peter Shire*. Milano: Rizzoli, 1991.

Saunders, Raymond; Bomani, Asake; Rooks, Belvie., Rand, Lydia, trans. *Paris Connections: African American Artists in Paris*. Bomani Gallery, San Francisco and Jernigan Wicker Fine ArtsGallery, San Francisco. Ft. Bragg, CA: Q E D Press, 1992.

Sharylen, Maria. *Artists of the Pacific Northwest: A Biographical Dictionary, 1600s –1970*. Jefferson, NC: McFarland & Company, 1993.

Shepherd, Elizabeth, ed. *Secrets, Dialogues, Revelations: The Art of Betye and Alison Saar*. Seattle: University of Washington Press, 1994.

Sultan, Terrie and French, Christopher C., eds. *William T. Wiley: Struck! Sure? Sound/Unsound*. New York: Corcoran Gallery of Art, 1991.

Tsutakawa, Mayumi; Lau, Alan Chong; and Nakane, Kazuko, eds. *They Painted from Their Hearts: Pioneer Asian American Artists*. Wing Luke Asian Museum Archives of American Art. Seattle: University of Washington Press, 1995.

Visions from the Left Coast: California Self–Taught Artists. Santa Barbara: Santa Barbara Contemporary Arts Forum, 1995.

Weschler, Lawrence. *Seeing Is Forgetting the Name of the Thing One Sees: A Biography of California Artist Robert Irwin*. Berkeley: University of California Press, 1982.

Westphal, Ruth Lilly. *Plein Air Painters of California, the Southland*. Irvine, CA: Westphal Publications, 1982.

Westphal, Ruth Lilly and Dominik, Janet B., eds. *Plein Air Painters of California: The North*. Irvine, CA: Westphal Publications, 1986.

William T. Wiley: What Is Not Drawing?, December 5– January 2, 1988. Los Angeles: Lapis Press, 1989.

———. *William T. Wiley: Watching the World*. Philadelphia: Locks Gallery, 1995.

———. *William T. Wiley: One Man's Moon, April 1–April 29, 1992*. Philadelphia: Locks Gallery, 1992.

Wortz, Melinda. *Variations III: Emerging Artists in Southern California*. Los Angeles: Fellows of Contemporary Art, 2000.

Yau, John. *Ed Moses: A Retrospective of the Paintings and Drawings, 1951–1996*. Berkeley: University of California Press, 1996.

Yood, James, et al. *William Morris: Animal/Artifact*. New York: Abbeville Press, 2001.

Yu, Chingchi; Kellman, Michelle; and Matthews, Paul M. *Art of Northern California: Painting, Drawing, Sculpture, Photography, Printmaking, Mixed Media*. London: Alcove Books, 2003.